CATHERINE MCDERMOTT

MADE IN BRITAIN

Tradition and style in contemporary British fashion

MITCHELL BEAZLEY

MADE IN BRITAIN
Catherine McDermott

First published in 2002 by
Mitchell Beazley, an imprint of
Octopus Publishing Group Ltd,
2–4 Heron Quays, London E14 4JP

ISBN 1 84000 545 9

A CIP catalogue copy of this book is
available from the British Library

Executive Editor Mark Fletcher
Executive Art Editor Christie Cooper
Managing Editor
 Hannah Barnes-Murphy
Project Editor Emily Asquith
Copy Editor Kirsty Seymour-Ure
Design Geoff Borin
Picture Research Rosie Garai
Production Controller
 Alix McCulloch
Indexer Ann Parry
Proofreader Sue Harper

Set in Minion & Bodoni
Printed and bound in China by
Toppan Printing Company Limited

CONTENTS

A HISTORY OF BRITISH FASHION

BRITISH TAILORING

TRADITIONAL FABRICS

BRANDS REINVENTED

GETTING DRESSED UP

REBELLION & SUBVERSION

A HISTORY OF BRITISH FASHION

This introduction presents a series of images, drawn from two hundred years of history, that express unique approaches to fashion in Britain and that have helped to shape the way we dress in the modern world. The themes of British style and identity in fashion are diverse but linked by common threads: principally a focus on the outdoors and on the countryside, and the evolution of practical, durable garments. Britain has contributed to the world of fashion a tradition of woven fabrics in tweed and tartans that continues to influence the design of clothes, a history of innovative tailoring that still inspires, and the postwar phenomenon of rebellious youth culture.

A national taste for practical, simple garments was always partnered with a rather different consciousness, the idea that clothes could express independence of mind, radical social values, even revolution. This intriguing mix can be identified as much in the image of Brooke Boothby in 1781 as in the photograph of Johnny Rotten taken two hundred years later. Alongside the social and economic changes of the Industrial Revolution that Britain pioneered was a trend for a more simplified style of dress, which was seen by the rest of the world as typically British; practical clothes for outdoor wear and physical pursuits that were in sharp contrast to the elaborate silks favoured by the European courts. But more than this, it was the style picked up in post-revolutionary France as the democratic way of dressing. British fashion suggested that clothes might express ideas that opposed the mainstream, such as Romanticism, social revolution, and cultural, artistic, and sexual freedom: themes that we can read in the images of Brooke Boothby and William Morris, in the Mod military parkas and the minidresses of Twiggy.

Alongside such images of individual expression ran the codified rules and traditions of British fashion, which still endure. These included the formal styling of men's dress expressed by the tailoring houses of Savile Row, the development of specialized clothes for sporting activities, and the emergence of uniforms for official functions, for the military – and perhaps more uniquely British – for school, whose rules for hats, blazers, and colours remain with us to this day. This historical archive offers today's designers infinite possibilities for plunder, to enrich the references and styling of contemporary fashion. If we decode the work of current British designers, of Luella Bartley or Timothy Everest, of Dai Rees or Lizzy Disney, we can understand that what is unique, compelling, and innovative in British fashion is the reworking of that rich tradition.

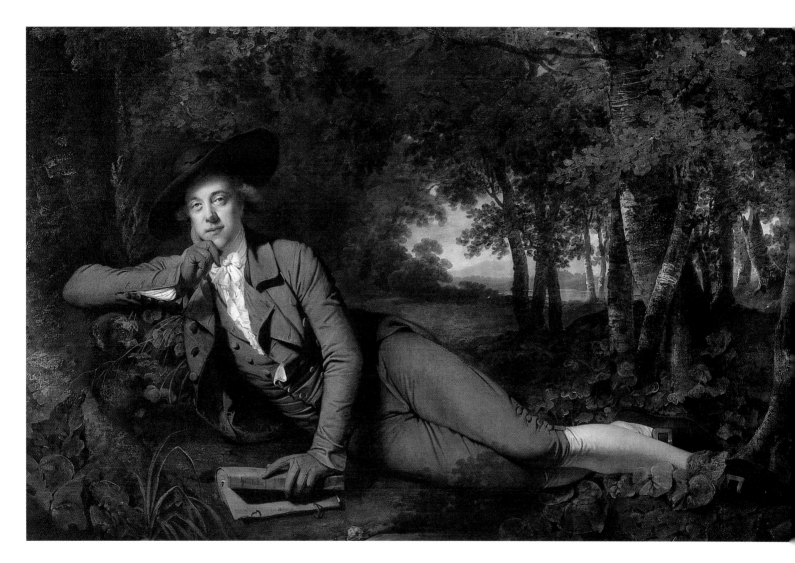

This Romantic portrait of Sir
Brooke Boothby (1744–1824) by
Joseph Wright of Derby (1734–97),
painted in 1781, is a unique
example in British art of male
fashion used to express an
intellectual position. Here is the
defining image of the late 18th-
century British man of taste and
fashion, wearing an elegant, well-
tailored frock coat and matching
suit, styled in every detail, from
the flat shoes to the wide-brimmed
hat; the white cravat tied in a loose
bow was called by the French a
cravate à l'anglaise. Boothby knew
the French Romantic philosopher
Jean-Jacques Rousseau, and it is
one of Rousseau's books that he is
so self-consciously studying here.

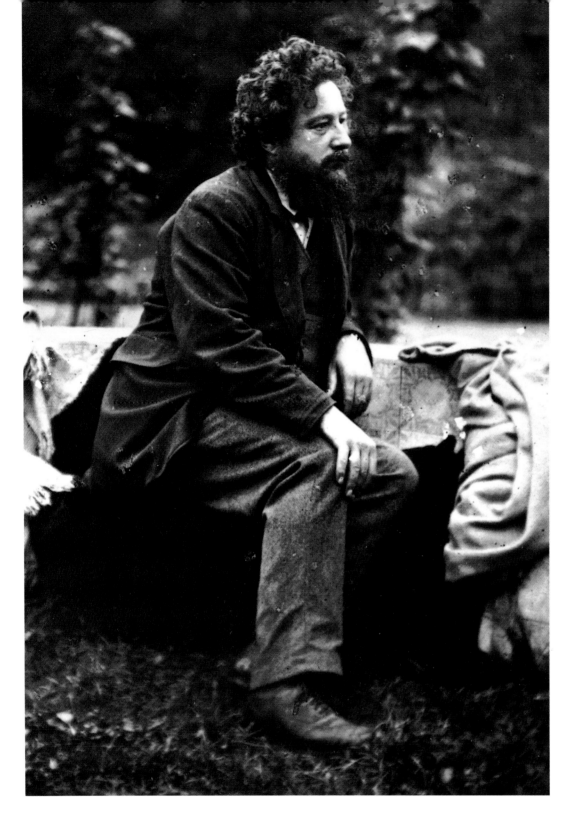

In this photograph, taken in the 1860s, the socialist writer, designer, and craftsman William Morris (1834–96) epitomizes a certain kind of middle-class English male disregard for fashion, which remains part of the national psyche to this day. The look proclaims that one's personal values are more important than fashion. Morris chose an image that by the standards of the day was scruffy and dishevelled and like the man himself highly politicized: the adoption of a slightly unkempt, working-class style – rough wool suit, simple unstarched shirt, practical outdoor shoes, long ungroomed hair – reflected his opposition to the image of the immaculate Victorian gentleman of property. In his later years he adopted a more extreme version of dress which included a battered hat, indigo-dyed shirts and a suit of blue serge – the prototype uniform of the radical revolutionary for the 20th century.

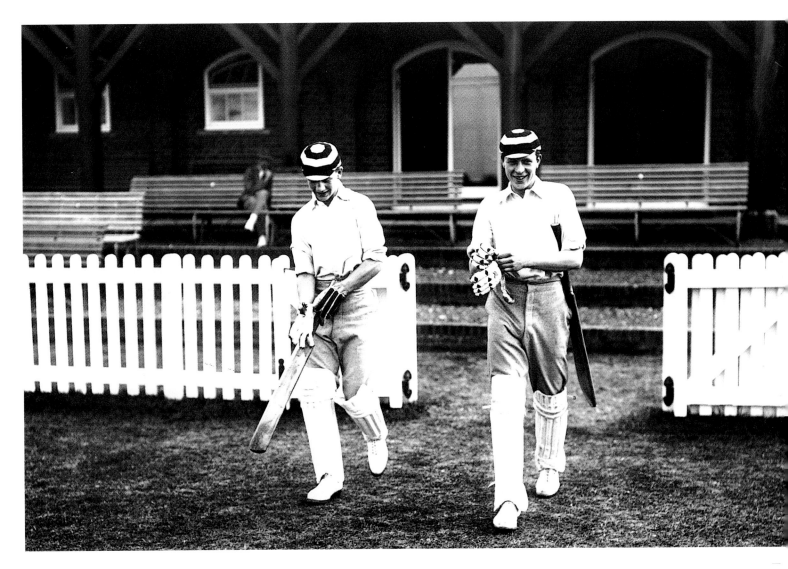

This 1860s photograph shows pupils of one of Britain's most famous public schools, Eton, striding out on to the field to play cricket. In the 19th century English public schools codified the rules of dress for a whole series of British rituals, including sports. By the 1850s the dress code for cricket was fixed into a uniform of loose cotton shirt, flannel trousers, and a cap in the club or school colours, with padded gloves, and leg-pads tied at first with tape and then with a buckle and leather straps. In the mid-19th century players wore a woollen jacket; this was gradually replaced by a knitted white sweater with a distinctive stripe within the V neck.

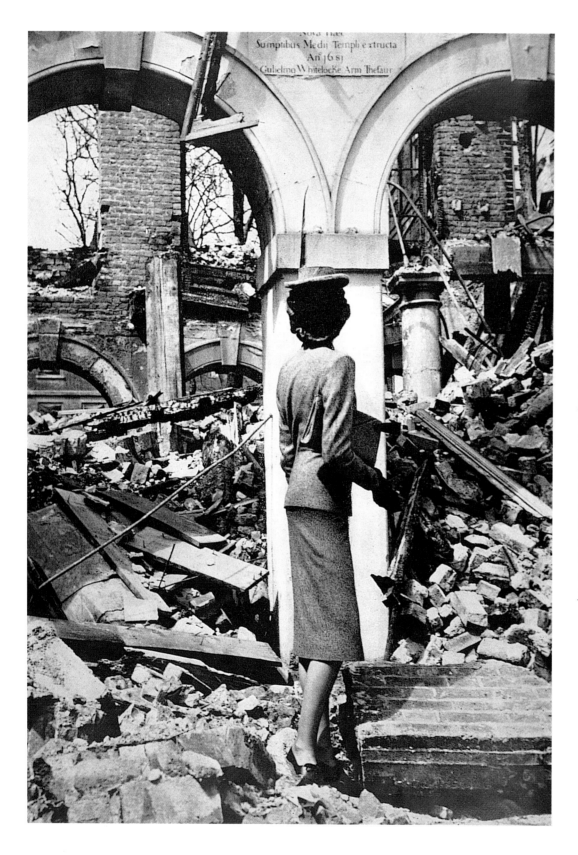

This grey tweed suit by Digby Morton was famously photographed by Cecil Beaton for British *Vogue* in 1941 in the bombed-out ruins of a 17th-century Christopher Wren church in the City of London. It was intended as an image of hope and renewal to publicize the government-backed Utility programme, which offered fashion to the civilian population, albeit within the context of rationing and a severe shortage of materials. Morton was a member of the Incorporated Society of London Fashion Designers, a group of leading British couturiers, which headed the Utility scheme during the war. In the 1920s Morton had worked in Paris and was famous for his women's suits in coloured tweeds worn with soft silk blouses to soften the severity and masculinity of the tailored suit. Although every detail of hem length, fabric, buttons, and trimmings was controlled, the Utility scheme enabled British women regardless of class and income to have some access to the style and design of couture fashion for the first time.

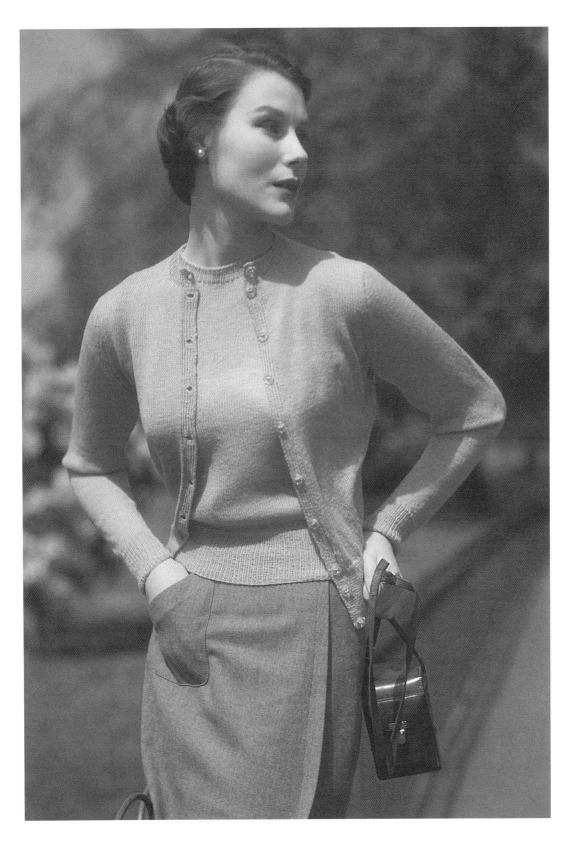

The woollen twin set has become an indispensable element in British womenswear. It is a piece of Modernist fashion: simple, streamlined, undecorated, and functional, which has come to represent the International style in much the same way as a tubular-steel chair or a Bauhaus lamp. Developed in the 1930s, a simple knitted vest worn with a matching cardigan in the same colour, it was comfortable, easy to wear, and supremely versatile: the cardigan could be worn buttoned in cold weather, open or draped over the shoulders in warm. It crossed social and age barriers. In the 1950s, worn a size too small it was figure-hugging and sexy; worn by royalty it was accessorized with a single string of pearls; worn by middle-aged, middle-class women it was a casual but smart solution that said conservative and safe. Such an icon was ripe for exploitation in the punk era: Vivienne Westwood commissioned a range of twin sets in bright colours emblazoned with her orb logo from the knitwear company John Smedley. The twin set remains an enduring symbol of British style.

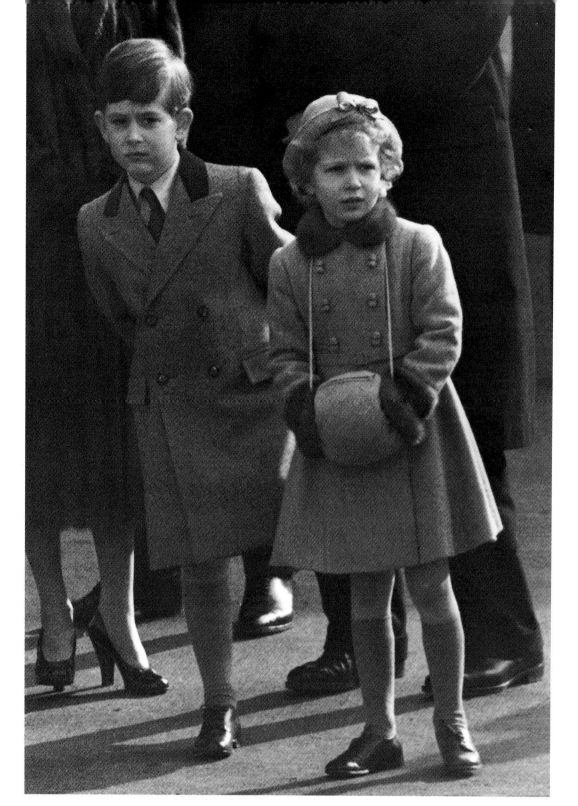

In the 20th century English style was expressed in a certain kind of upper-class children's clothing, worn here by Prince Charles and Princess Anne in 1956, waiting at London Airport for the return of their mother the Queen. Both coats borrow their styling from men's overcoats – double-breasted with a velvet collar for Charles and customized with a feminine fur-trimmed collar and cuffs for Anne. The other distinctively British element is their Start-Rite shoes. Start-Rite Shoes of Norwich, founded in 1792, is the oldest footwear-manufacturing company in England. From the 1920s the company pioneered the idea of properly fitted shoes for children, in a range of classic styles that are still popular. Start-Rite shoes famously included the one-bar shoe and T-bar sandals in navy, brown, red, and black. Shown here is the popular S42 Oxford lace-up shoe dating from 1950.

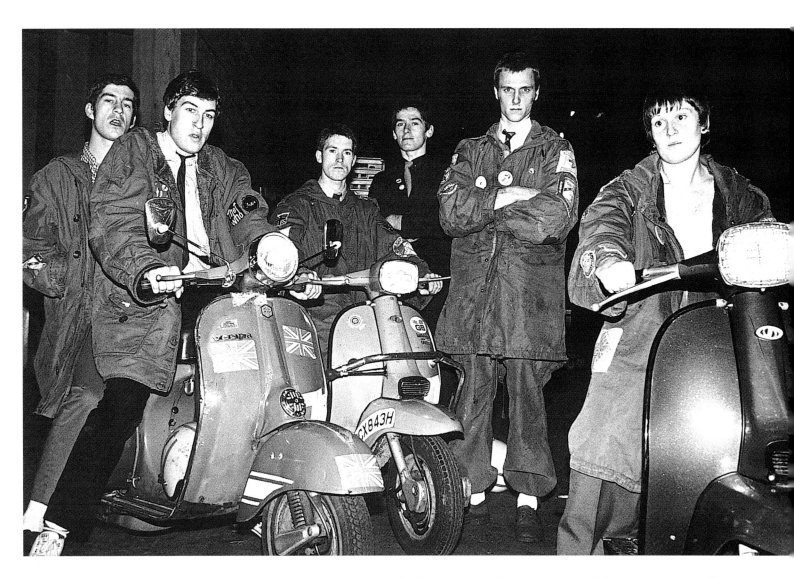

This photograph of Mods highlights one of the important style directions of British youth culture in the 1960s. The Mods were a distinctive movement in opposition to Rockers, who adapted American style. They represented a shift from American to European styling, seen in the cult of coffee bars and Italian fashion. Mods exuded a streamlined, minimalist cool, with their stylish shirts and ties, short haircuts, Clarks suede desert boots, and Italian Vespa scooters. Interestingly their defining garment, the green cotton parka jacket, often with a fur-trimmed hood and emblazoned with badges, originally derived from American army uniform.

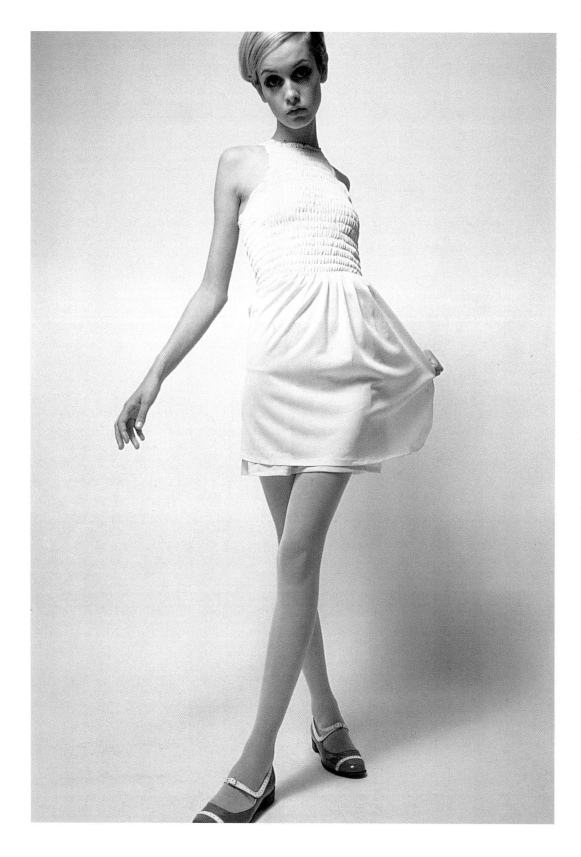

Until the 1960s the point of fashion was to make the wearer look grown-up, older and more sophisticated. British fashion was to change that: the desirable age came to be teenage, the figure became androgynous, and the focus shifted to youth. Twiggy, aged 17 and a British size 6, came to epitomize "swinging London" and the hip, trendy shopping scenes of King's Road and Carnaby Street populated by girls in white ankle boots, brightly coloured stockings, and miniskirts. The dress shown here develops another twist in British fashion: the minidress or miniskirt as a statement to reinforce the sexual revolution of the age. Here the erotic appeal of youth is expressed by adapting the imagery of children's clothes, using a little girl's simple bodice top and short skirt gathered in at the waist, but made in shiny white fabric and teamed with glitter tights and two-tone shoes. Forty years on, that look still has a powerful impact.

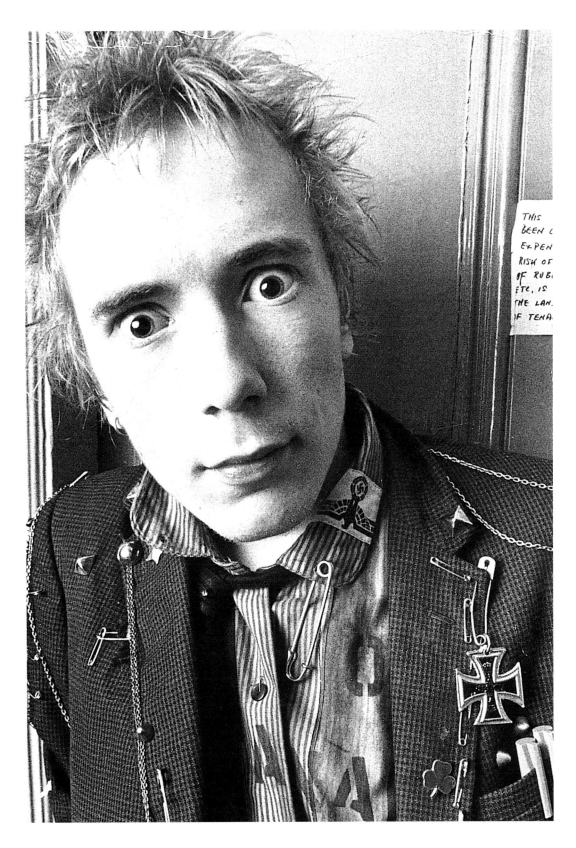

John Lydon, aka Johnny Rotten, was the articulate spokesman of the seminal 1970s British punk band the Sex Pistols. The band was famously conceived by Malcolm McLaren from his King's Road shop SEX and dressed by Vivienne Westwood in clothes that used ripped and torn fabrics, safety pins, and political slogans. Westwood plundered and subverted tradition to attack the establishment culture that they felt should be challenged and changed. The Sex Pistols' music, attitude, and style kick-started a revolution in British music, design, and fashion that still has an impact on attitudes today. Original and uniquely British, there was quite simply nothing else like punk. Seen here in the 1970s Johnny Rotten is wearing a smart Mod shirt with the kind of formal jacket that suggests old-style working class values but with his ironic addition of a war medal pinned to the lapel.

b　　r　i　　t

i　　　s　　h

t　a　i　l　o

r　i　n　g

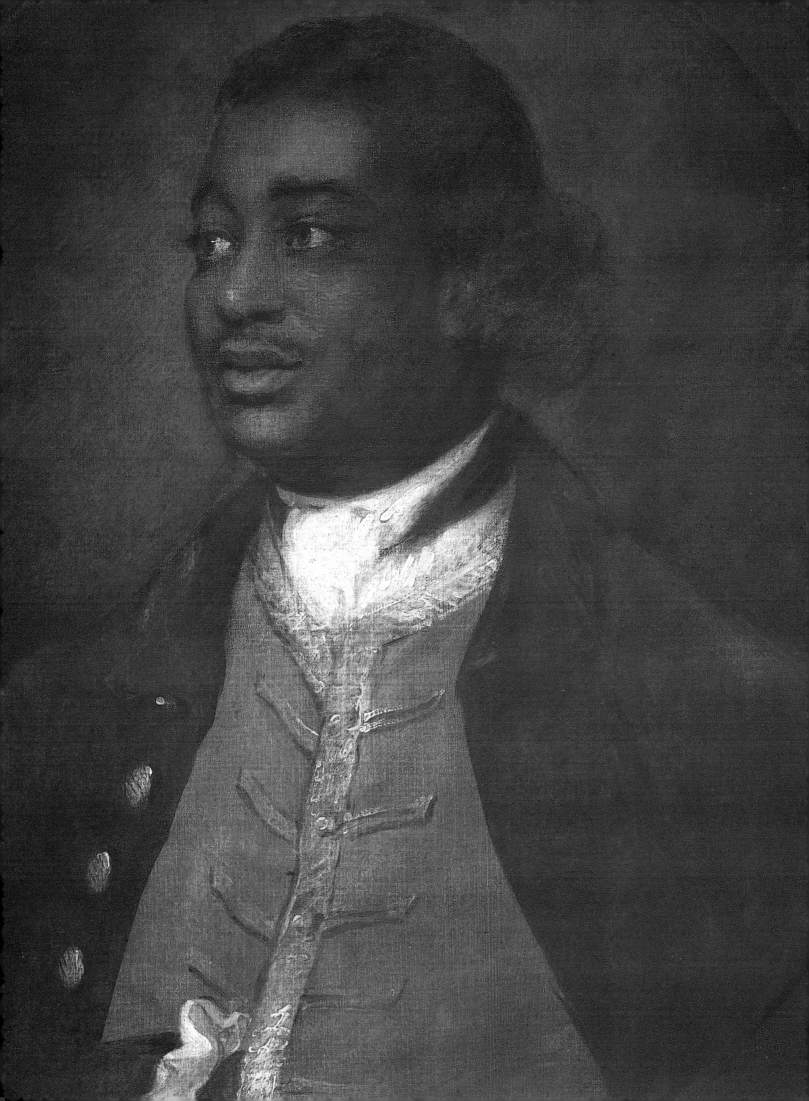

The tradition of quality tailoring has become associated with British fashion in a unique way. Indeed the very idea of the suit, an outfit of matching jacket and trousers, is widely credited as being British. For more than 200 years British menswear has produced original and authentic fabrics and garments, including tartan and tweeds, the Norfolk jacket, and the striped sports blazer. In the late 18th century, the fashionable tailors who developed British menswear formed a tight circle in London's West End around Savile Row, and also including Bond, Conduit, and Maddox streets. With workshops tightly packed, the area had a village-like atmosphere that was unique to London – no other European city combined making and retailing in quite the same way.

The name "Savile Row", however, has come to denote much more than high-quality, hand-made, bespoke menswear. The codes, traditions and culture of Savile Row, evolved in the late 18th and 19th centuries, define a certain kind of Englishness, based on a sense of belonging to an élite circle of public schools, universities, clubs, and teams. The dress codes of Savile Row sanctioned and defined the rites of upper-middle-class Englishness, not only at home but throughout the British Empire, leaving its heritage in Asia, Australia, the Americas, and Africa.

18th-century Britishness

British style was fundamentally about practicality, comfort, and the outdoors. The 18th century merged two traditions – the plain clothing of the Protestant ethic and the more modern evolutions of fashion – into a high style that was uniquely British. One of the seminal images of the period is Gainsborough's *Morning Walk*, now in the National Gallery in London. This is the embodiment of the 18th-century *style anglais*, and we can identify the elements of a British national identity in fashion that have remained fixed, albeit with many subsequent inter-pretations. For women, natural hair and the appropriation of country items such as straw sun hats and simple cotton dresses came to the fore. But it was men who played a more high-profile role in establishing a sense of British style, represented here in a frock coat and waistcoat that are func-tional but made in expensive wool cloth and with a restricted and sophisticated palette of colours.

Such clothes expressed an active relationship with the outdoors, and the idea that everyday items of clothing could cross over into formal wear signalled a revolution in men's clothing. Tailors helped to transform the practical look of a country squire into high fashion; in this period English tailors are credited with a number of innovations that changed the cut and the look of menswear. These include the jacket with the sleeve cut high under the armpit, allowing a narrow but not tight fit; the introduction of a horizontal waist seam which offered a more defined jacket shape; and the conversion of the riding coat, with its sloping front edges, into daywear.

The Industrial Revolution and fashion

At this point, the "art" of tailoring was largely intuitive, relying more on an instinct born of expe-rience than on any pattern-cutting system. The 19th century would change the world of bespoke tailoring. Numerous inventions helped tailors to progress to a rational system of production; a simple innovation was the tape measure, replacing the technique of paper strips marked where

PAGE 17 *The painting of Ignatius Sancho (1729–80) by Thomas Gainsborough, dating from 1768, is the best-known portrait to depict the small emergent black middle class in London of this period. Gainsborough portrays a social equal, fashionably dressed in a stylish waistcoat with gold brocade edging and black necktie. The hand inside the waistcoat is the elegant pose of a gentleman.*

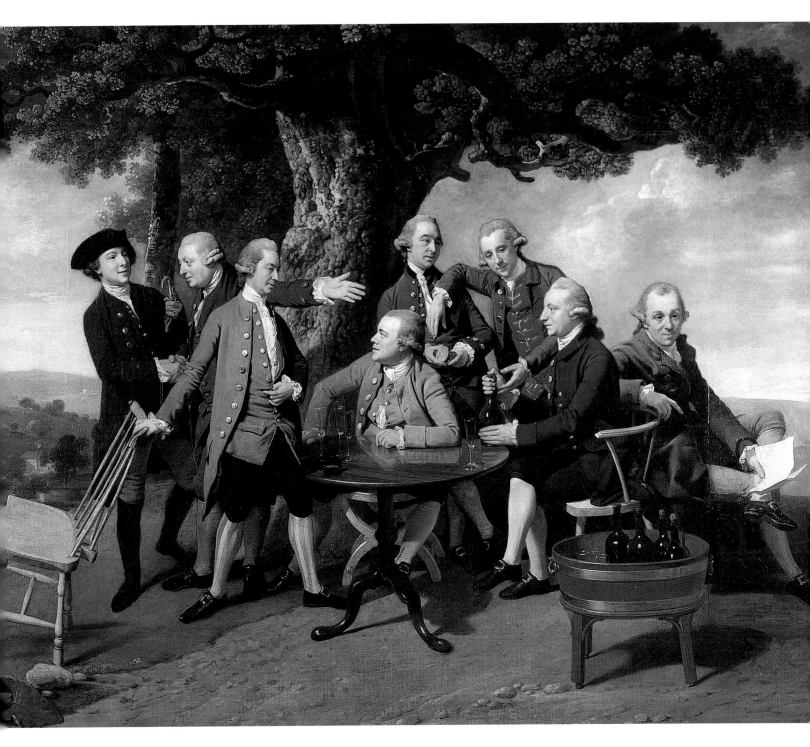

ABOVE This group portrait, by
Johann Zoffany, dating from 1769,
serves to document the clothes and
attitudes of educated, successful,
and wealthy middle-class men.
Robert Ferguson is shown here
introducing the heir to his Scottish
estate, William Berry (far left),
to a group of friends. Their outfits
indicate how 18th-century British
men's fashion could be customized
by using different colours, collar
details, neckties, and waistcoats.

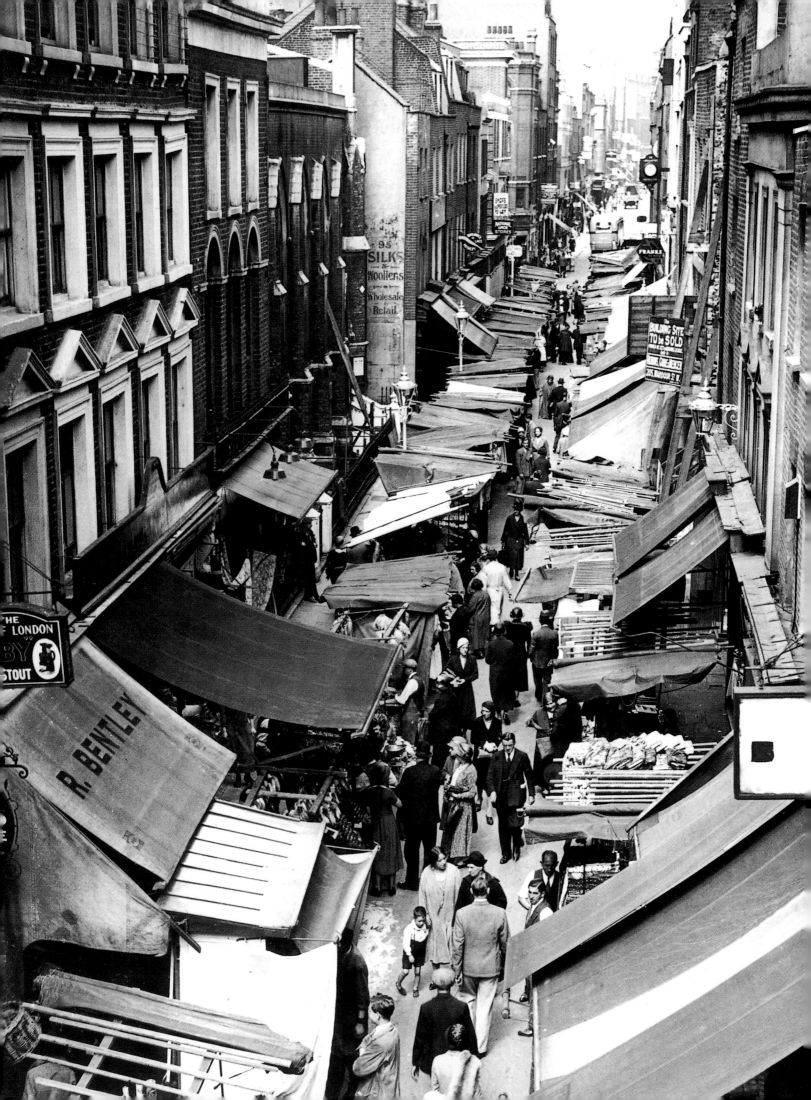

LEFT *Berwick Street market, seen here in the early 1920s, remains a lively street market in the heart of Soho and the location of specialist tailoring outworkers' workshops. Savile Row tailors traditionally did the cutting and sent out the detailed work to makers who specialized in pockets, jackets, and waistcoats. At the end of the 19th century such outworkers were largely of Jewish origin, from Poland, Russia, and Hungary. In the postwar period immigrant tailors included Greek Cypriots and Italians, and more recently craftspeople from China and India.*

RIGHT *Savile Row is the name of the famous street in London's Mayfair that, throughout the world, has come to denote bespoke tailoring. Established in the 18th century as a tailoring district, it remained the centre of a thriving industry until the 1960s, but by the 1980s only around 50 companies remained. Renowned surviving tailoring establishments include Henry Poole & Co. at No. 15, Kilgour French Stanbury at No. 8, Gieves & Hawkes at No. 1, and H. Hunstsman at No. 11, while more recent names include Richard James and Ozwald Boateng.*

the fabric was to be cut; the strips evolved into paper patterns. These were attempts to apply the revolution of 19th-century science to tailoring, to rationalize the process through mathematics and geometry. This scientific approach to new tailoring techniques reflected the wider revolution in industrial methods of production, which for the textiles industries meant an increase in the availability and choice of fabrics. The new world that the late 18th century ushered in broke the dominance of aristocratic taste and opened up the notion of individual preference. Fashion was no longer placed in strict social hierarchies but became more accessible to all classes. It was perceived that fashion might express personal, even political, ideas and that its development was no longer in the hands of an élite.

It is ironic that the fashion leader of his age was the Prince of Wales (later King George IV; reigned 1820–30), while the hero of the move towards fashion as a more egalitarian expression of personal vision was his friend Beau Brummell. With the curtailing of the restrictive power of the trade guilds in the late 18th and 19th centuries, some tailors became "personalities"; one of the most famous was Stulz of London. Stulz helped Brummell create not only a refinement of the 18th-century outfit of frock coat, soft boots, trousers and lightly starched cravat, but a whole image that was more than clothes. Brummell's contribution to British fashion was to offer a modern sense of self, a male sensibility that also legitimized time spent on shopping and dressing. This image was to fuel the worlds of the Romantic movement, the dandy, and the rebel.

It was inevitable that the idea of fashion as a powerful mode of individual expression should also encounter opposition. The reaction of the establishment in the 19th century was a move into a world of formality dominated by sober black uniforms for men: but the rigid rules nonetheless allowed for modifications. The pivotal figure was Queen Victoria's eldest son, Edward (reigned 1901–10). Often photographed in outdoor "manly" pursuits, Edward was interested in

establishing a visual image for sporting activities and helped to create the notion of British clothes as stylish yet casual. Flannel trousers were introduced for tennis and cricket; the Norfolk jacket, a classic informal style, made in tweed and prized for its durability, warmth and resistance to rain, was worn for sporting and country use from the 1870s. Uniforms from schools and sports clubs were also important; the striped wool blazer has remained an enduring fashion style.

The values of the Edwardian age were challenged in the early decades of the 20th century, and the stage was now set internationally for menswear that defined Britishness and offered a modern, easy and relaxed style that matched the times. It attracted a following in Europe and America and on this international stage a second member of the royal family helped to shape British menswear. This was Edward, Prince of Wales and briefly King Edward VIII (reigned 1936). As a young man Edward looked for ways to distance himself from the restraints of court dress. The clothes made by his Savile Row tailor, Scholte – lounge suits, flannel trousers, coloured coordinates, knitwear – marked his personal sense of style. His postwar autobiography, *A Family Album*, was nothing short of the story of his life through fashion, in which he identified a personal quest for modernity through a passion for clothes.

Womenswear and tailoring

British womenswear also has a long connection with tailoring. In the 18th century women's experience of tailoring was restricted to riding habits generally made by male tailors. Tailoring

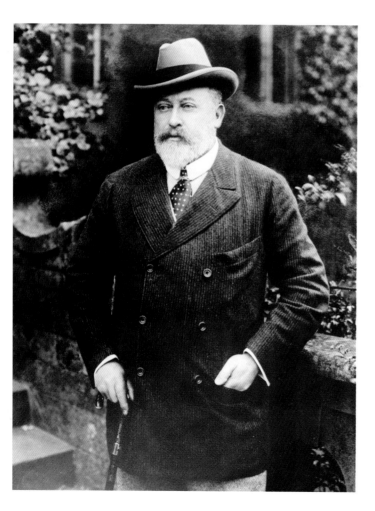

LEFT *King Edward VII (1841–1910) led new developments in British menswear, notably in sportswear – for shooting or tennis – or, shown here, in more casual daywear. The king is wearing the Homburg hat with the stiff curved brim that he favoured. He adopted the hat after discovering it in the German spa town of Bad Homburg, with the result that it became popular throughout Europe. It is worn here with a white shirt with pin collar, spotted silk tie, and double-breasted pinstriped jacket.*

RIGHT *The Duke and Duchess of Windsor, formerly King Edward VIII (1894–1972) and Wallis Simpson (1896–1986), are pictured at their temporary home near the Ashdown Forest, Sussex, after their return from France at the start of World War II. The Duke patronized the Savile Row firm of Scholte for the double-breasted suit in a chalk pattern on a grey background, a classic look that he popularized in the 1930s. He also pioneered the brown suede brogue worn as a leisure shoe.*

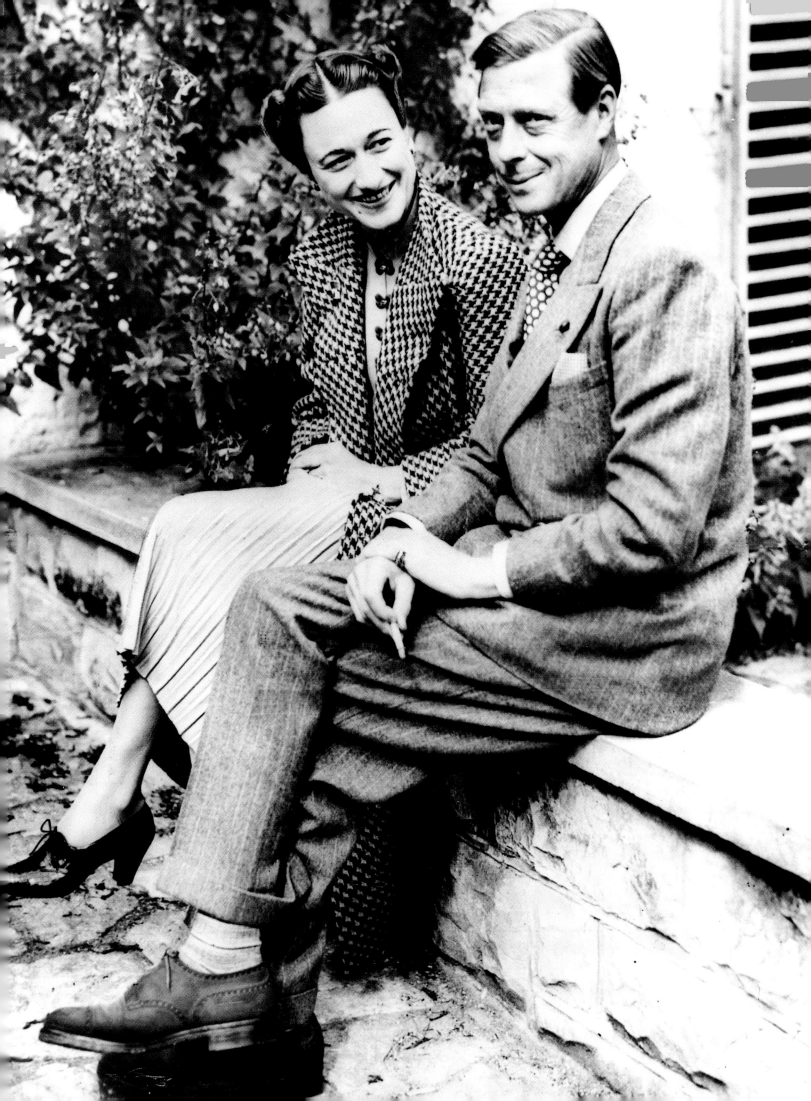

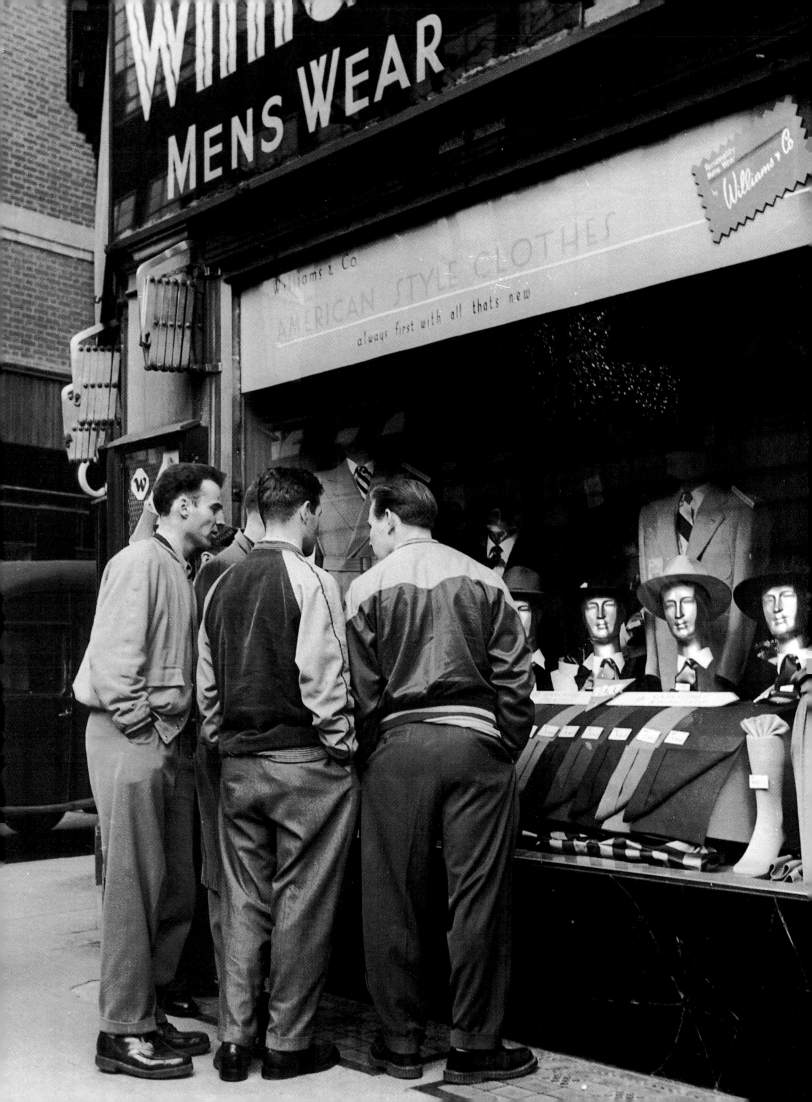

became a way forward for women searching for comfortable and streamlined garments that broke away from the 19th-century taste for the fussy and the elaborate. For a generation of women at the end of the 19th century, tailor-made suits heralded the beginnings of a change in attitude and a new freedom. A move away from the dress, a suit offered the simple possibility of taking off the jacket and wearing a skirt and shirt – a practical and flexible alternative.

One fashion designer was to embody this search for a new approach and a new freedom, the French designer Coco Chanel, who led the revolution towards sporty and relaxed clothes for women which were suited to their changing lives. Many of her ideas were adapted from men's clothing and the tradition of English tailoring, which she learned first-hand from wearing the breeches and tweed shooting jackets of her English lover the Duke of Westminster, and applied to her own couture range in the 1920s. The classic Chanel suit represents this new approach. It looks simple, with its geometric, boxlike cardigan jacket worn over a short skirt, but it relies for its effect on the principle of couture: although simple, its cut, finish, and fabric are always of the highest quality – in this case, using British fabrics woven in Scotland.

Via Coco Chanel a direct line can be traced from English tailoring to Paris couture and thence to the Hollywood film industry with its enormous international impact. By the 1930s trousers had moved irrevocably from the male to the female wardrobe, and the trouser suit was adopted by some of Hollywood's most famous film stars, including Marlene Dietrich, Katharine Hepburn, and Greta Garbo. In their films and press photographs they emanated a fashionable sexual ambiguity, reworking the old device of wearing men's clothes to enhance femininity. But trouser suits needed to be adapted to the female form. Women's trousers needed to have the fly

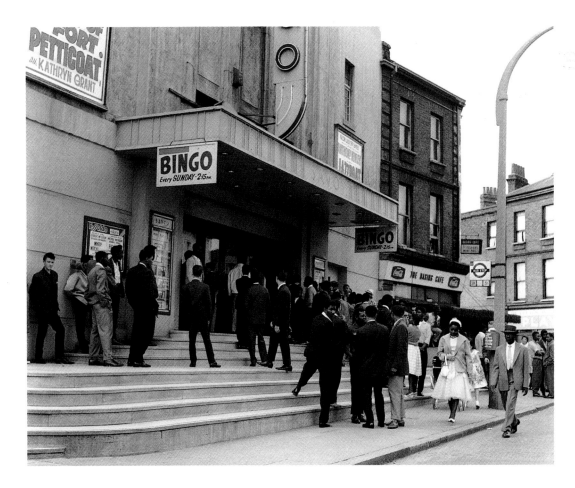

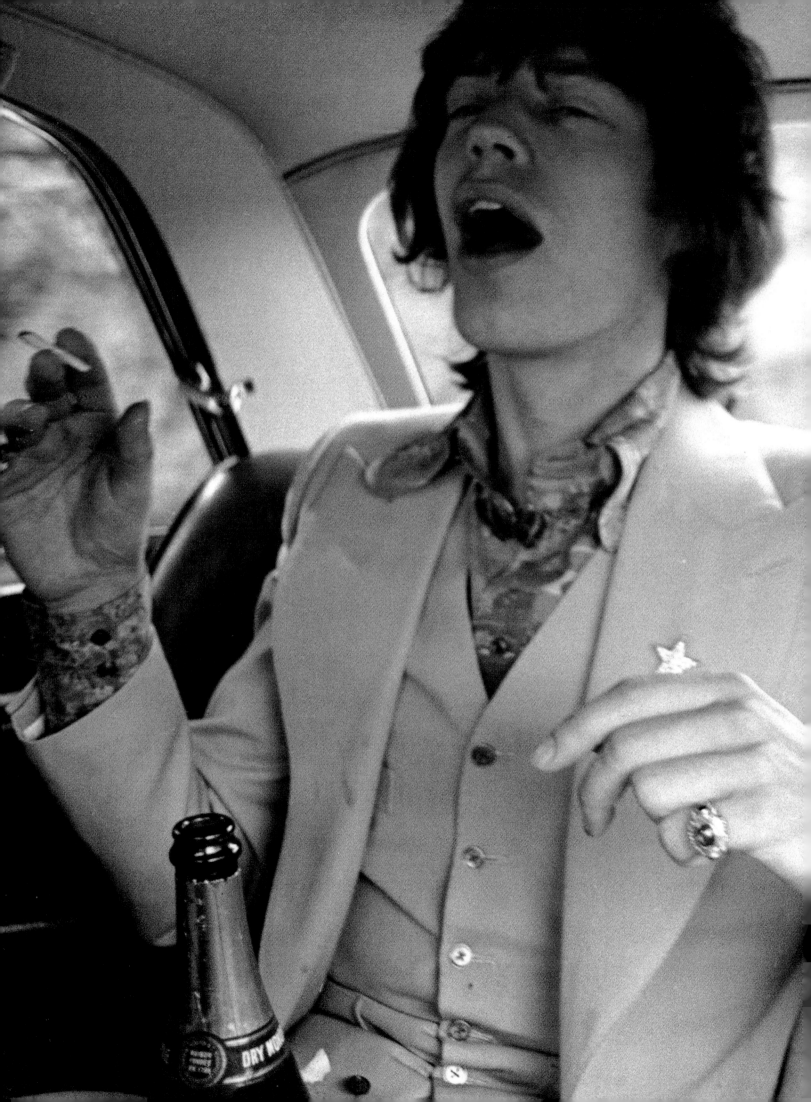

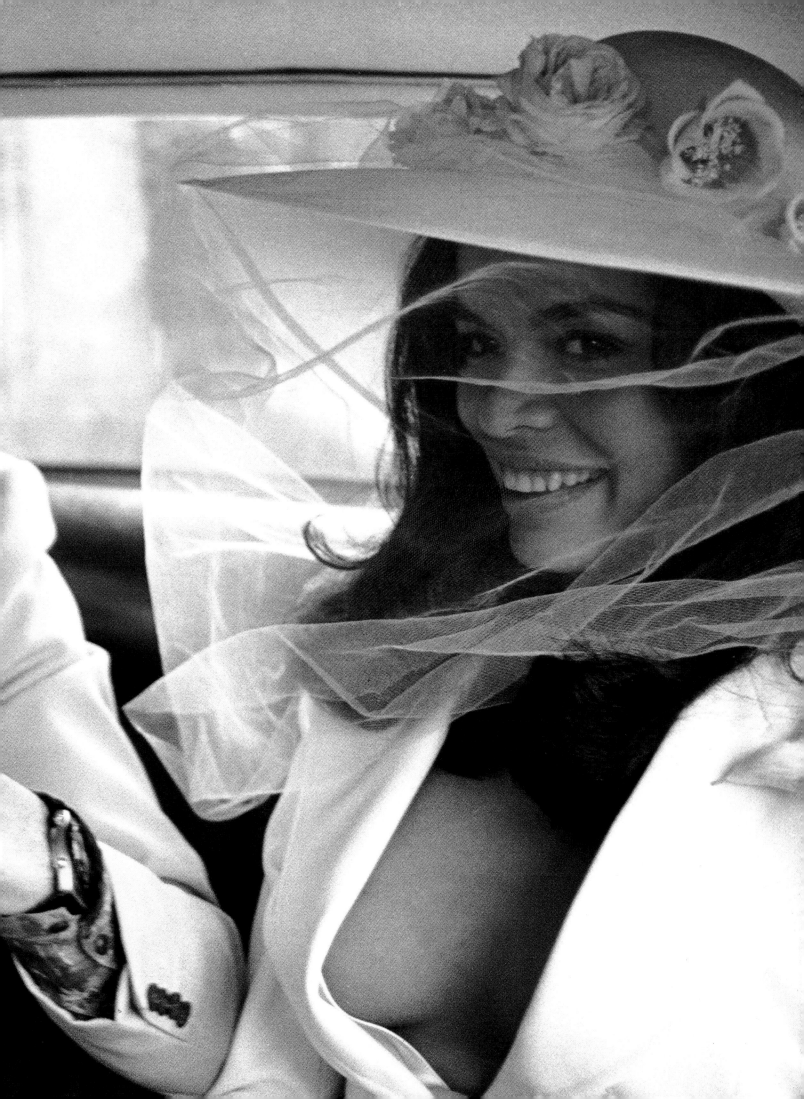

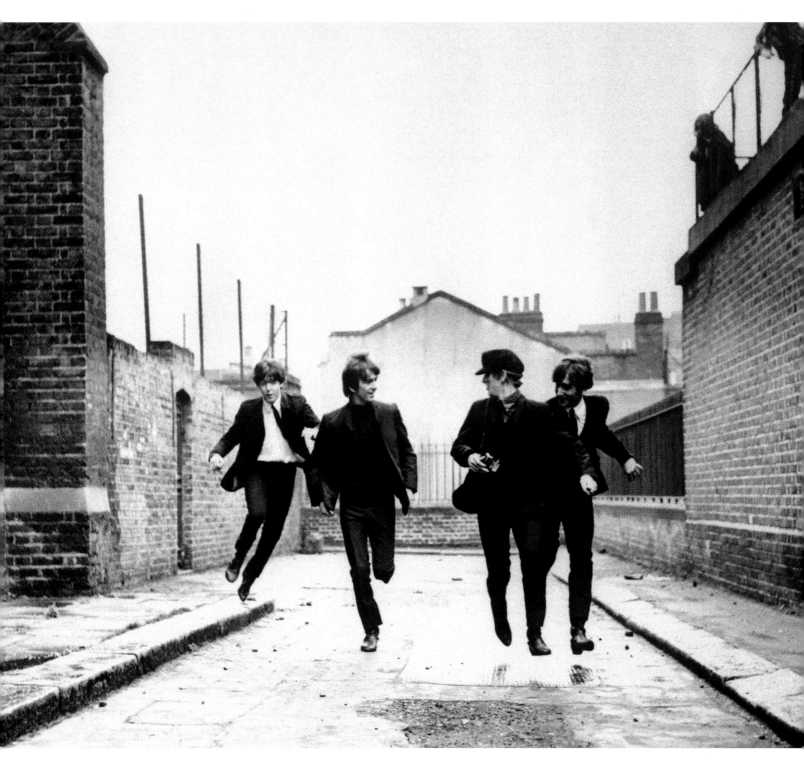

ABOVE *The Beatles, seen here in a still from their 1967 film* A Hard Day's Night, *are wearing black lightweight wool suits and pointed Chelsea boots. Their outfits reflect a fashion for a Continental style in Britain, with a narrow profile, broad shoulders, tight trousers, and shirts or polo-neck sweaters.*

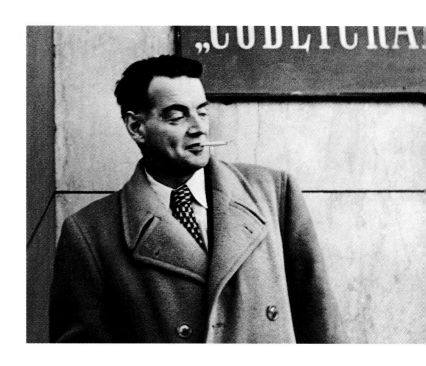

piece replaced by side zips and to have tailored waistline darts introduced, while in the jacket the stiffened men's interfacing was replaced by two layers of fabric. Tailoring therefore needed to be specifically for men or for women, and although there are points of crossover they remain separate areas of production even today.

The made-to-measure revolution

After World War I the era of the personal tailor was challenged by the renewed interest in men's suits as practical and functional dress for all social classes, not only for the wealthy. This development was made possible by the growth of the multiple tailoring industry. By the 1930s an estimated 150,000 suits a week were being produced and sold in Britain by companies such as Montague Burton of Leeds. These suits, halfway between bespoke and off-the-peg, were called "made-to-measure", and were sold in retail chain outlets all over the country. The process involved adjusting a set pattern to individual measurements and allowing the customer to choose the cloth and other details. The production methods were simple. After the cloth was chosen and the customer's measurements taken, the order was sent to a factory, where it was cut by hand and finished on the machine. By the mid-1950s 60 per cent of men purchased their suits from the large companies such as United Drapery, Hepworths, and Burton's, and by 1952, Burton's had become the largest made-to-measure men's tailored outer-garment business in the world, with 600 shops and 14 factories, one of which made 5000 suits per week.

Another social upheaval was in progress that was to reshape the fashion industry from bespoke to the high street – that of the teenage consumer. In the postwar years men and women looked for alternatives to Utility and uniforms, and for ways to overcome fabric shortages and restrictions on dyestuffs. For women Christian Dior revisited the femininity of the 19th-century

ballgown. Dior's 1947 *New Look* collection – so dubbed by the American fashion editor Carmel Snow – was more than a new direction in style: it was one of the truly original moments in 20th-century fashion. Dior looked not to the future for his radical collection but to the *belle époque* era of the 1880s, with large skirts using metres of fabric and tight tailored jackets. Men also looked to the past – to Edwardian long jackets and fitted trousers. Then something very interesting happened to fashion.

For the first time working-class teenagers had access to money, and they wanted to explore a style exclusive to them, not only in fashion but in products, films, music, and dance. In 1959 a seminal study of key shifts in consumer markets, *The Teenage Consumer*, highlighted the new phenomenon of teenage taste and style, in which the new teenage markets of the 1950s were dominated for the first time by the style aspirations of working-class teenagers. By 1954 a group of largely male, white, working-class young men were taking the Edwardian revival and mixing it with American style to create a unique new look: the Teddy boy, with drainpipe trousers, long jackets, and quiffed hair.

At the same time, into the London of the late 1950s came the new clothes, coffee bars, and food of Italian style. Tailoring was again a key element, bringing in a taste for coloured shirts, tight trousers, and short tailored jackets. The Italian vogue also crossed over into another world, the intellectual world of art schools and beatniks, that was more European than American.

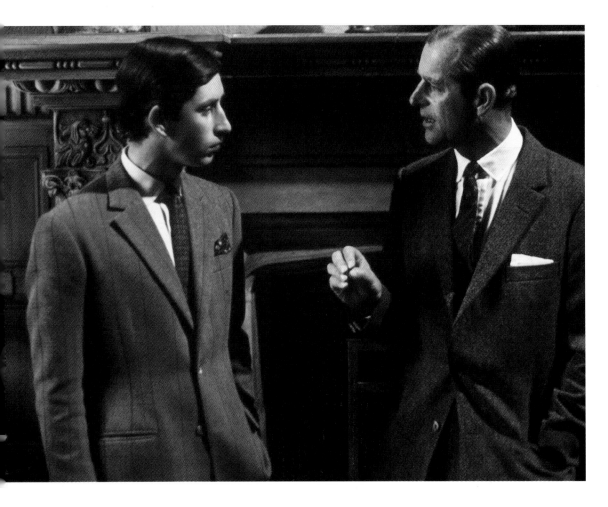

LEFT *Prince Charles and his father, Prince Philip, the Duke of Edinburgh, photographed at their country estate of Sandringham, Norfolk, in 1969. Prince Philip originally used the Savile Row tailors Curtis & Hawe for his classic style that has remained essentially unchanged for 50 years. Charles dresses in the same aristocratic tradition, wearing shirts with cut-away collars by Turnbull & Asser and double-breasted suits by Anderson & Sheppard. Here he wears a suit in in rough, hard-wearing tweed in a window-pane check of heavy greenish brown, with horn buttons, reflecting the traditional British taste for hard-wearing, warm, outdoor clothing.*

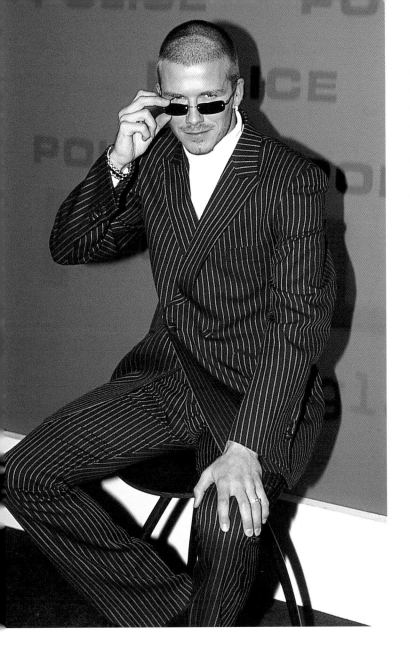

Tailoring in the swinging sixties

In 1961 the Beatles were photographed wearing jeans and leather jackets, with mop-top hairstyles: by the following year they had been transformed. An influential figure behind their change in image was their manager, Brian Epstein, who came from a more affluent background and had a taste for expensive tailored suits and accessories. It was the London tailor Dougie Millings of Great Pulteney Street who copied the Pierre Cardin style for sharp grey wool suits, cropped collarless jackets, tight trousers, and Chelsea boots for the Beatles. In the 1960s the details of the suit were pared down to an absolute minimum, but the ultimate step – a tight one-piece – was seen only in science-fiction films and television series such as *Star Trek*.

The 1960s brought a fundamental change in retailing. In 1964 *Time* magazine published a map of "swinging London" identifying the three important shopping streets of London as the King's Road, Kensington High Street, and Carnaby Street. On these streets had sprung up the new independent boutiques such as Mary Quant's Bazaar (designed in 1957 by

Terence Conran), Granny Takes a Trip, Hung On You, Mr Freedom, and Biba. These offered young people other choices that expressed the spirit of social change.

Ironic comments on British tradition underpinned many of the new fashions. "Hipness, decadence, and exquisite tailoring such as England had not seen since the Restoration of Charles II" was how Marianne Faithfull, in her 1994 autobiography, described the mid-1960s world she inhabited. The Rolling Stones were impressed by a new era of young, hip aristocrats and wealthy dilettantes, and parodied the decadent nobility of the past in their foppish clothing. In 1967 tailoring came sharply into focus when band members Mick Jagger, Keith Richards, and Robert Fraser were charged with possession of drugs and attended their trial dressed as exquisite dandies, in clothes that the press documented in detail.

Before long the components of 1960s style – dandyism, new materials, bright colours, and, particularly, the appropriation of uniforms – swept through the traditions of Savile Row. "Bespoke" comes from the term "be spoken", meaning that the customer describes to the tailor exactly want he wants. But it was not quite as simple as that, as each tailor worked within the parameters of his own core style. Savile Row did not design, it evolved garments, and by the 1960s customers were asking for things it could not, or would not, do.

One new tailor, Tommy Nutter, was determined to try. He came to prominence in the late 1960s as the man who combined the traditions and craftsmanship of Savile Row with the revolution of that decade. He gained a knowledge of his craft as an apprentice on Savile Row, which gave Nutter a firm belief in the supremacy of the English suit and English cloth. Nutter started his own business in 1968 and, backed by clients such as the singer Cilla Black and her husband Bobby Willis, became an immediate success. For the famous cover of the Beatles' *Abbey Road* album of 1969, in which they are photographed striding across a pedestrian crossing, Nutter dressed three of the four (George Harrison elected to be photographed in denims). The custom of other rock stars followed, including Mick Jagger and Elton John. Two images of Tommy Nutter clothes ensured international coverage of the new 1960s British tailoring: John Lennon and Yoko Ono in white suits for their wedding; and Bianca's white dinner jacket with white satin facings for her wedding to Mick Jagger. In this way Nutter applied his craft to dressing female icons of the period and helped to focus attention on the revival of the women's trouser suit.

Although Tommy Nutter was to remain a one-off on Savile Row, tailoring still played a part in women's fashion in the 1960s. Jean Muir made trouser suits in floral silk patterns, and went on to develop tailoring further with the launch of her own label in 1966. Muir, who died in 1998, was a highly skilled tailor renowned for her precision-cut clothes using jerseys, matt crêpes, and soft leather.

From sixties swing to eighties affluence

Another in the new generation of British fashion designers who began to explore tailoring is Margaret Howell. For thirty years Howell has reworked the themes of British tailoring and tradition in her clothes, using tweeds, linens, pinstripes, and cotton gabardine. Howell is in many

RIGHT *A double-cuff poplin shirt with peak-back flannel trouser skirt from autumn/winter 1995 by Margaret Howell. Howell's designs combine interesting details with the pleasures of wearing worn-in country clothes that evoke the English tradition. It is a look she has evolved since the 1970s when she started her collections using traditional fabrics.*

ways the archetypal English designer, in the sense that she is more of a maker than a designer, with her work revolving around construction, detailing, and materials. She originally trained as a fine artist at Goldsmith's College in London, and started her own clothing business in 1972. This period saw a renewed interest in the updating of English classics, and Howell made her name redesigning the men's shirt, employing skilled workers to produce one of her trademark details – hand-sewn buttons with an "X" of thread rather then a "II".

The product designer Geoff Hollington remembered his early impression of Howell: "In the 1970s I used to get all my clothes at jumble sales, old man tweed sports jackets, collarless shirts and baggy pleated trousers; Margaret started making it all new …" In an interview collected in the Victoria and Albert Museum's *Cutting Edge* catalogue Howell talked about her earthy, classic English taste, citing her influences as, among others, "a love of our countryside, the climate and the colours, the English country house … the English tea room and cottage gardens". For Margaret Howell the idea of continuity is important, and she invariably includes classic items from her previous collections in each new show: for example, there is always a trench coat, a shirt, and a pinstripe suit.

Paul Smith is another designer to explore the territory of updating British tailoring for a modern market. The second British fashion designer to be knighted (Hardy Amies was the first), he fronts the UK's most commercially successful fashion business, accounting for a significant proportion of the sector's £145 million annual turnover. Paul Smith represents the single most important shift in attitude to British menswear in the 1980s. Into this extremely conservative market he introduced a range of classic men's clothes with a twist, and his fresh and edgy designs quickly attracted a market both at home and abroad, particularly in Japan. He took the standard office uniform of suit and tie and introduced new fabric choices and colourways that gradually won over a new generation of customers. In this, Smith had identified an important market: the new affluent professional man of the 1980s who wanted to look serious for business but did not want to dress in the obligatory drab, dark suit.

With this design strategy as his mainstay, Paul Smith could afford to develop more adventurous lines, including his trademark patterned shirts printed in Day-Glo colours with 3-D images of fruit, flowers, and vegetables. Such shirts echoed the tradition of the 1960s while building on the 1980s trend for colour, pattern, and decoration. Now the affluent young city trader or media upstart could wear a suggestion of radical chic but remain perfectly safe in the knowledge that to wear Paul Smith was a mark of excellent taste. This rediscovery of the classic encouraged a new market in which old establishments such as Cordings in Piccadilly could sell sportswear and country clothes in British fabrics, while newly created companies such as Hackett and Duffer of St George could offer a sharper mix of traditional and more modern styling.

Experimental tailoring

When designers such as Smith and Howell started their careers, tailoring was effectively a choice between the classic or the experimental. The experimental was about to take centre stage with the

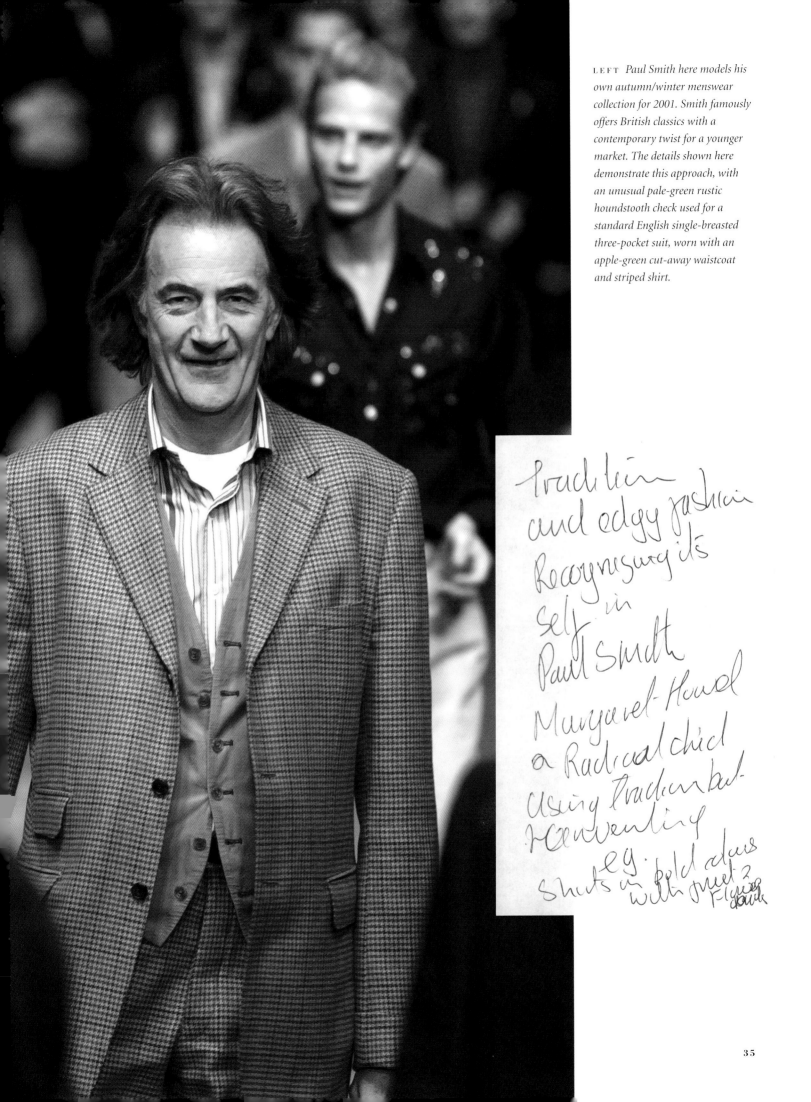

LEFT *Paul Smith here models his own autumn/winter menswear collection for 2001. Smith famously offers British classics with a contemporary twist for a younger market. The details shown here demonstrate this approach, with an unusual pale-green rustic houndstooth check used for a standard English single-breasted three-pocket suit, worn with an apple-green cut-away waistcoat and striped shirt.*

35

LEFT *Vivienne Westwood's shooting jacket, of which a detail is shown, is from the* Time Machine *collection for autumn/winter 1988. Made of Breanish tweed with a cotton velvet collar, this jacket sees Westwood return to her familiar themes of exploring British traditional tailoring, as in the cutting of the traditional pleats at the front and in the waistband and pocket details. The jacket also allows Westwood to play with her enduring themes of cross-dressing, tradition, and social class.*

RIGHT *This early 20th-century advertisement for Chas Baker & Co. shows a Norfolk jacket – a traditional shooting jacket made of tweed with three or four buttons, a belt, pleats for ease of movement, and roomy pockets to hold provisions. The Norfolk jacket is a perfect example of an individual British garment tailored to a particular purpose. It is worn here with plus-fours, so called because an extra 4 inches (10 cm) of material was added to the length below the knee.*

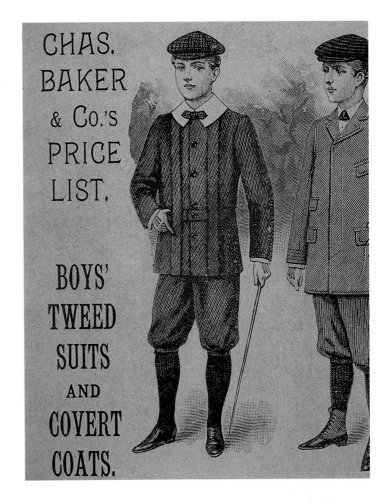

CHAS. BAKER & Co.'s PRICE LIST.

BOYS' TWEED SUITS AND COVERT COATS.

international focus on the new British fashion of the 1980s, that of the post-punk revolution of Vivienne Westwood, John Galliano, and Alexander McQueen.

London's great tradition of tailoring, the city's centuries-old skills in making suits and uniforms, had always inspired Vivienne Westwood. In the 1990s, the results of that complex inspiration were designs so original and innovative that Westwood became London's first fashion superstar. She had always had an interest in the cut and construction of both early garments and more recent couture. Many of her typical designs revisited historical costume – the cut and slash devices of the 17th century, the codpiece, the corset, the 18th-century jacket, and the crinoline. Then in the 1990s she took her work in a new direction, against the prevailing trend towards a simplification of cut and tailoring, and returned to the complex and sophisticated women's tailoring masterpieces of the 1950s: the work of Christian Dior and Cristobel Balenciaga. For Westwood it was now not a matter of detail but of cut. Using highly intricate patterns normally associated with couture she mingled couture and ready-to-wear in such an extraordinary way that it will remain her great contribution to fashion history.

In spite of her reputation for iconoclasm, therefore, Westwood's work is rooted in tradition and underpinned by technique: she stands at the crossover between designing and making. Her flagship store in Conduit Street is in the heart of London's tailoring district, just around the corner from Savile Row, and she is intrigued by a Britain famous for its pattern-cutting and

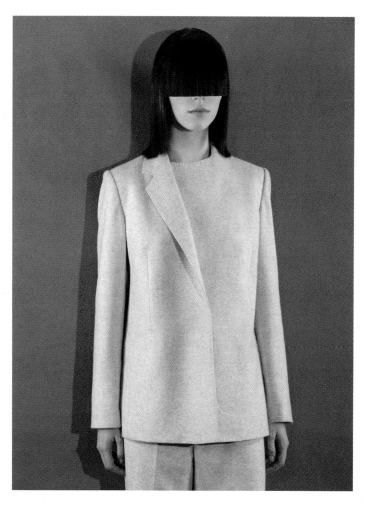

quality fabrics, its worsted, woollens, and tartans, and its classic outdoor wear such as the Norfolk jacket and the Burberry mac. Westwood visibly draws on these historical strengths, but puts traditional elements together in a highly individual way.

Other British designers followed her lead, the two most important being Alexander McQueen and John Galliano, who emerged in the 1990s as international superstars. Tailoring has been a significant element in their approach to design, particularly for McQueen, whose combination of exquisite tailoring and fantastical creations was to redefine late 20th-century fashion.

The skills of bespoke tailoring have been central to Alexander McQueen's vision since his apprenticeship in Savile Row at the age of 16 to Anderson & Sheppard, Prince Charles's principal tailor. (Legend has it that McQueen indulged his notorious taste for rebellion while at Anderson & Sheppard by marking the lining of a suit for Prince Charles with the words "McQueen woz 'ere".) His clothes reflect a passion for classic tailoring fabrics, as seen in his signature use of the Prince of Wales check, subverted and treated with aggressive tailoring details – such as chevron panelling for his début menswear collection, *The Hunger*, in 1996. For women his tailoring features diagonal and flag panelling and sharp tailored neoprene jackets teamed with traditional fabrics such as a Prince of Wales and houndstooth check embroidered with roses. His recutting of long military-style coats has revealed his mastery of the traditional techniques of cut and construction. McQueen crosses the formalities of tradition with the daring ideas of the street, as illustrated by his bold trousers of 1996 known as "bumsters". For this design he cut the trousers to lie a dangerous five centimetres (two inches) lower on the torso than hipsters, falling to the thigh and then sliced and curved across the pubic bone at the front while redefining the "builder's bum" at the back.

The influence of traditional tailoring continues to inspire a new generation of British fashion designers. Born in 1961, the great-granddaughter of Sigmund Freud and the daughter of one of Britain's great painters, Lucian Freud (who created for her the dog image that she uses as her logo), Bella Freud may be placed somewhere between the Galliano and McQueen tailoring revolution and the new experimental direction represented by designers such as Tristan Webber. Freud first studied tailoring in Rome at the Istituto Mariotti tailoring school, graduating in 1985, after which she worked in Vivienne Westwood's studio where she had first-hand experience of Westwood's creation of radical new forms derived from traditional and historical tailoring. This wealth of historical sources, from the dandy to the corsetted silhouette of the Victorian age, opened up possibilities of subversion and a world of ideas that Freud could personally relate to. When she established her own label in 1990, she continued to use tailoring to reinvent and convert historical sources for modern clothing and in this way her clothes bridge a gap between the two extremes of tailoring, the classic and the experimental.

The experimental can be clearly seen in the work of two very different and younger designers, Tristan Webber and Shelley Fox. Tristan Webber, born in 1972, is a Central St Martins graduate, who started to design his own label in 1997. Well known for his innovative and manipulative tailoring using leather, he acquired his skills at the Cordwainers College in London,

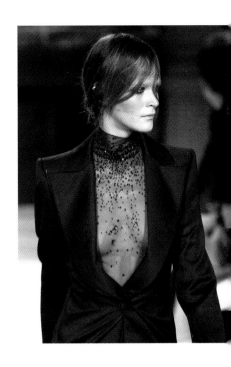

ABOVE *Alexander McQueen trained in Savile Row and tailoring remains a key element of his work. Shown here is a play on the black tuxedo jacket, designed for the House of Givenchy, worn with a see-through diamanté blouse and detailed with extra-wide lapels and fastened with a button so that the fabric drapes round the waist.*

FAR LEFT *Hussein Chalayan is revered in the industry as a designer whose talent for creative cutting has developed into an art form. Here he collaborated with photographer Marcus Tomlinson for an image-series of tailored suits called "Memory Jackets", which was part of an animated film shown at the Hyères Fashion Festival in 1999 at Man Ray's villa in the South of France.*

on one of the few remaining courses in the UK specializing in shoe making and design. Webber's approach to cutting revolves around precision and geometry, typically seen in his body-hugging dresses in leather and latex. His 2001 collection explored the contrast between hard and soft materials, inspired by 20th-century women who had pioneered scientific advances, a theme he translated into tailored clothes with the juxtaposition of chiffon and leather.

Shelley Fox is another young designer inspired by cut and construction, but with a different agenda. Although many view her as a conceptual designer, it is the commercial and wearable aspects of her work that have ensured her reputation in the fashion world. It was her ability to realize her ideas through tailoring that won Fox the prestigious Jerwood Fashion Award in 1999, judged by a panel that included Alexander McQueen. A sensitive and intelligent designer, Fox uses tailoring to achieve simple and arresting forms. Tailoring is the starting point for garments notable for both experimental cut and experimental fabrics. Her research has led her to use diverse and unusual sources for fabrics not usually thought of in the context of clothes; for example, she has used stretch and knitted bandage fabric from medical suppliers to create fabrics that are then boiled, burned, torn, and cut, sometimes with laser techniques, and the forms of her clothes echo Victorian dress and military uniforms. Her clothes are as much sculptural as wearable objects, such as Braille-embossed felted-wool skirts. In Fox's hands tailoring is a way to express an understated but highly intelligent vision for women's clothes that appeals to women who want to express a certain empathy for ideas, for research, and for intellectual pursuits.

The new bespoke: tailoring for the 21st century

The designers mentioned above use tailoring as one method among many to create the look they want. There is another group of British designers who are first and foremost tailors, and who are updating the customs of Savile Row to be relevant to the 21st century.

The classic Savile Row suit is designed to fit an individual client: cut and constructed by hand, it takes up to 80 hours to create. The usual fabric for tailoring remains wool cloth; other fabrics simply do not possess the durability and versatility needed for fine tailoring or the strength and body to enable them to hold a shape. There is a whole grammar of suit design, involving the number of buttons, variations on the size of vent, the width of lapel, the length of a jacket, and so on. Yet the suit itself has never really changed: rather, it has slowly and carefully evolved, and Savile Row has taught designers what the structure of the suit will take.

The changes in retail and fashion in the 1980s had the effect of isolating Savile Row, which by the early 1990s was facing a financial crisis. The developments in styling of the postwar years had become fixed; many of the potential customers with the amount of money a bespoke suit cost were buying into the Italian soft tailoring revolution of Giorgio Armani, while the Savile Row suit had come to represent a quality and elegance that had less to do with fashion than with tradition.

Three British menswear designers were to change that, and to revitalize the idea of tailoring with their version of the new bespoke. They were Richard James, Ozwald Boateng, and Timothy Everest. James and Boateng came from art school and retail backgrounds before they opened their

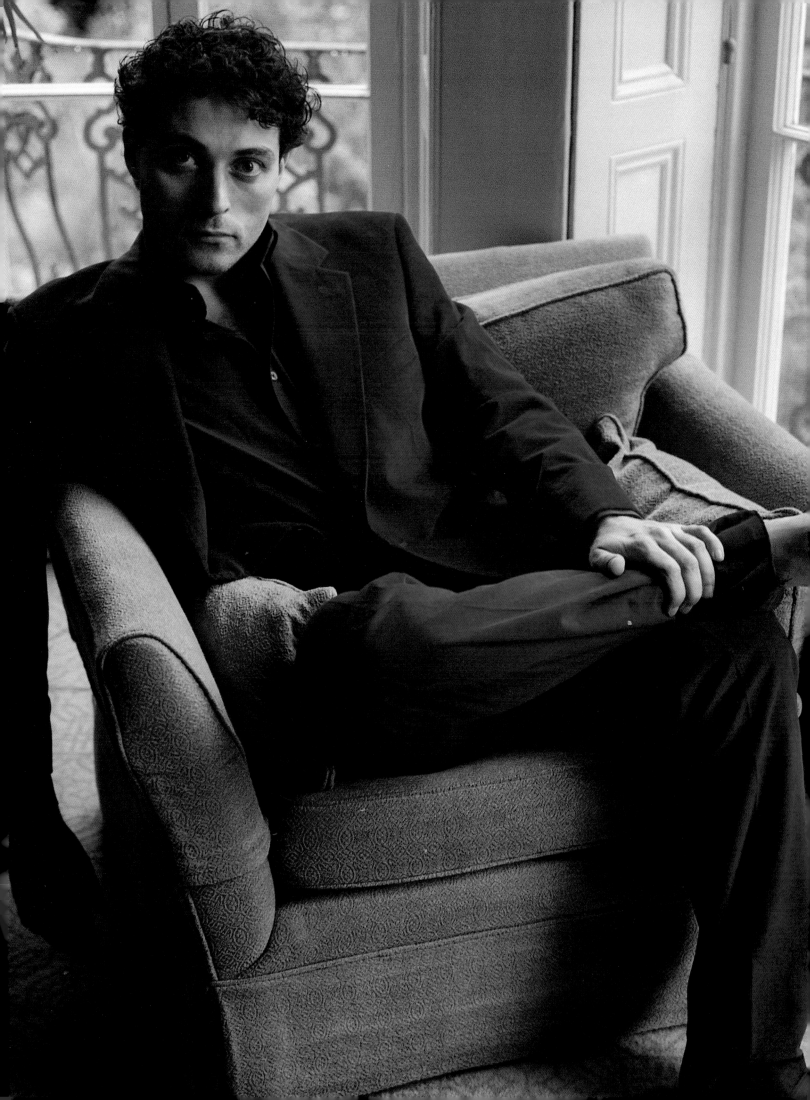

tailoring shops in Savile Row and Vigo Street respectively. Everest is different in two respects. His premises are in Spitalfields in the East End, while he has in fact a more traditional Savile Row background – he was apprenticed to Tommy Nutter. In a recent visit to fashion students at Kingston University he described himself as "a tailor who designs, not a designer who tailors".

All three designers recognized that the needs of the new customer could not be met by old-style Savile Row. But the qualities of bespoke, of exclusive personal service and fit, remained highly desirable if they could be presented in a new way to a wider market. They each started with that model of an English suit defined and refined over generations in Savile Row. But they were the newcomers, the upstarts in Savile Row, altering the design of shop fronts and changing the rules for the way the clothes were marketed and publicized. It inevitably led to friction with their neighbours who claimed centuries of tradition and experience.

What did not change were the methods of production that still dominate the closed and secretive world of Savile Row. Traditional tailoring establishments do not now make each suit in house, relying instead on outworkers who specialize in each aspect of suit production. Waistcoats, jackets, lapels, pockets, all are sent out to workshops located mainly in Soho, run by skilled crafts-people still dominated by Greek and Italian migrants and their families, a reminder that British craftsmanship has always relied on the skill of "foreign" workers. The role of outworkers in the retail bespoke tailoring industry has a long history. Traditionally their rates of pay were laid down by the Board of Trade for the Retail Bespoke Tailoring Trade. "Time logs" detailed each part of a suit, the time it should take to complete each part, and the rates of pay per hour for the various classes of worker (apprentices, pocket or buttonhole or waistcoat specialists, and so on). These specialist workers still exist, a highly skilled group of tailors whose contribution remains little appreciated.

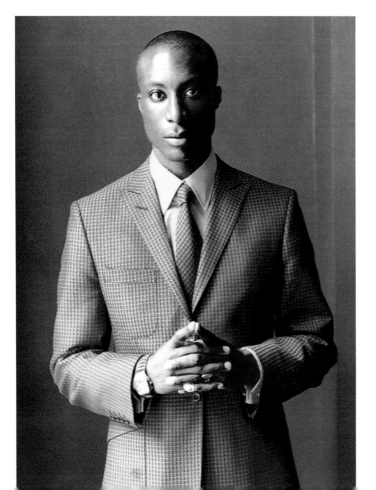

LEFT *Ozwald Boateng is well known for what he describes as bespoke couture, a fusion of design and traditional tailoring. This photograph of the designer was used on the invitation to his party in Paris to celebrate the launch of his spring/summer 2002* Tribal Traditionalism *collection. Boateng wears vivid colours for a collection inspired by his Anglo-Ghanian heritage, which also explored the use of African prints.*

Alongside the older Savile Row establishments, Richard James and Ozwald Boateng are about service, the art of measuring, design, and the selection of fabrics. Unlike the older companies, they set out to court celebrity clients in order to attract international publicity, and the new celebrities came from the worlds of sport, music, and Hollywood rather than from the establishment.

In 1992 Richard James was the first of the new wave bespoke tailors to set up in Savile Row; in 2001 his continuing success brought him the award of Menswear Designer of the Year. James had originally trained in photography at Brighton Polytechnic, graduating in 1978, but he changed direction to fashion and moved to London. His shop on the corner of Savile Row became famous for his daring use of colour, with colourful linings in hot pink or printed paisley, and for a cut of suit leaner and closer to the body. The details of a typical Richard James suit include a double vent for the jacket and tapered trousers, as seen in the suit for pop star Liam Gallagher's wedding to Nicole Appleton in 2001.

Ozwald Boateng opened his shop in Vigo Street in 1995 and, like James, set out to shape the key elements of traditional English suits into a longer, slimmer silhouette, coordinating sharply cut suits with brightly coloured shirts, and bright pink, green, or turquoise ties that reflected his Anglo-Ghanaian heritage. His spring/summer 2002 collection *Tribal Traditionalism* was a tribute to this heritage; suits were teamed with vibrant embroidered shirts and beaded belts. Unlike James and Everest, Boateng shows his collections on the catwalk, with his first show staged in Paris in 1994; in 1996 he was awarded the French Trophée de la Mode for best male designer.

The new British bespoke not only helped change British menswear but influenced international developments. In 2002 Tom Ford, Gucci's creative director, acknowledged that the suit was still the most important outfit in a man's wardrobe when his collection returned to the formality of the suit. He introduced a made-to-measure service for men: customers select the style, fabric, and colour, then have their suit fitted by a Gucci tailor. According to Ford, the individual suit is the right look for men in the early 21st century: an opinion that surely bodes well for British tailoring.

LEFT *The exterior of the Timothy Everest Atelier, 32 Elder Street, London E1, originally an 18th-century silk merchant's premises. In the early 20th century it was the home of the painter Mark Gertler (1891–1939). There is no Timothy Everest Atelier sign to identify the premises and no traditional shop frontage or display.*

RIGHT *Timothy Everest is seen in the showroom of his atelier wearing a lightweight summer suit in grey, green, and yellow check with a yellow check shirt and plain yellow tie. Everest likes to explore vibrant colour ranges, which he often exaggerates by embellishing traditional English patterns with bright overchecks.*

TIMOTHY EVEREST

Timothy Everest is the best known and most successful exponent of the new vogue for English bespoke tailoring. Not only has he established his own highly successful tailoring establishment but his influence extends internationally with his E1 range for the DAKS company and his Autograph menswear collection for the high-street retailer Marks & Spencer. Everest attracts worldwide press coverage via his celebrity clients: David Beckham wore an Everest suit for his wedding, as did the British chancellor, Gordon Brown. More famously perhaps, Everest designed the suits for two high-profile Hollywood films, *Mission Impossible* and *Eyes Wide Shut*, both starring Tom Cruise. Cruise, who wore an Everest suit to the Oscar ceremony, reportedly commented "of course it fits, it's a Timothy Everest".

Timothy Everest has described himself as a tailor rather than a designer, and it was the discipline of the tailoring trade that formed his background. As a young man he served his apprenticeship with the legendary Tommy Nutter, whose highly individual talent helped revitalize Savile Row in the late 1960s. The two retained a close working relationship and friendship until Nutter's death in 1992, and it was Nutter who inspired the young Everest to experiment with colour and to successfully mix unlikely combinations of tones and patterns.

In 1990 Everest made the decision to locate his shop in London's East End, away from the traditional area of Savile Row. In 1995 he acquired an early 18th-century silk merchant's house in the warren of streets bounded by Spitalfields market and Brick Lane. From the late 17th century the area had been home to the Huguenot silk weavers and merchants exiled from France, who brought their textile skills with them. When the industry fell into decline the area became a district of notorious

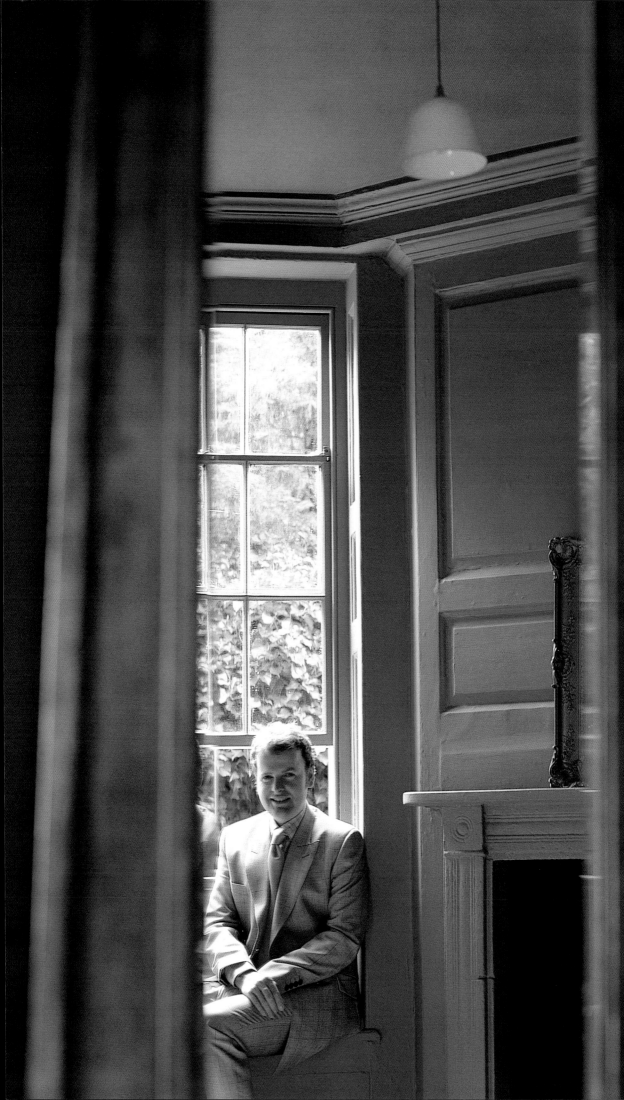

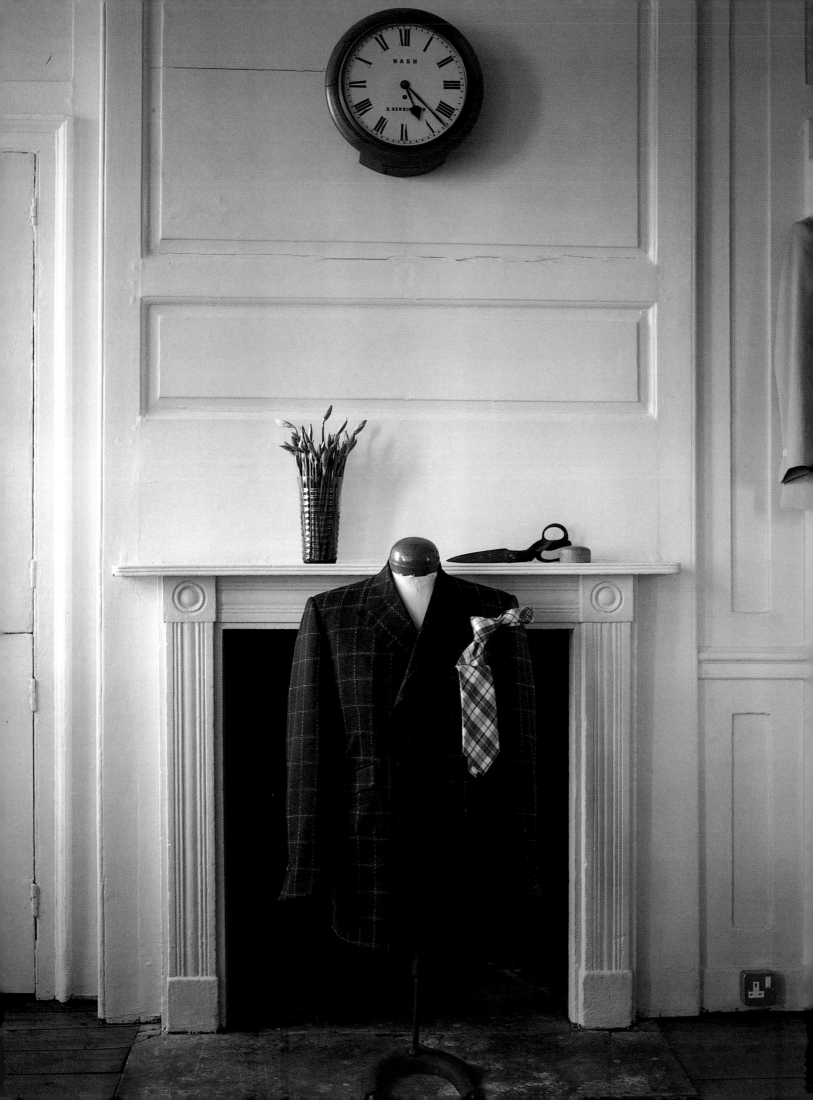

LEFT *A Timothy Everest suit jacket and tie photographed in the ground-floor showroom at Elder Street. This promotional picture reveals typical Everest details: the traditional fabric is navy wool with large-scale counterpane check using broken stitching; the angle of the cuff and the double slanted pocket are exaggerated details of typical English tailoring.*

BELOW *The swing tag is used only for the ready-to-wear collection, for ties, shirts, and accessories. The image on the tag is a detail of an old rusty pair of cutting scissors, or shears, that Everest discovered in his former premises on Princelet Street, which remain on display in the shop as an iconic symbol of traditional tailoring skills and the trade.*

poverty and deprivation, colonized first by the Jewish community, and more recently by Asian families and businesses. By the 1990s, however, the area saw a marked upturn in its prosperity. When Everest opened his premises, Spitalfields was being transformed by the influx of London's creative industries to the converted warehouses in the east and of City financiers in the west. The house was restored by Everest, each room painted in a colour customized by paint specialist Richard Clark and furnished with interesting antiques and found objects. Everest cultivated the atmosphere of a private club with an exclusive feel which customers felt they discovered by word of mouth. The marketing strategy is to be private, exclusive, and low key; there is no shop sign, there are no magazine advertisements or publicity. There is hardly any shop display, merely a discreet item placed in the window to suggest that the house is a shop.

Everest aimed his business at young, successful professional men with the money and the ambitions for bespoke tailoring, who wanted quality and personal service but did not want Savile Row; Everest core clients are City financiers and media professionals. For them an Everest suit would be a single-breasted two-button high jacket with a purple Bemberg lining, cut slightly narrower than the norm, with a flat-fronted trouser without turn-ups, made up in a light 225 gram (8 oz) fabric – mohair being a favourite – in dark grey, black, or navy.

The approach seen in the shop runs through the labelling of the garments, which have no designer names, simply Everest's signature use of a patterned 18th-century Huguenot silk, which he discovered in an archive of old fabric samples owned by the silk weavers Vanners Silk Industries in Sudbury. There is no Everest branded logo; customer carrier bags are

TIMOTHY EVEREST

Fine garments for men and women

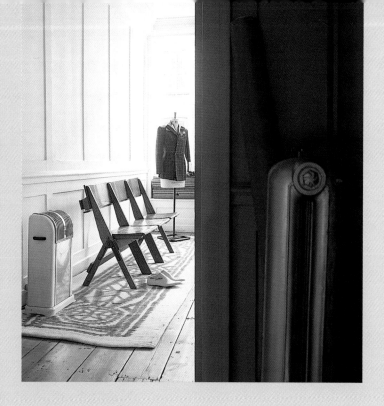

LEFT *Shown here are two details from the first-floor showroom. Everest designed the look of the rooms himself, buying and collecting eclectic objects that relate to the past in an interesting way. The radiator was rescued from the old London County Hall offices, the bench with its hymnbook stands from a local church. More modern are the rugs commissioned from a local Spitalfields craft workshop using neutral colours and geometric patterns.*

discreetly stamped with the shop name and address using an old-fashioned hand-stamp. To identify the designer you have to be in the know – the ultimate label.

The shop itself offers a full service. A bespoke cobbler, Jason Amebury, works from the basement; upstairs are the fitting and alteration rooms. Everest also sells a range of accessories, including shirts and ties using British-woven silk from Vanners of Sudbury, who also make up the ties. For a suit, the customer is measured, a pattern is drawn up, cut and tacked together, and the suit is sent to outworkers in Soho, to be returned for the final re-cut and fit in Everest's workshops.

Everest prefers the old to the new, the traditional to the modern. The heart of his activity, the centre of his work as a tailor, remains the traditions and cultural references of bespoke, and his vision of contemporary menswear explores the influence of the past. In an interview with *The Guardian* on 15 September 2000, Everest had some interesting things to say about what he identified as the real strengths of British mens-wear. "In producing a collection about modern British I looked to David Bailey and Mick Jagger. I discovered British menswear was more rugged than we remembered. … I tried to marry that ruggedness with a Jermyn Street eccentricity."

This is the familiar territory of combining traditional forms with something eccentric, something slightly odd or quirky. Everest understands tailoring and fabrics and combines these in modern ways. His distinctive details can be found in his design of accessories – a double cuff lifted from 1930s cocktail shirts for daywear; fishtail cuffs on shirts; the revival of the deep Edwardian collar. Everest's success lies in his ability to combine high fashion with the values of tradition.

ABOVE *Tom Cruise, dressed by Timothy Everest, in a still from* Mission Impossible. *Everest styled a whole look for Cruise's character in the film. Shown here is a classic English tailored suit using a navy-blue English worsted with an electric-blue stripe. The suit is cut with a slim and contemporary profile, shaped to the waist, with angled pockets and a slight flare to the sleeve, and has a handkerchief pocket, and four buttons on the cuff.*

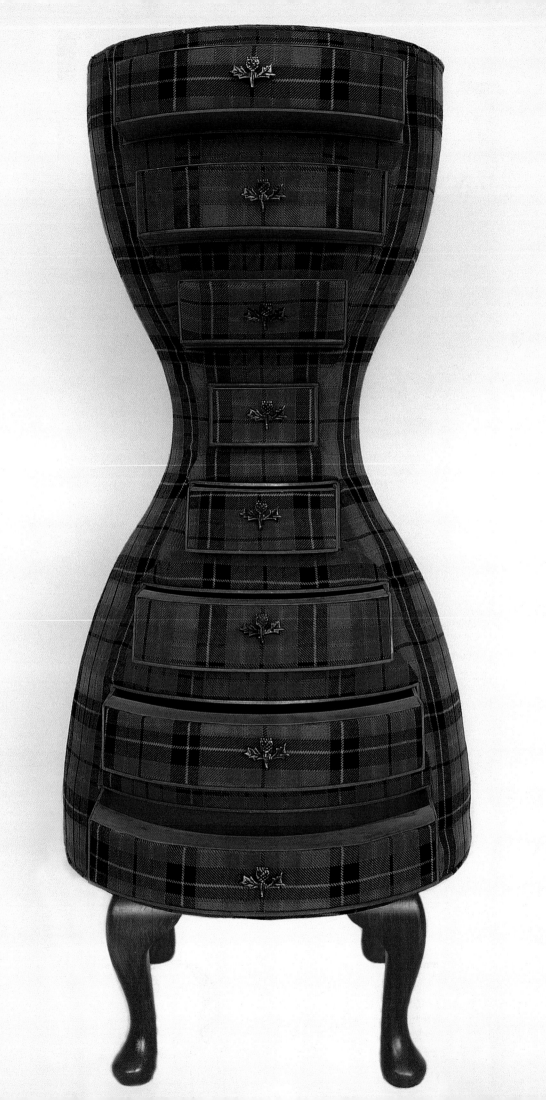

t r a d i

t i o n a l

f a b

r i a c s

The economic development of Britain as a modern industrial nation, its historical power, and its cultural evolution have always been bound up with the production of high-quality cloth. Wool was at the centre of early British prosperity. In the 17th century that sense of power, prestige, and national confidence was expressed in the architecture, for example, of the small wool town of Chipping Camden in the Cotswolds, south-west England. Still perfectly preserved, the merchants' houses and commercial architecture reflect an enduring vision of British assurance and skill.

In the 18th century the historical map of British textiles was extended to include Lancashire cotton. Cotton was to become the driving industry and economic power of the Industrial Revolution. From the late 1890s to World War I, for example, more than 7000 workers were employed in a single factory by Howard and Bullough of Accrington, Lancashire, to manufacture textile-spinning machines. Today the cotton industry located around the north-west mill towns of Rochdale, Oldham, Burnley, and Bury has virtually disappeared, as have smaller and more specialized areas of textile production such as Nottingham lace and East Anglian silk.

The structure of the British textile industry

The once mighty British textile industry is no more, yet within living memory – during the 1950s – the UK was the largest exporter of wool textiles in the world. The much reduced industry that remains is located in what economists refer to as "small industrial clusters": traditional centres that include West Yorkshire and Scotland for wool, Ireland for linen, and the Midlands and Scotland for knitwear. In 2001 the British Government Department of Trade and Industry commissioned a report called *A National Strategy for the UK Textile and Clothing Industry*, which provides the statistics to review the current industry and to assess its structure and special qualities.

It reveals that the UK textile and clothing industry's contribution to the economy is substantial, and that the industry is not at the stage of economic insignificance. Significant capability exists in traditional areas such as yarn spinning, knitting, weaving, and making up. As the industry has modernized increasing emphasis has been placed on activities such as design, branding, and distribution, making textiles an important part of the 21st-century knowledge-driven economy. Textiles and clothing is the ninth-largest manufacturing sector in the UK, employing around 277,000 people in the East Midlands, Yorkshire, the Scottish Borders, and Northern Ireland. Wool textiles is one of the few sectors of industry in which the UK enjoys a trade surplus and in some parts of the country, textiles and clothing are the main or sole manufacturing industries.

Yet the British textiles and clothing industry is facing the greatest challenge in its history. Low labour-cost suppliers are securing an increasingly large share of world markets, and high-street consumer demands are rapidly changing. Textile mills in Yorkshire and Scotland still produce sought-after cloth, but for a smaller market: British designers extol the merits of British textiles, but the reality is that the runs required by an independent designer such as Vivienne Westwood or Timothy Everest are in the category of craft production only.

The massive reduction in the scale of the British textile industry in the 21st century is closely tied to the clothing industry. The domestic market is highly significant: the UK has the

PAGE 50 *Precious McBane is a young Scottish design group based in Glasgow. This limited-edition chest of drawers called Lankie Lassie is from its first collection,* Tartan Tales, *designed in 1994. Precious McBane worked with a tailor in order to achieve an exact fit for the tartan, provided by Lochcarron of Scotland, over the hourglass shape.*

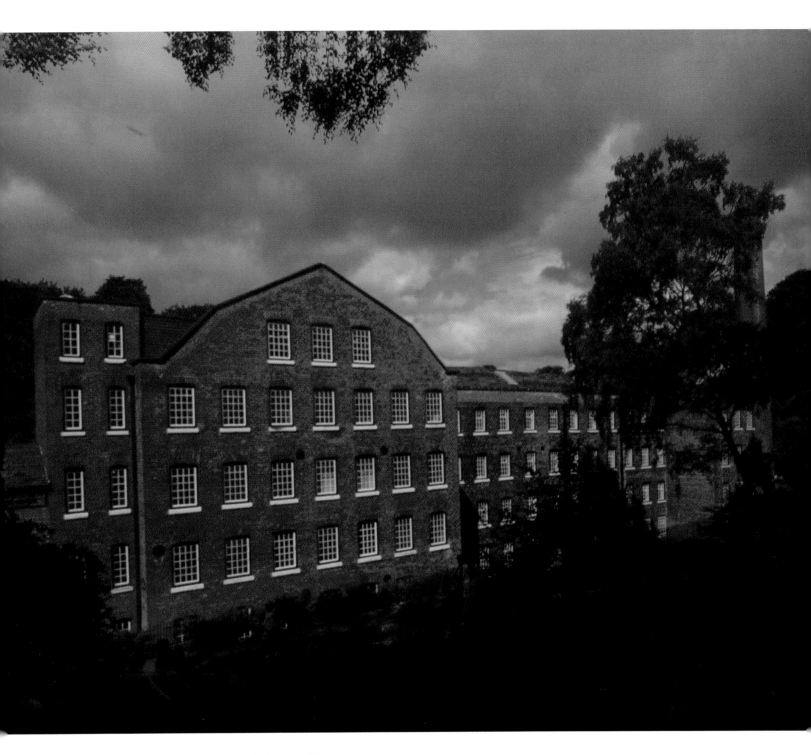

ABOVE *Founded by the Greg family in 1784, Quarry Bank was one of the first generation of water-powered mills and is the most complete surviving Georgian cotton mill. The site, at Styal village near Wilmslow, Cheshire, offered the necessary water and communications but a sparse local population. To address this problem, between 1790 and 1847 around 1000 orphaned children were apprenticed to work at the mill and sent to live in Styal. Now owned by the National Trust, this imposing brick building represents an important part of Britain's industrial heritage.*

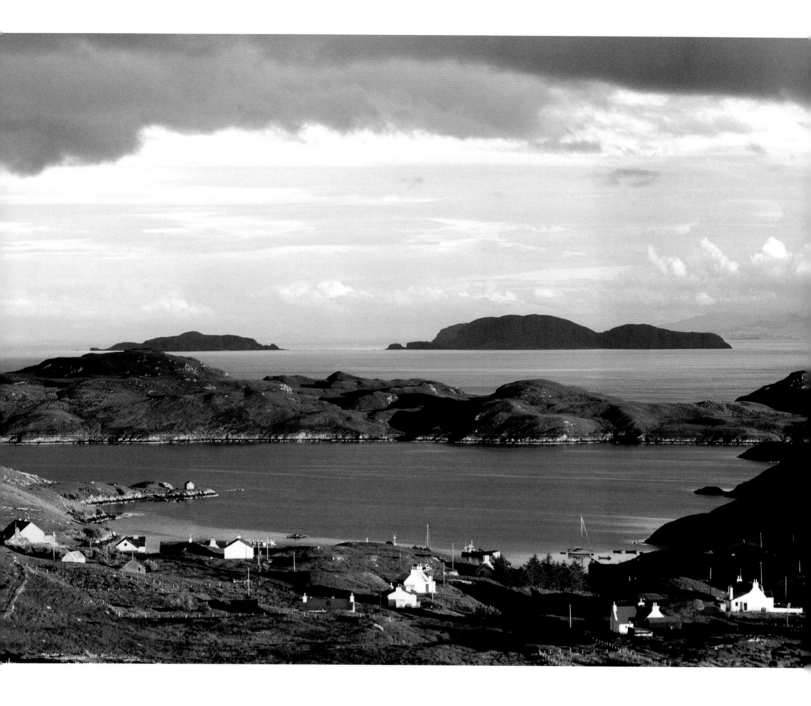

ABOVE *Lemreway
(Leumrabhagh), South Lochs,
Lewis, Outer Hebrides. The
qualities of the water-resistant and
hard-wearing Harris tweed are a
result of the remote, weather-beaten
islands on which it is made. The
cloth's intense and varied colours
reflect the reds and browns of the
landscape and the soft purples,
greys and greens of the sea.*

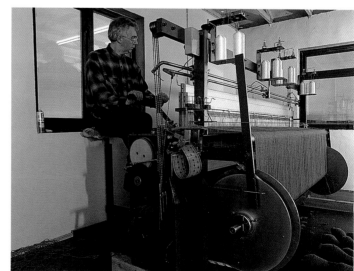

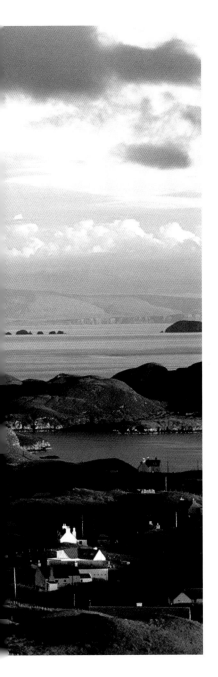

most concentrated retail structure in Europe and the manufacturing base has evolved to serve it. Retailing is dominated by a small number of large companies on which depend industries such as textiles. This industry basis has allowed no, or very few, label brands from UK manufacturers to emerge, and its heritage is an extremely fragile manufacturing structure. For example, in the post-war years Yorkshire mills sold almost exclusively to tailoring giants such as Montague Burton, weaving the cloth to supply the made-to-measure men's suiting industry: this meant long runs of standard fabrics for garments sold under the retailer's name. In the 1970s and 1980s, the Yorkshire companies went on to supply cloth for the suits of the high-street giant Marks & Spencer, and when that company faced financial problems, the knock-on effect was severe. Thus, simply finding another large client customer has not proved the solution to establishing a strong base for the textile industry, and opportunities for selling British cloth to British garment manufacturers are becoming ever fewer. DAKS, which owned the second-largest garment manufacturing facility in Europe, at Larkhall in Scotland, now source their production overseas; large-scale clothing manufacturing companies such as the Dewhirst Group have radically scaled down their operations. Fewer and fewer companies in the UK now make clothes.

British textiles, nonetheless, enjoy a reputation for high quality, based on tradition and history but also on the quality of raw materials and a high standard of finish. British fabrics often use traditional methods that ensure a quality of texture that is still hard to match. Fabrics for men's suiting still reflect a formal look but the cloth is now also about comfort and lightness, as found in cashmere, smooth tweeds, and fine jacquard. Such factors explain why, for example, the Italian menswear company Brioni, which employs more than 100 tailors and makes some of the most expensive hand-made suits in the world, uses British fabrics for its men's suits.

Scottish textiles: tweed

Scotland is best known for two fabrics that have helped to create its sense of national identity: tweed and tartan. Tweed, woven from carded short wool, using rough fibres and warm rustic colours, has come to evoke the countryside and the spartan outdoors associated with Britishness.

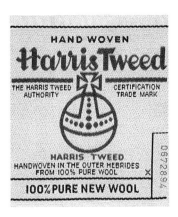

FAR LEFT *When the Industrial Revolution brought mechanized methods of production to the Scottish mainland, the islands of Lewis and Harris retained their traditional craft-weaving skills, producing tweed cloth on 19th-century wooden looms. In the late 1980s, the industry set out to modernize itself, in 1996 introducing the Bonas-Griffith* *double-width loom, seen here. This loom allowed the production of the wider fabric that the industry required and of softer, lighter, and more modern tweeds.*

LEFT *Every measure of Harris tweed is certified as genuine by the Harris Tweed Authority. The orb motif was reworked by Vivienne Westwood for her label logo.*

The word itself is an English variant on the Scottish word *tweel* which referred to the wool cloth woven by hand by Scottish highlanders and island dwellers. The term became associated with the Tweed River dividing England and Scotland and then became a description for all carded home-spun wool, including Irish Donegal and Cheviot tweeds. Harris tweed, however, is the unique Scottish fabric that has helped to build an international profile for Scottish textiles.

This cloth originates from the beautiful and remote islands of the Outer Hebrides – including Lewis, Harris, Uist, Barra, and Benbecula – off the west coast of Scotland. The cloth woven there, known generically as "Harris tweed", has become one of the most famous wool textiles in the world, used predominantly in the menswear market. The production of Harris tweed supports around 350–450 freelance weavers, mainly located on the islands of Harris and Lewis. The industry owes its history to a project pioneered in the 1840s by Lady Dunmore, wife of the Laird of Harris, who championed the weaving of Harris tweed to encourage the local economy.

The unique selling point of Harris tweed is its use of local materials and hand-craft techniques. The wool is produced principally on the mainland of Scotland and is taken to factories on the islands where it is prepared and dyed. The traditional colours derived from natural materials: orange from ragweed, green from heather or iris, red from lichen scraped from the rocks, yellow from bracken roots or peat soot, and reddish brown and fawns from lichen scraped from coastal rocks. Natural dyes are still sometimes used, but they have been largely replaced with synthetic dyes able to maintain the consistent repeat patterns and styles the modern clothing industry requires.

After the dyeing process the coloured and white wools are weighed in predetermined proportions, blended, and carded. By 1906 the tweed industry in Lewis was large enough to support two carding mills in Stornaway, and today the Harris tweed mills include Kenneth MacKenzie Ltd of Stornaway, Kenneth MacCleod (Shawbost) Ltd, and Bruce Burns of Stornaway. The resultant yarn is spun to give it strength and then warped, a process whereby the basic pattern of the colours is established by winding the threads on to a frame of wooden pegs ensuring an even tension throughout. The warp is then delivered, together with yarn for the weft, to the croft weavers, who continue a centuries-old tradition of weaving fabrics in their homes on traditional Hattersley looms. The British Harris Tweed Authority requires each weaver to sign an agreement that he or she will hand-weave all the fabric; typically each weaver produces about 78 metres (256 ft) of cloth in each batch. To achieve the unique effects of Harris tweed – famous for its colourways and complex patterns – each weaver receives precise design instructions and a pattern sample.

The woven tweed is then collected and returned to one of the mills on Lewis to be "finished". It is washed to remove the oil from the spinning stage, then the milling process removes any final impurities, and it is dried and cropped to give a smooth surface. The finished tweed is inspected and stamped with the certification mark. Harris tweed has struggled to protect itself from competitors and today every measure of Harris tweed is stamped on the reverse side with its trademark orb and Maltese cross by a member of the Harris Tweed Authority to "promote and protect the name of Harris tweed". As early as 1905 the Trade Marks Act allowed the registration of Standardisation Marks and offered a way to counter the growth of imitation fabric.

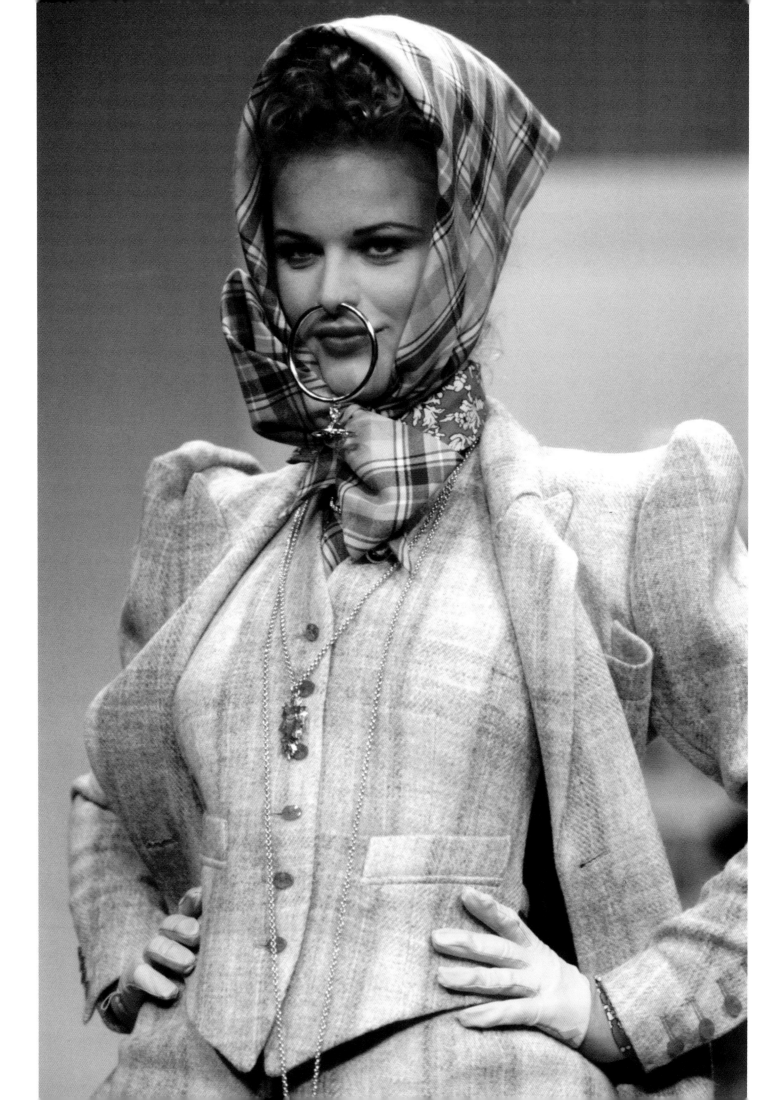

ABOVE *A section of Lochcarron's Waverley Mill, Galashiels. Lochcarron is one of Scotland's best known suppliers of traditional and new tartan fabric, supplied in a variety of weights and yarns. Inspired by the fashion revival of tartan they have established a reputation, most famously with Vivienne Westwood, and more recently with Luella Bartley, for supplying special designs to meet the needs of contemporary fashion.*

In the 1980s, the industry faced another crisis with a slump in the American and Asian markets, and foreign manufacturers undercutting prices with inferior versions of Harris tweed. To protect the industry an Act Of Parliament was passed in 1993 providing a legal definition of Harris tweed as "hand-woven by the islanders at their homes in the Outer Hebrides, finished in the islands of Harris, Lewis, Benbecula, Uist and Barra and their several purtenances and made from pure virgin wool dyed and spun in the Outer Hebrides". In 2000 the value of the world market in Harris tweed was £4 million and the KM Harris Tweed Group, incorporating Kenneth Macleod, Kenneth Mackenzie Ltd, and the Harris Tweed Trading Company, supplied 95 per cent of the market.

It is hard for an industry located on the periphery to maintain a visible international profile and Harris Tweed faces the demands of a fiercely competitive market. The industry is determined to invest in its commercial future. Traditionally, for example, croft weavers have woven single-width 75cm (29½in) wide fabric, but because wider fabric has more commercial viability, in the 1990s the Highlands and Islands Enterprise Board invested in double-width looms manufactured by Griffith Textiles Machines Ltd of Sunderland. Harris tweed has also responded to the demand for lighter fabrics. The islands' traditional weight of tweed (470 grams per square metre / 1½ oz per square foot) is too heavy for today's requirements and the industry has looked to lighten that weight to 260 grams (9 oz). Bruce Burns of Stornaway has experimented with a lighter fabric that handles like a wool/cashmere blend. The introduction of new colours and patterns has also ensured the appeal of hand-woven Harris tweed in the fashion centres of Paris and Milan, as well as to British designers such as Timothy Everest, Elspeth Gibson, Margaret Howell, Richard James, Ronit Zilkha, and Vivienne Westwood (see p.57).

Scottish textiles: tartan

Tartan is the other Scottish fabric that has come to symbolize the national identity and it enjoys a long history in Scotland as a woven, patterned wool-cloth. There is evidence that the ancient Celts used striped and checked woollen material for practical and warm garments similar to the Roman tunic; there is also documentation to support the claim that tartans marked membership of different clans. What is certain is that by the 18th century tartan was politicized and within the Scottish Highlands was seen as the flag of rebellion. After the Battle of Culloden in 1746, the British government attempted to crush the spirit of the rebellious Highlanders with the 1747 Act for the Abolition and Proscription of Highland Dress, decreeing that "no man or boy, within that part of Great Britain called Scotland, should wear the plaid …". But the production of tartan cloth continued, as the Act did not apply to the Scottish Lowlands, to women or to the gentry, nor to soldiers in the Highland regiments who needed regimental tartans. The army provided a large market for tartan cloth, which was supplied by the famous weaving firm of William Wilson & Sons. Wilson started his business in Bannockburn on the outskirts of Stirling, south of the Highland boundary, and therefore unaffected by the Act. William Wilson & Sons not only provided the Highland regiments with the large orders of standard tartan fabric they required, but also helped to create many of the standard patterns we recognize today.

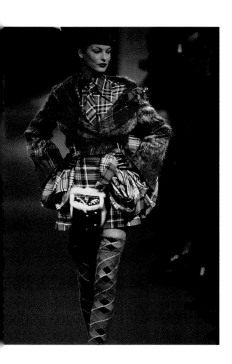

ABOVE *Since her earliest collections Vivienne Westwood has been passionate in her support of traditional fabrics and traditional British industries. The outfit here using Lochcarron tartan is from her 1993 autumn/winter* Anglomania *show. Westwood was one of the first British designers to collaborate with traditional fabric companies, often with demanding specifications, to include different colourways and yarns.*

Throughout the 19th century the fashion for all things Scottish became an obsession; tartan came to represent a certain kind of Scottish identity, evoking the romantic image of the wild, untamed, rebellious Highlands. Queen Victoria and Prince Albert continued this fascination with Scotland, creating their own Caledonian retreat, Balmoral Castle. Codifying the mythology of tartan became big business. The second half of the 19th century witnessed a huge industry of books detailing tartan designs – most of them an exploration of a "history" that was more invention than fact. Tartan's romantic heritage is part history, part mythology, and part Hollywood invention, as seen in films such as Mel Gibson's *Braveheart* (1995). In the context of Western male dress the tartan kilt was, and is, a unique opportunity for men to wear a brightly coloured patterned skirt and yet remain firmly masculine. For women its enduring appeal makes tartan a staple that moves in and out of the fashion focus but never entirely disappears.

Tartan fabric is now woven all over the world, a multi-million pound industry in which Scotland has to compete. Scottish tartan occupies a quality prestige niche: the best-known mills are Lochcarron, Peter McArthur (bought by Calzeat), and Robert Noble. Robert Noble focuses on an area of manufacture that does not face international competition: tartan kilts. Modern weaving is not suitable for the production of traditional kilts whether worn for ceremonial purposes or as fashion apparel. Robert Noble is known for Scottish regimental kilt fabric which has to be woven on old-fashioned, slow, and cumbersome weaving machines. Only these old-technology looms can create a piece of fabric that is level edge to edge in the way that kilt production requires.

Lochcarron is a family-owned business based in the Scottish Borders at Waverley Mill, Galashiels (see p.58). It manufactures tartan and tartan garments and accessories, under its own brand name and also as a supplier to design houses, exporting more than 60 per cent of products to Europe, Asia, and North and South America. Lochcarron claims the world's most comprehensive range of tartan designs (more than 1000) as well as designing new tartans including the National Millennium tartan (McLlennium), the Diana, Princess of Wales Memorial tartan, and the McAndreas tartan commissioned by Vivienne Westwood for her husband. The company's origin was in the production of Scottish craft weaving and its founder, John Buchan, was still weaving hand-loom tartans for King George V in the 1940s from the Highland village of Lochcarron. As well as tartan Lochcarron supplies the striped material, developed in the 19th century for sportswear, used in traditional blazers for English public schools and clubs. These blazer stripes have seen a revival in fashion in the 21st century and Lochcarron supplies its fabric to some of the world's most innovative designers, such as Comme des Garçons, Camilla Ridley, Anthony Symonds, and Luella Bartley. Flexibility and quality are key factors in the company's success.

Other Scottish textiles

An interesting story in the regeneration of Scottish textiles is provided by Bute Fabrics, founded after World War II by the 5th Marquess of Bute to provide work for ex-service men and women, supplying woollen upholstery fabrics to the furniture trade. When the company was taken over by Johnny Bute in 1993 it was transformed into an award-winning design leader. Bute successfully

collaborated with the new British design community, including supplying the fabric for Jasper Morrison's pH chair for Damien Hirst's super-fashionable Pharmacy restaurant in London's Notting Hill Gate. Fashion designer John Rocha selected Bute textiles for the interior of the Morrison Hotel in Dublin, while furniture designer Michael Sodeau launched his Mono sofa for the UK design company SCP in 2001, for which Bute produced the tartan in a seven-colour palette dominated by orange, blue, red, and cream.

The Scottish textile industry concentrates on tweeds and tartans but it also includes the production of wool fabrics for men's suiting. High-profile manufacturers in this field include Reid and Taylor of Peebles. Reid and Taylor was originally established in 1830 in the Scottish border town of Langholm to produce Cheviot cloth, for which it won a gold medal at the Great Exhibition of 1851 in London. By the early 1930s the mill had focused its production on specialized high-quality fine-twist worsted cloths, which were originally sold to merchant houses and distributed direct to traditional hand tailors. Other companies in this sector include Robert Noble of Langholm, which weaves fashion fabrics for mens- and womenswear. Noble now owns another long-established Scottish company, Whiteley and Green, famous for its tradition of up-market country fabrics, including cavalry twill for hunting and fishing clothes.

West Yorkshire woollen and worsted men's suiting

In contrast to the more diverse profile of Scottish textiles, the West Yorkshire textile industry focuses on the production of wool fabrics for men's suiting. A damp climate is especially suitable for the spinning of cotton and wool, as a great deal of water is used in the processes of textile production: Yorkshire, with its abundant rainfall and Pennine water, has a long history of producing wool and textiles, especially cloth for men's suiting in the area around Bradford and Huddersfield. With such a fragmented industry it is difficult to collect accurate information but in

September 2001 the Department of Trade and Industry estimated that there were 300 wool and worsted enterprises employing a total of around 13,000 operatives.

Yorkshire companies are proud bastions of tradition, whose history and expertise often stretch back over 200 years of continuous production on the same site. That history has shaped the culture of the surviving industry, which is very tough and very male. Faced with fierce competition, the industry is focused on survival. It is a sector that has not invested in research and development as fully as other industries; it is notoriously slow in the areas of information technology and design, and companies have little experience of working collaboratively, which may explain resistance to initiatives to promote and market British wool textiles as a generic brand.

The survival of Yorkshire companies is represented in pockets of excellence, tradition, and expertise that continue to supply the quality fabrics that in the past made British textiles a byword for excellence throughout the world. Such companies include Moorhouse Brook, William Halstead and Co., Schofield and Smith, Albert Moor & Sons Ltd, Abraham Moon & Sons Ltd of Guiseley, Leeds, C. & J. Antich & Sons Ltd, Huddersfield Fine Worsteds, Moxon's, and James Walker & Sons, Holme Bank Mills. Bower Roebuck is another high-profile success story and was established in 1899 in the Holme Valley in Yorkshire, in an area whose woollen industry dates back to the 16th century. They continue to produce traditional weights of suiting fabric, but with advanced textile technology they have developed more specialized and technical yarns.

Manufacturers such as Kirkheaton Mills, near Huddersfield in West Yorkshire, compete in the tough international markets by producing traditional fabrics and also more exotic cloths that

LEFT *Worsted manufacturers Broadhead & Graves purchased Kirkheaton Mills in 1909. The company had already developed a reputation for manufacturing superfine worsteds. In 1932 the Duke of York, later King George VI, visited the mill and ordered suiting fabric for himself. This promotional photograph showing the mill delivery van loaded with an American export order of cloth is from the same period. The van is loaded with wooden crates bound for New York on the transatlantic liner the* Queen Mary.

ABOVE *An ecclesiastical architect,
a relation of the company's
founder, was commissioned to
redesign Kirkheaton Mills and
the main section of the present
building was completed in 1882.
In 1964 a major fire destroyed the
company's drawings and patterns
going back to the 1830s. The
mill now houses a number of
established local companies.*

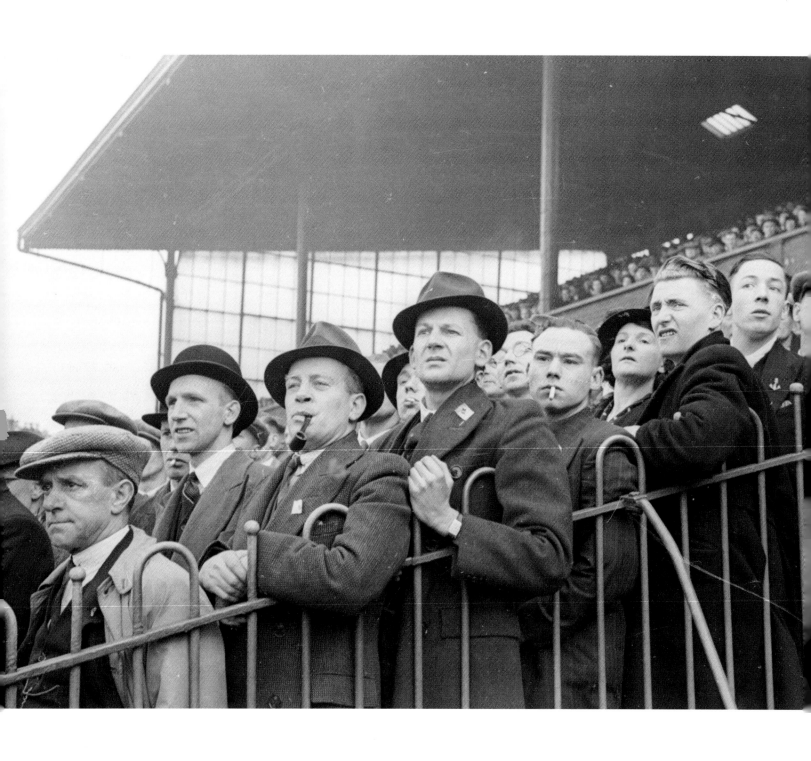

LEFT *This 1950s photograph shows working-class Northern men on the terraces of a football match at the Sheffield Wednesday ground. It shows the formal dress code of the period for men of all ages and for all social occasions, including football matches: a two- or three-piece woollen suit in a practical dark shade, a woollen overcoat, and either a soft tweed cloth cap or a more formal soft-brimmed felt hat. The suits would have been made from British cloth and manufactured in the UK.*

offer unusual and rare fibre contents and blends. Their reputation is based not only on traditional woollen men's suiting but on pure cashmere suiting fabrics and new specialist products developed from cashmere, mohair, and silk blends. The appeal of these high-technology cloths is that they are incredibly light. By investing in new Dornier Rappier looms and computer programs, Kirkheaton Mills specialize in yarn counts that extend the technology of cloth production. Fifty years ago it would have been unusual to produce a cloth of less than 400 grams (14 oz); now their cloth is rarely over 300 grams (10½ oz) and often as little as 160 grams (5½oz).

Irish linen

Another strong element within British textiles is linen. The industry is now concentrated in Northern Ireland within an area traditionally bounded by the Bann and the Lagan rivers. Northern Ireland produces 20 per cent of the European Union's linen yarn, and in terms of fabric Northern Ireland weaves approximately 2000 tonnes of linen per annum, with apparel fabrics forming roughly 75 per cent of total production. With an estimated annual turnover of £150 million and exports of £85 million, the linen industry plays a key role in the economy of the region.

Although linen was produced by hand-loom methods all over Ireland from the 16th century, by the 18th century the port of Belfast came to dominate linen cloth exports to English wholesale customers. The industry was challenged by the success in Britain of mechanized cotton spinning; because flax fibre was brittle, only coarse linen could be produced using the new spinning inventions. In 1825 a major advance was developed by James Key of Preston, who patented a method of "wet" machine spinning, which passed the flax through troughs of water and enabled a much finer yarn to be spun. The establishment of the Irish linen industry had begun. By the mid-19th century the fine quality of Irish linen was recognized all over the world. Belfast became the business headquarters for the majority of Ulster linen firms, offering the financial and technical expertise they required. Some of the manufacturing companies are still in business today, including William Barbour and Sons Ltd, established in 1784. By 1914 Barbour's employed almost 2000 people in the Lisburn area and was the largest linen-thread works in the world. Robinson and Cleaver's Department Store in Donegal Place, Belfast, established in 1870, became a worldwide mail-order retailer and supplier of linen through its catalogues.

Today Irish linen is still marketed by the Irish Linen Guild, founded in 1928 in Hillsborough, County Down. It represents around 30 members ranging from spinners and weavers to finishers, designers, and merchants. Pure, classic Irish linen continues to have an important place in the fashion world. Linen's absorbency and coolness make it a unique natural material: it can absorb up to 20 per cent of its own weight in moisture, while still feeling dry to the touch. Linen is also environmentally friendly: the production process from fibre to end product uses the whole flax crop, the left-over linseed, oil, straw, and fibre being used in products ranging from linoleum and soap to cattlefeed and paper.

The story of linen as a high-fashion fabric started in the 1950s when Irish fashion designers, including Sybil Connolly, began to realize its possibilities. The vogue for linen was

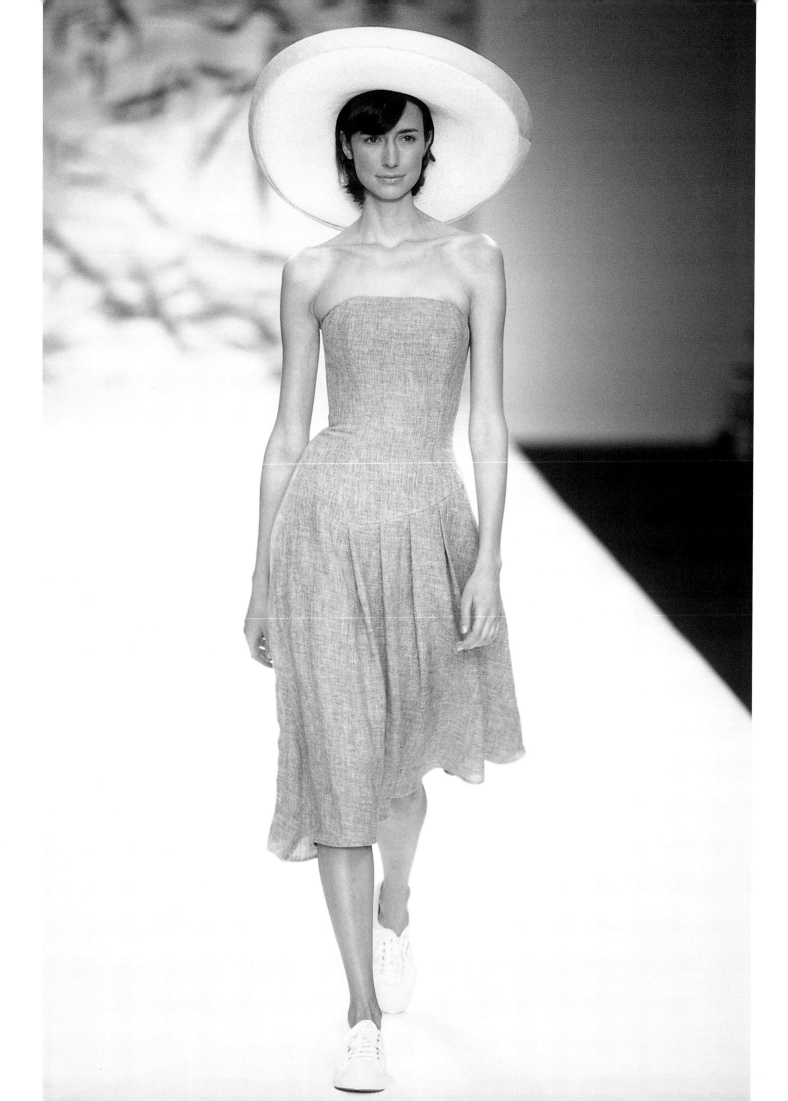

boosted in the 1980s with the arrival of Giorgio Armani's Italian soft-tailoring revolution. Armani made suits in lightweight fabrics including linen, creating a softer, more relaxed style. Linen was the perfect material for jackets that were now more like shirts, and comfortable loose-fitting trousers whose appeal was enhanced by the fabric's natural crumpled appearance.

Linen remains one of the most comfortable and durable fashion fabrics, and is the speciality of the well-known Irish designer Paul Costelloe, who launched his own label in 1979, based in County Tyrone, Northern Ireland. Costelloe's creativity has been recognized by the International Linen Council, which has awarded him the prestigious Fil d'Or Award on three occasions. Fashion designers can now take advantage of the development of new blends and finishes that have extended the market for linen fabrics. Applied new technology, particularly in the spinning and finishing, has improved the characteristics of linen. Linen/silk and linen/mohair are two new luxurious natural blends, while linen blends with new microfibres such as Tencel have resulted in exciting new textures. Well known in this sector is the Northern Irish company John England Textiles, whose production of original lightweight weaves and different finishes includes an innovative linen–Lycra mix.

The future for British textiles

The profile of the British textile industry remains a difficult one. It offers specialized textiles to high-fashion designers who only require small production runs, dyed and finished to specific requirements. It can compete at the top end of the market with its combination of traditional expertise and its use of the finest natural fibres such as cashmere, wool, mohair, cotton, linen, and silk. Growing and expanding into new markets is the difficulty. The textiles future is now widely seen as technology-led: advanced textile technology offers new performance capabilities, high-tech coatings, shape memory alloys, microfibre fabrics, laser cutting, and cloth derived from industrial applications. For the future of the British textiles industry the balance between traditional skills, new technology, and the global market is a critical one.

ABOVE *John Smedley's staff assemble in 1900 to celebrate the relief of the town of Mafeking during the Boer War. Smedley had been producing fine-gauge knits in this stone-built mill since 1756, but its revival as a fashion brand began in 1986 when Vivienne Westwood commissioned classic twin sets to which she added her orb logo and motif, embroidered by Halls of Mansfield. For subsequent collections she commissioned intricate intarsias (decorations knitted into the pattern) and Sea Island cotton Argyle leggings.*

FAR RIGHT *A magazine advertisement from Smedley's autumn/winter collection of 2000, showing a range of classic knitwear including a tomato red twinset and sleeveless polo neck. Contemporary fashion detailing is evident in the gathered neckline of the black leotard top and the open-weave pattern and exaggerated waistband of the cream V-neck twinset.*

The British knitwear industry

Knitwear is a distinct sector of the market, a hybrid of textiles and clothing. For knitwear, manufacturers buy in the yarn and knit it direct, shaping it on knitting machines, or knitting fabric lengths that are then cut and assembled into garments. For the last 200 years the industry has been located in its traditional centres of Scotland and the English Midlands.

Three well-known companies dominate British high-fashion knitwear: the English company John Smedley and the Scottish companies Pringle and Ballantyne. The Scotch House, established by the Glaswegian Gardiner brothers in 1839 selling Scottish tweeds and tartans, also deserves a mention. These companies continue to produce distinctive and high-quality knitwear garments, including the jumper and the twin set pullover and cardigan produced in distinctive patterns that have come to represent an aspect of British style. They have secured a place in the modern international market, however, by combining tradition with contemporary design and high-quality yarns.

John Smedley is famous for the quality and style of its fine-gauge knitwear in natural fibres, which it supplies to designers including Paul Smith and Yves Saint Laurent, opening in 2000 its first standalone store in London. For more than two centuries the company has been located at Lea Bridge in Derbyshire. In 1784, when Peter Nightingale and John Smedley set up a spinning mill, Derbyshire had already become a key centre of the Industrial Revolution. In 1819, John Smedley's son of the same name set about building a separate business to concentrate on the spinning, knitting, and manufacture of hosiery. In the 19th century it expanded to include the manufacture of fine-gauge underwear. By 1877, full-fashioned knitting machines had been developed, an innovation that allowed the knitting of body panels and sleeves to the right shape without having to cut the fabric. Smedley's success in knitted outerwear took off in the 1930s with the demand for knitted swimwear, sportswear, and nightwear; only in the 1960s did the company move into the sweaters that were to transform it into a high-fashion brand.

In the 21st century Smedley combines technology and craft to achieve what many feel are some of the finest-quality knitwear products in the world. The company has developed one of the world's most specialized plants for fine-gauge knitting, from 24 gauge through to superfine lightweights at 30 gauge. Alongside this technology Smedley specializes in traditional methods of hand-finish: once the body panels and sleeves have been knitted they are linked together by hand, for perfect seams, and hand-finished using a wooden former, then steam-pressed, and pressed again with flat irons. The range and quality of colour is another distinctive feature, achieved using a technique of "top-dyeing" (in the yarn) rather than garment-dyeing, to give an even depth of colour. Smedley also enjoys a reputation for the quality of its yarn, typical of which is New Zealand Merino wool, which has the long, strong, fine fibres required for the worsted spinning that gives a characteristic smooth finish. Sea Island cotton, a long-staple fine cotton, is another trademark luxury yarn that Smedley has developed for knitwear.

Another firm that enjoys a long heritage is Pringle, founded in 1815 in Hawick in the Scottish Borders by Robert Pringle, which by the 1820s was manufacturing knitted underwear. In 1858 Pringle introduced the first steam-driven knitting frames into its factory. In 1859 Walter

Pringle wrote to a client asserting that "quality is of the utmost importance, for even in adverse times there are those who will buy high quality goods; the customer is our lifeblood". By 1885 the company had moved into retailing its own branded products, establishing itself in the retail business with the opening of its first shop in Noble Street in the City of London. Pringle was an early pioneer of knitted outerwear, inventing new techniques such as cable stitching for lady's jackets in the 1890s. More famously, however, the company is credited with two stylistic innovations indelibly identified with British style: the Argyle pattern and the twin set. The Argyle pattern was a multicoloured diamond repeat that originated in the Western Isles of Scotland. Legend has it that Pringle took the pattern from 1920s golfing socks worn by the Duke of Westminster and adapted it for the now ubiquitous sweater patterns. It proved immensely popular and by the 1930s the Argyle pattern was knitted mechanically on intarsia (knitting a raised or textured pattern or motif into the wool) machines. By the 1970s new technology could knit four fronts at a time with the use of automatic intarsia cards operated by a punch card; these were replaced in the mid-1980s with the first electronic intarsia frames, capable of knitting eight fronts at a time.

Pringle also claims the invention of another classic British garment, the knitted twin set, a simple sleeveless round-neck vest worn under a straight button-up cardigan in the same colour. It was a brilliant idea, credited in 1934 to Otto Weisz , then the designer for Pringle. The twin set was wonderfully flexible: worn tightly it could be sexy and reveal the figure, yet it was also a cover-up that was comfortable and allowed movement. It could be dressed up or down and appealed to

ABOVE LEFT *During the 1950s Pringle commissioned a series of simple studio photographs of British film stars wearing Pringle knitwear. These included the actress Margaret Lockwood (pictured), Phyllis Calvert, Moira Shearer, and Jean Simmons.*

ABOVE *The cover of the* Pringle Bulletin, *Issue 12, 1952. The bulletin was a magazine intended for customers and retailers to update them about company news. Depicted is the Pringle factory, which reflects the company's pride in its manufacturing heritage.*

FAR LEFT *Pringle's distinctive Argyle diamond pattern from the autumn/winter collection of 2001. The traditional Scottish pattern was originally used on golf socks but was later transferred to golf sweaters, a trend encouraged by the Prince of Wales in the late 1920s.*

LEFT *Jo Gordon knitted balaclava hat. Gordon's knitwear is often inspired by traditional British knitting patterns and shapes. Her current range includes handknit, fine-wool socks and quirky hats, including this balaclava. Originally worn by British soldiers during the Crimean War, the balaclava carries with it associations of combat and masculinity that Gordon has subverted here with a fun and witty detail, the addition of knitted-on rosy cheeks.*

people of all ages and social status. The twin set was a classic modern design for the 20th century and possibly no other garment has reflected so closely an image of British women. It quickly became fashionable, worn in the pre-war period both by the royal family and by actresses such as Patricia Culvert and Margaret Lockwood. After the war the twin set could evoke either a sense of straightforward practicality, or stylish chic from Margot Fonteyn, and sexy glamour from Diana Dors.

Another Scottish company, Ballantyne was originally founded in the 1920s and continues to operate from its Caerlee Mills in the small town of Innerleithen, near Peebles in the Scottish Borders. Ballantyne builds on the high-quality tradition of Scottish cashmere, sourcing the longest cashmere yarns from Mongolia and China. Scotland, with its soft water, wet climate, and long history of weaving, spinning and knitting, has developed a high-profile specialization in cashmere, reflected by companies such as Lochcarron, Pringle, Lyle & Scott Ltd, and N. Peal Cashmere, as well as Ballantyne. Dawson International, which now owns Ballantyne, is determined to secure its place in this luxury market, signing up Matthew Williamson (see p. 124) as design consultant to produce a new collection, which was shown in 2002.

Innovative knits

Alongside these well-known manufacturing companies, independent British fashion designers have also explored knitwear as an area for innovation and creativity. Since the 1980s Vivienne Westwood has appropriated Smedley classic twin sets with her distinctive orb logo to wear with more outrageous accessories, and she has played with Fair Isle patterns for garments with unusual

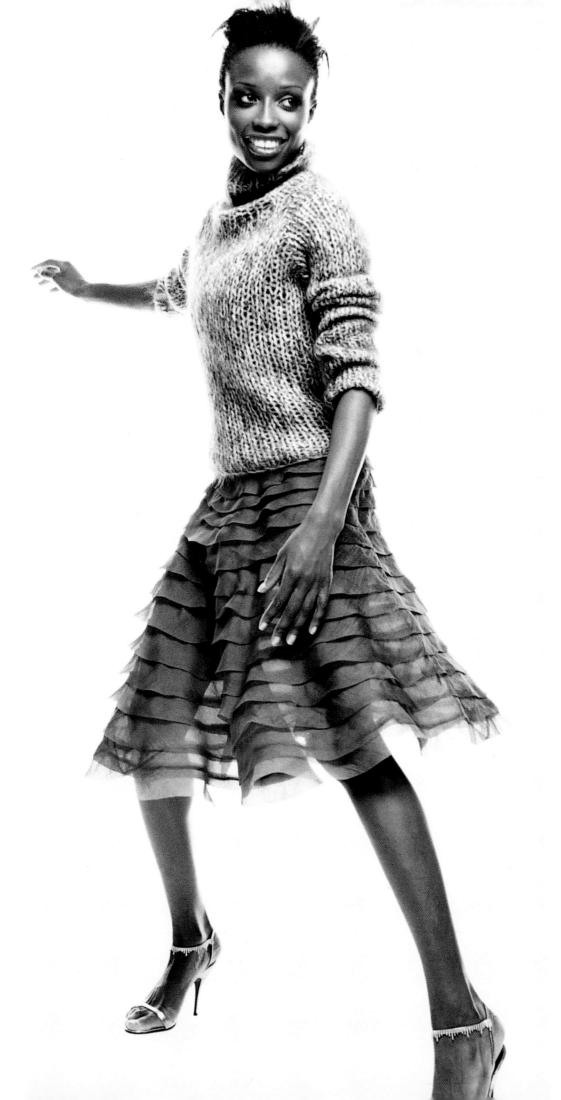

LEFT *Mohair sweater and silk organza dress both by Nicole Farhi, autumn/winter 1998. This outfit reflects a British talent for combining different elements, here a fragile layered organza dress with an open-knit high-neck sweater and delicate silver jewelled stiletto-heeled shoes. The effect is interesting but not outrageous. The traditional loose sweater is shaped by Farhi close to the body and is knitted not in wool but expensive cashmere.*

styling, opening for example not vertically across the body but horizontally. The potential for more radical and experimental knitwear using new fibres, shapes, and styles has also been developed by the Dublin-based designer John Rocha. Rocha has taken traditional British themes and updated them in an original and modern way, such as using hand-crafted Nottingham lace knitted into delicately detailed sweaters of beautiful simplicity.

Extending the traditional parameters of knit has now become a strong British fashion trend. Julien MacDonald is credited in the 1990s with reinventing knitwear for a younger audience, his passion for hand-knitting reflected in fragile but highly-technical cobweb knits used for crocheted minidresses, typically using bright green Lurex yarns. The design duo of Suzanne Clements and Inacio Ribeiro also introduced new directions in knitwear in the 1990s, including rainbow-striped twin sets aimed at a fashionable younger market, which helped to introduce cashmere to a wider market. Knitwear is a key element in their collections for both mens and womenswear, with their knits in cashmere manufactured by the traditional company Barrie of Scotland. Their signature mixture of colours, stripes, and textures was seen in a key piece from their 2001 spring/summer collection: a tight-fitting rugby sweater knitted in red and white stripes.

Younger designers have also been attracted to knitwear. Jo Gordon started her career designing and making a series of hats from felted wool, shaped and formed in a way that reflected her background – she studied first at Aberdeen School of Art as a sculptor and then at the Royal College of Art on its specialist millinery course. She began her career making couture hats for designers, including Karl Lagerfeld at Chanel and Romeo Gigli, but during a trip back to her home village of Baffron in Stirlingshire, Scotland, Gordon came across a pull-on woollen hat owned by her father which inspired her to produce a range of simple knitted shapes developed from 1950s knitting patterns. To make her knitted accessories Gordon employed local women knitters, and she sold the products at first only as a sideline; however, they proved such a success at the 1996 London Fashion Week that she turned her full attention to knitwear. Gordon attracted international attention for her autumn/winter 1999 collection, where she famously launched her trademark stripy socks, hats, and scarves.

In contrast, Nicole Farhi is one of Britain's most successful and commercial womenswear designers. Her vision for women's clothes is essentially a 1980s one, comprising stylish casuals for professional women; they are clothes that blur the edges between day wear and evening wear, in soft structural shapes using natural fabrics and yarns. Her clothes are intended to be fashionable but not to make a strong fashion statement. From her early collections onward, knitwear played a vital part in the Farhi look. Not fundamentally an innovator in design, Farhi has adapted the British traditions in knitwear for a wider market. She has reworked the classic handknit tradition of patterned jumpers and cardigans and the baggy "sloppy Joe" sweaters of the 1950s, and has also explored the more contemporary use of new synthetic yarns in Lurex and luxury fibres such as cashmere. Offering elements of British quirkiness overlaid with a more European appeal, Farhi reflects just one of the ways in which British designers have incorporated knitwear as a continuing theme for contemporary fashion.

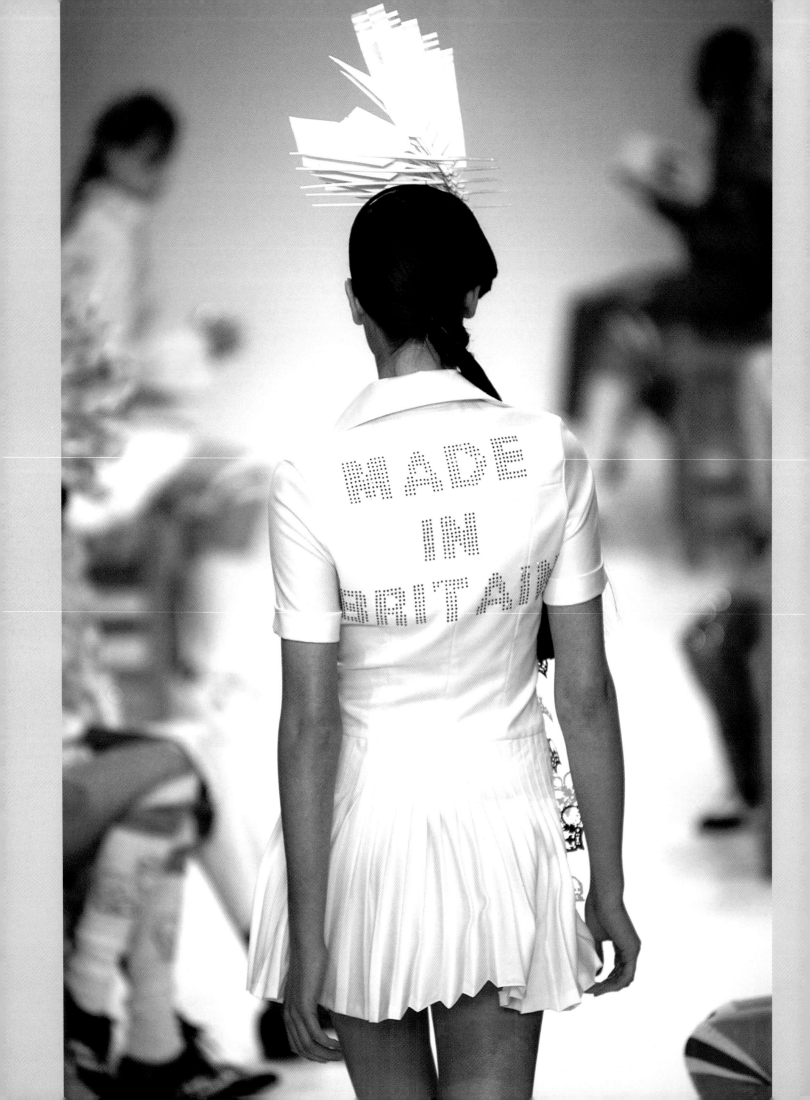

LEFT No More Useless Beauty, *spring/summer 2002. These catwalk images are from the London Fashion Week show at the Natural History Museum, South Kensington. The collection explored British fabrics, and shown here is a traditional pleated tennis skirt in white wool. The "Made In Britain" shirt is made from fabric supplied by Acorn, one of the last specialist cotton shirting weavers in the UK, located in the Lake District.*

RIGHT No More Useless Beauty, *spring/summer 2002. A blue summer wool suit in British fabric: when the jacket is closed it reveals an asymmetrical strip in a darker blue tone running across the front. The motifs that decorate the clothes use laser-cut acetates and are derived from national symbols, including the Tudor rose, and the crown and the thistle shown here, an image taken from the English £1 coin.*

DAI REES

Dai Rees is the collaborative design partnership of Simon Munro, a landscape architect, and Dai Rees, who trained in ceramics and glass at Central St Martins and the Royal College of Art. Their approach is well known for its high-profile use of traditional British textiles and knitwear as a starting point for collections that reinforce their belief in the importance of tradition and heritage as a way forward for the future. Their clothes often rework traditional areas such as English sportswear using fabrics customized so as to comment on themes of national identity, appropriating for example the crown and thistle marks used on British currency. Dai Rees apply this iconic imagery using diverse techniques, from laser-cut acetates to embroidery and hand intarsia knitting. They use ideas and slogans in a direct, even confrontational way. Printed on garments for their 2002 collection was a series of questions for the audience, one of which simply asked, "What exactly do you care about?" Fashion from Dai Rees is subtly conceptual and from 1998 has been widely exhibited in leading galleries and museums.

After graduating Rees worked independently on catwalk show accessories for several of Britain's leading designers, including distinctive quill head-pieces for Alexander McQueen and exotic body constructions for Julien MacDonald. These one-off, hand-built pieces established him as one of Britain's most talented, imaginative makers, best known for millinery. Typically building forms using turkey quills, Rees explored the material in a new way for each collection, stripping the quills back and wrapping them in fabric, or layering the feathers in complex constructions. His experience of working with other materials brought to millinery a fearless approach to form-finding.

In 1997 he set up in business with his partner Simon Munro and their combined talents have won them a national and international reputation. Their collections initally comprised the millinery and accessories for which Rees was known; sponsorship from the British Fashion Council's New Generation scheme helped finance their first collections of hats, jewellery, and leather accessories, *Simorg Anka* (1997) and

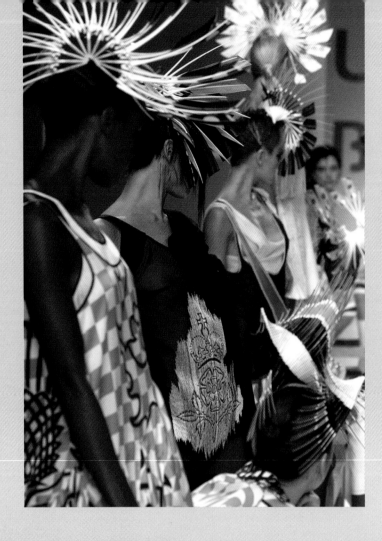

Pampilion (1998). Subsequent collections of womenswear, using Scottish tweeds, Irish linen, and Yorkshire woollen cloths, combined Munro's eye as a landscape architect for colour, texture, and form with themes derived from the Celtic heritage of Rees' South Wales background. They started to explore ways of using traditional and new British fabrics and patterns and motifs drawn from the landscape. *Aon* (autumn/winter 1999), used British tweeds and tartan mohair and included woven and knitted garments, hats, and accessories; *Ail* (spring/summer 2000) used Irish linen draped round the body to suggest the contours of the landscape. Further collections continued to develop their personal fashion agenda.

Dai Rees now offers a distinctive vision which combines Rees' dramatic head-pieces with themes and patterns inspired by the landscape, national identity, and national fabrics. Unlike so many of their peers, they use textiles woven in the British Isles, and also use more specialized sources from independent workshops and factories. Wales is a preferred location, with fabrics commissioned from small textile manufacturers such as Cambrian Woollen Mill, Llanwrtyd Wells, Powis, and Melin Teifi-Trefiew Woollen Mill in Llandysul.

Rees and Munro care about how they position their work and the values they express. In an industry dominated by powerful companies they strive to retain an independent vision, believing that the way they design and work offers a viable alternative to the mainstream. A revealing aspect of their collections is that a proportion of the clothes they show is not designed for production: such garments are individual pieces with an attention to detail and finish associated with couture. Underlying Dai Rees' approach to fashion are sincere personal ethics, with great value placed on sustainability and on the origin of materials, be that a Welsh workshop or wool from rare-breed sheep.

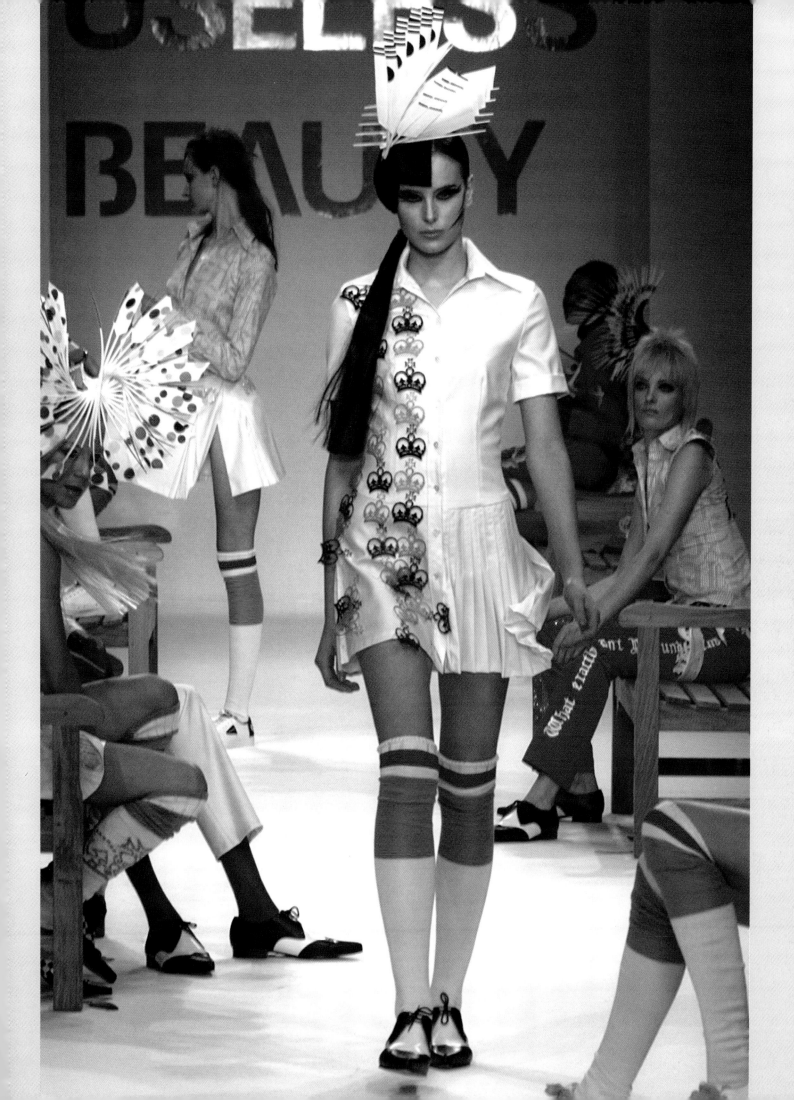

brands reinvented

MULBERRY

Aquascutum
OF LONDON

DAKS

BURBERRY

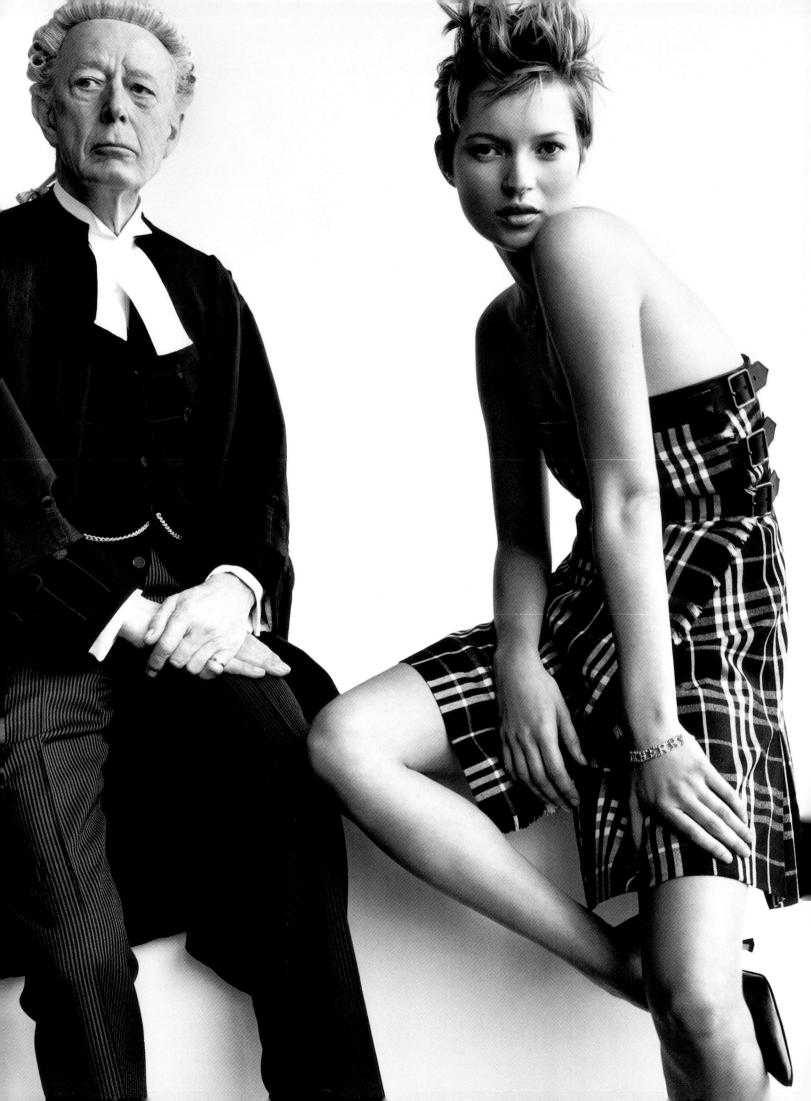

British fashion in the 21st century has witnessed the remarkable rebirth of a series of traditional English companies, including Burberry, Mulberry, DAKS, Aquascutum, Austin Reed, and Jaeger. These were mainly companies that enjoyed a 100-year-strong reputation for heritage, style, and quality but not for leading fashion designs. Their appeal in the late 20th century was predominantly to middle Englanders of a certain age looking for conservative clothes, and to foreign tourists who wanted to buy into a safe idea of British tradition and heritage. The inherent problem was that this customer base was growing older and the companies were failing to appeal to a younger market. All this was set to change. These companies were determined to develop a wider appeal and to establish themselves internationally, and as such they represent the first real attempt by British fashion to conquer the tough and competitive world of international brands.

So successful have they been that these brands are now collectively referred to in the media as "Brit chic". They offer a combination of heritage and hipness that might dissuade existing customers but is intended to appeal to a more youthful market. Their rise to success is linked to the obsession with celebrity culture that has become a hallmark of contemporary style. The buying public has now become more educated in terms of image, style, and promotion, and with that a generation of consumers, both at home and abroad, aspires to celebrity image. Fashion celebrities are the new marketeers of what to wear and when to wear it; what superstars are photographed wearing has become of basic importance to the success of a brand. Exploiting that is fundamental to these new directional British fashion brands, and one of the themes they have come to reflect so successfully is the trend towards accessibility in brand fashion. Many brands are as famous for their bags as for their clothing, a phenomenon that is opening up access to brand image, since more people can buy an accessory than a whole outfit.

British designers and design – along with British films and art – attract endless media interest and publicity, totally out of synch with one important detail: their size. The economic size of the British fashion industry is small compared with its major competitors in Italy, France, and the United States. British government figures for 1996 gave the total value of the UK designer industry as £600 million, in contrast to a value for the Italian industry of £1.5 billion. The American Council of Fashion Designers estimates the value of the US designer industry as £5.2 billion. The issue is as much about structure as size, however. The designer sector in Italy is made up of huge fashion empires including Armani, Prada, Gucci, Gianfranco Ferré, Versace, and Dolce & Gabbana; American fashion design follows a similar pattern, dominated by four major brands, Ralph Lauren, Calvin Klein, Donna Karan, and Tommy Hilfiger.

It is important here to understand something of the structure of the British fashion retailing industry alongside these major foreign competitors. In the UK, six retailers account for 70 per cent of garment sales, with only the remaining 30 per cent accounted for by independents. Because Italy, Germany, and the United States have a more fragmented retail structure, that situation is reversed, making it much harder for competitors to enter these markets.

Italy is the model of successful fashion industry practice, enjoying the highest clothing exports in the world after China. Not only does Italy manufacture its own major brands as well as

PAGE 83 *One of the most successful stories in contemporary British fashion is the rebranding of a group of traditional British clothing companies. These companies, which include DAKS, Burberry, Aquascutum, and Mulberry, had enjoyed a long history of marketing tailored and sporting clothes to both men and women since the 19th century. By the 1990s however they faced decreasing markets and looked to expand sales by investing in luxuriously refurbished flagship stores, high-profile advertising campaigns, and new design teams to capture a younger, more affluent, and more international customer.*

LEFT *The photographer Mario Testino was commissioned by Burberry to take a series of advertising images that positioned the company's new range, worn by one of the most famous British models of the period, Kate Moss. Each image places Moss alongside a figure of the British establishment such as a Buckingham Palace Guard or, as here, a High Court judge in traditional gown and wig. The photographs, from the autumn/winter 2001 campaign, were shown in 2002 at a high-profile one-man show at the National Portrait Gallery in London, thereby ensuring their status as seminal fashion images of the period.*

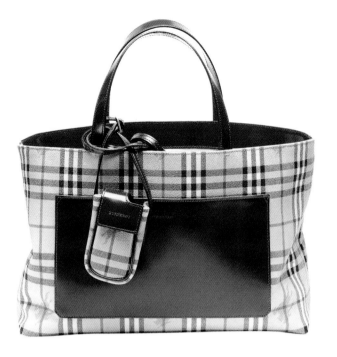

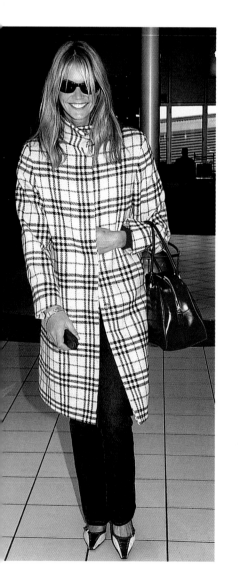

high-profile smaller designer brands, but it also has a textile industry linked to the fashion production industry. Italy's strength lies in the fact that it manufactures both garments and fabrics. Furthermore, the Italian domestic market offers flexible opportunities for fabric producers to promote their own brands through their own and independent outlets alongside international brand names such as Armani and Gucci, thereby ensuring both domestic demand and international sales for clothes using Italian cloth.

Italy has succeeded in developing the largest and most modern textile and clothing manufacturing base in Europe. In contrast, the UK has a lack of quality, flexible garment manufacturing facilities. The manufacturing base is structured around the British retail market, in which the high-street chains monopolize the larger fabric suppliers, with the result that British designers, working on a small scale, are mostly obliged to source their fabrics abroad, with three notable exceptions: linens, woollens, and worsted fabrics.

To compete in the new global fashion industry Britain has needed to develop brand stables on the American and Italian models. This chapter explores this phenomenon with the development of a number of British clothing brands built on the new profile of "heritage" companies that have pioneered the 21st-century cool of a British home-grown, high-status label. Such brands have successfully penetrated world markets on the strengths of high quality, good design, and effective marketing. British designers have been central to this turnaround in fashion, including Timothy Everest as the new creative director at DAKS, Michael Hertz at Aquascutum, Scott Henshall at Mulberry, and Bella Freud at Jaeger. Other traditional British retailers were quick to follow the pattern: the British jewellers Asprey & Garrard appointed Jade Jagger, daughter of Rolling Stone Mick Jagger, as their creative director, with Hussein Chalayan heading their new fashion range, while Hardy Amies appointed Jacques Azagury for its new ready-to-wear range.

OXFORD STREET

SOUTH MOLTON STREET

D BOND STREET

NEW BOND STREET

BURBERRY

CONDUIT STREET

SAVILE ROW

REGENT STREET

ABOVE *This Burberry party invitation to the launch of its collection in September 2000 cleverly uses the Burberry check to replicate the grid structure of New York, shown here as a map marking out the location of the store and nearby premier London shopping streets. The invitation won the prestigious D&AD Silver Pencil Award for graphic design in 2001.*

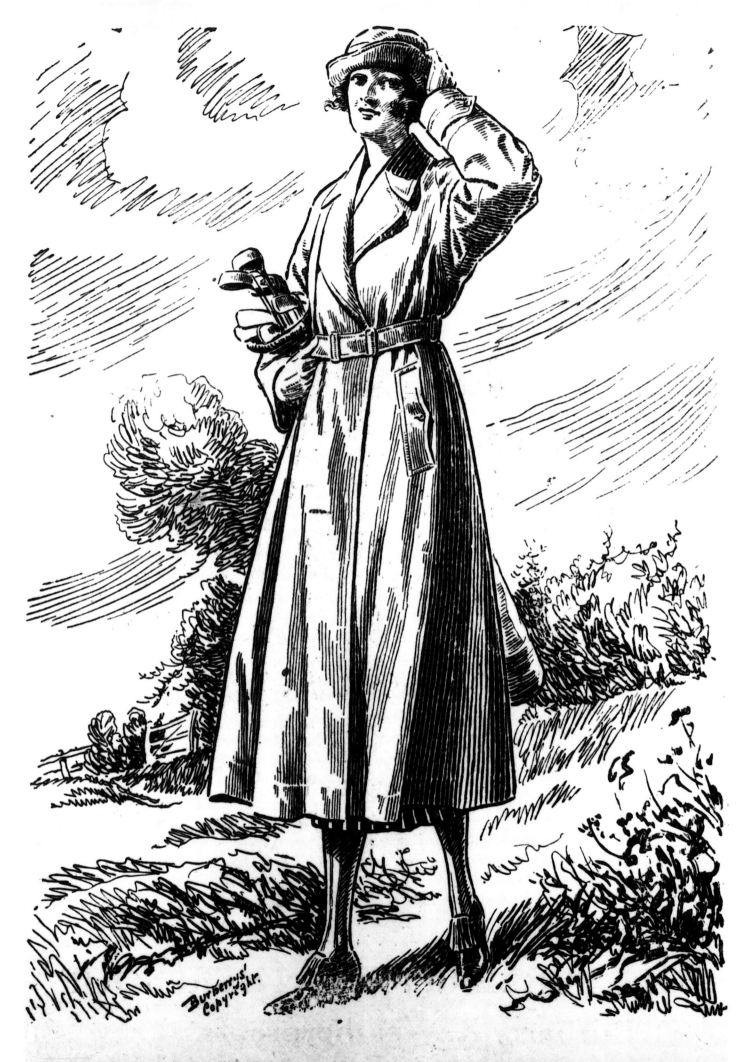

TIELOCKEN WEATHERPROOF

Burberry

The origins and traditions of these long-standing British companies make for fascinating reading. Their products – waterproof mackintoshes, tweed country jackets, sporting casual clothes – reflected authentic British passions. It is a simple point, but so much of what is recognized as typically British fashion and fabrics has been controlled by the weather, the infamous British climate of cold and rain. Perhaps one of the best-known garments to exemplify a practical solution to a very British problem is the Burberry mac, now almost synonymous with the waterproof raincoat. Styled like an army overcoat, with its trademark check lining it became one of the most familiar fashion items of the 20th century. Burberry's origins, however, go back to 1856, when Thomas Burberry started his own draper's business and developed a waterproof cloth that was hard-wearing and impenetrable to rain yet cool and light to wear. By the early 20th century Burberry macs had become a standard for practical outdoor clothing as well as being adapted to offer specialist protection for sportspeople and explorers. Scott of the Antarctic and his team, for example, wore specially designed Burberry windproof suits on their ill-fated expedition. Its position as a contemporary British classic has been challenged only in the last 30 years by waterproof rivals such as the short Barbour jacket, manufactured in traditional green by J. Barbour & Sons, also established in the 19th century. But the Burberry mac was more versatile: it appealed to men and women alike, while versions were even designed as school uniforms. It was both conservative and sexy; belted and with the collar upturned the mac became a cliché of the debonair film hero. By the 1990s, however, Burberry, although still known for quality had become dowdy and dull. Its turnaround has become a classic and much-imitated case study of retailing success.

Burberry's rebranding was led by an American, Rose Marie Bravo, formerly of Saks Fifth Avenue in New York, who was appointed Burberry's chief executive in 1998. Bravo brought with her the American approach to the market, and she understood that in order to survive, British fashion must confront the global marketplace. She employed one of the world's most influential art directors, Fabien Baron, to establish a brand logo with a new typeface, dropping the "s" of the

LEFT *The choice of model to relaunch a traditional brand is crucial, and Mulberry's decision, with the help of specialist branding consultant Four IV, to employ the young British actress Anna Friel to speak to a new generation of consumers was an inspired choice. Friel is shown here wearing an outfit designed by womenswear creative director Scott Henshall, whose brief was to make British tradition relevant to the global market.*

RIGHT *The Mulberry name is synonymous with quality leather luggage and handbags. The Mississippi Voyager suitcase and beauty case shown here are key pieces for spring/summer 2002.*

FAR RIGHT *Mulberry has become famous for a series of luxurious designer accessories, most famously this soft leather fold-up yoga mat. Yoga has become the expression of success for an older generation of celebrities including reputed purchasers of the mat, Madonna and Sting.*

original company name, which now became known simply as Burberry. Bravo also launched a strong advertising campaign, aiming to establish a certain kind of English aristocratic eccentricity: Mario Testino shot a series of advertisements in 1999 using the model Stella Tennant photographed against the setting of an English country house. For the clothes, Burberry employed Roberto Menichetti, who had launched menswear for Jil Sander, to work on modernizing the Burberry check and to develop a new label, Prorsum. Burberry's current designer, former Gucci designer Christopher Bailey, has explored fabrics and details inspired by Burberry's tradition since the 19th century of making military uniforms for the British army: suits in a material inspired by canvas tents, with military eyelets and buttons, are mixed with softer silk blouses; leather is mixed with lace. This collection is now located in a new flagship store in Bond Street, designed by Randall Ridless, formerly of Saks Fifth Avenue, with a strongly American feel. The store has represented "heritage" with check-etched glass, oiled oak, and wooden frames containing slogans such as "The trench coat: we invented it, we reinvented it". In this way an American has translated Burberry's British history and tradition into design details with an international appeal, giving an overall look that will be replicated in Burberry outlets in airports and malls all over the world.

Mulberry

Mulberry is the exception in this portfolio of rebrands in that it is a relatively young company. Founded by Roger Saul in 1971, the company began by designing belts and handbags for Pop boutiques such as Bus Stop and Biba. Mulberry launched its own retail business in the early 1980s with men's and women's ready-to-wear and home interiors, together with the leather accessories, including handbags, belts, and luggage, that remain at the heart of the brand.

In 2001 the Mulberry relaunch was funded in a spectacular way when Roger Saul entered a partnership with the Singapore-based fashion entrepreneur Christina Ong and her husband Beng Seng Ong, who invested £7.6 million to develop the company's presence in the American market – including a flagship store in Manhattan, opened in Spring 2002. Mulberry also appointed a new

designer, Scott Henshall, to reposition the company's image of "English style". Henshall revisited Mulberry archives from the 1970s for inspiration for the new womenswear collection, reflecting the wider shift in fashion from minimalism to colour and texture. He described his take on Englishness in the company's publicity as "about luxury and confidence. It's about the best traditional fabrics used in a way that's slightly disrespectful. It's about a certain quirkiness in the detail and the way it's put together, the old, vintage and raggedy-edged mixed in with the new. It blurs the boundaries between formal and casual." The Mulberry rebirth began in October 2001 with a £4 million retail concept for the flagship store in New Bond Street, with its bronze shop front and floor-to-ceiling display windows, and for the interior, leather-panelled walls and a chocolate limestone floor. The design concept will be followed by a second London store in Knightsbridge followed by franchises in Copenhagen, Stockholm, and Amsterdam.

The new Mulberry marketing image is reflected by the inspired use of the young English thespian couple Anna Friel and David Thewlis for an advertising campaign photographed by the reportage photographer Henry Bond. Burberry has enjoyed huge media success in positioning its products with international celebrities, so much so that, more than any other brand, it has come to represent the success of "Brit chic". An article in *The Daily Telegraph* at the end of 2001 listed the singer Robbie Williams as wearing a Mulberry mohair dinner suit in his pop video, and Bryan McFadden of the boy band Westlife as wearing a Mulberry cream corduroy coat. Mulberry is seen as the sharper, younger, and more hip label, and just as importantly, as the accessory brand. In the same article former Spice Girl Victoria Beckham was photographed with a Mulberry red leather vanity case and the singer Sting documented as one of several celebrity owners of the Mulberry

ABOVE *The new Mulberry store exploits the famous tree logo, with bronze entrance gates in the style of the boughs of the Mulberry tree, and window displays framed with branches. The store interior is designed to offer a modern and luxurious theme whose materials include a chocolate limestone floor oak, leather and amber glass, and changing rooms lined with suede.*

RIGHT *The Mulberry advertising campaign continued to use Anna Friel and her actor boyfriend David Thewlis to profile the new Mulberry look, commissioning the stylish photographer Henry Bond to take the images for the spring/summer 2002 campaign. The shoot was at the Italian harbour of Portofino, a fashionable British resort choice for the rich and famous since the 1930s.*

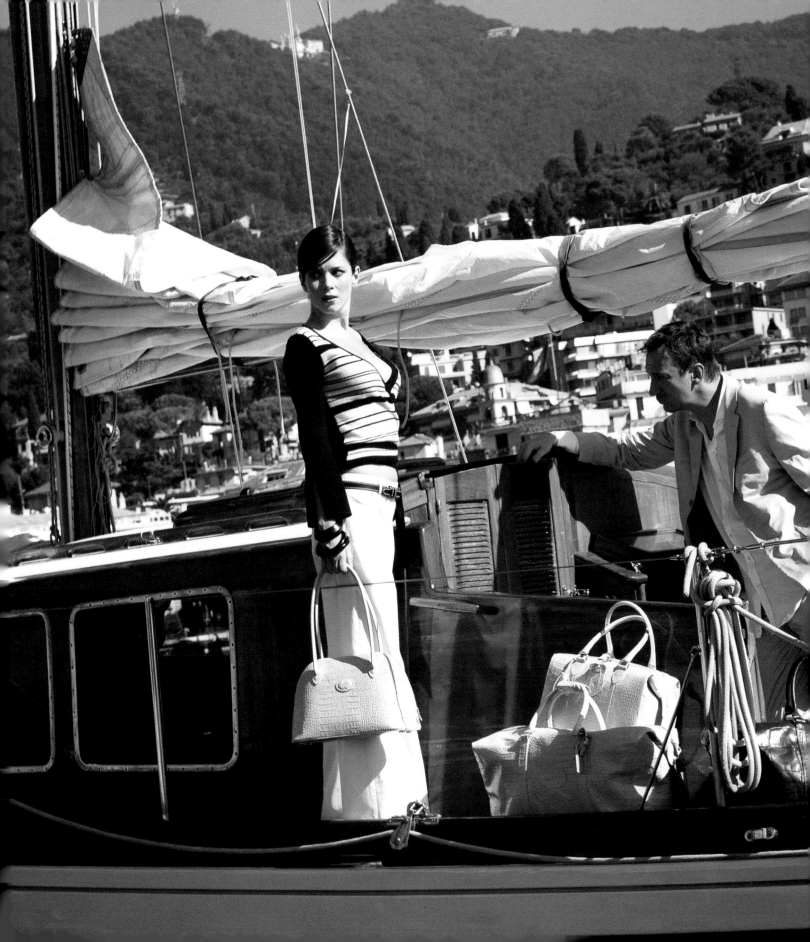

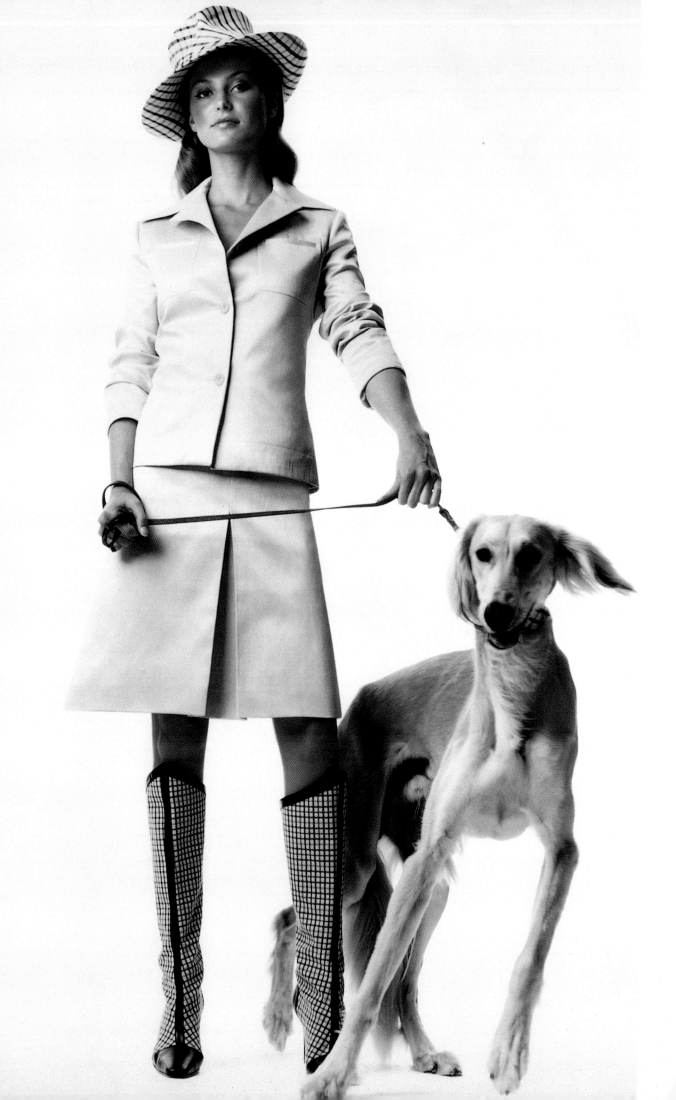

yoga mat with its own deerskin carry-case. As well as an extensive range of handbags (including the Islington, a claret-red ponyskin tote, the Livingstone in a reptile print, the Weave, a 1970s-style woven leather bag, and the Harness, in hide with raw finishes and top-stitching), Mulberry's range also incorporates matching bespoke items such as vanity, mini-disc, and digital camera cases. Mulberry accessories have come to represent more than any other British brand the desirable customer "must-have" object.

DAKS

While Burberry enjoys a Victorian heritage and Mulberry is a recent addition, DAKS reflects the modernist revolution of the early 20th century. Formerly owned by Simpson, the brand originated in 1894 when Simeon Simpson established a bespoke tailoring factory in Whitechapel to supply the men's retail trade. The business did well and a larger factory opened in 1917; in 1929 all the manufacturing was consolidated in new premises in North London. In 1948, manufacturing was relocated to Larkhall, near Glasgow. By the mid-1950s DAKS had become, and remained until recently, one of the UK's most important clothing manufacturers.

It was however Simeon's son Alexander who was to give the business a new modern profile for the 20th century. When Alec Simpson took over the company in 1932, he was determined to change the men's ready-to-wear business and offer an alternative to the constricting formality of the past. In 1934, he invented the self-supporting waistband for trousers, which freed the new 20th-century man from the old-style Victorian belt and braces. Innovative shirt design also offered another liberation from the formal dress of the past: shirts were made with collars attached in the factory and they buttoned all the way down – the days of the bib front and detached starched

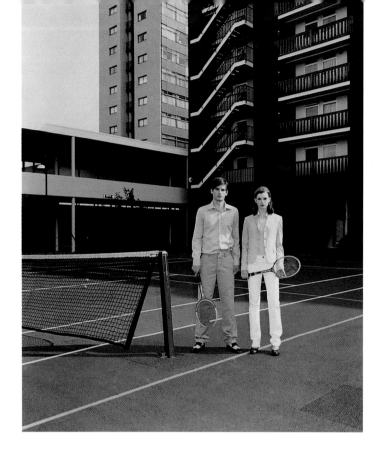

collars were over. Such innovations signalled a revolution in menswear, a move to more comfortable, casual and relaxed clothing, and to reflect this image Simpson registered these clothes under the new brand name of DAKS. The word itself reflected the 1930s fashion for merging words to create a new modern idiom, and the invention of the short and easy-to-remember "DAKS" combined "dad" and "slacks". To retail these new clothes Simpson wanted a London store in the same modern idiom, a state-of-the-art shop that would serve as an outlet for the whole range of clothing produced by his company. In 1935 the company bought a site in Piccadilly and commissioned the leading architect Joseph Emberton, a pioneer of Modern architecture in England, to design an International-style store for London. Completed in 1936, the shop remains one of the outstanding examples of the new architecture of the period, although it has now been converted into a bookshop and the DAKS brand relocated to Old Bond Street.

In 1991 DAKS was acquired by the Sankyo Seiko Group of Japan and a new team was put in place to develop the brand, which included Timothy Everest as creative director and Richard Ostell, formerly head of womenswear at Nicole Farhi and partner of Flyte Ostell, as head of design. Timothy Everest was a particularly interesting choice: he was in the process of building his own modern take on the British institution of tailoring, while DAKS was a British institution that needed modernizing. Everest concentrated on a new range for the company, called DAKS E1 (after the postcode of his own shop), which aims to retain a classic British feel but is directed at a younger market. For the main collection the focus is on developing classics such as the DAKS suit and sports jacket, and the approach is vintage quality and craft made modern through the use of new lighter-weight fabrics, cut, and technique.

Austin Reed

Now one of the largest British retailers, with more than 150 stores worldwide, 50 of which are located in Britain, Austin Reed celebrated its centenary in 2000. The original business started in 1900 when the ambitious young Austin Reed opened a men's tailoring shop in Fenchurch Street in the City of London. 11 years later he opened a much larger department store on Regent Street, which remains the company's flagship store. Reed offered the customer a new range of goods and services, including tailoring, but also a barber's shop, which is still in use today with its original features intact.

Austin Reed established a reputation both for the quality of its products and for its design and retail innovations. From 1925 it offered men the newly fashionable value-for-money ready-to-wear suits, but it also began to cater to the rising demand from women for more formal business suits, a demand that reached a peak in the 1980s, as more women than ever before entered professional careers. The 1980s saw the company launch a sister range, Country Casuals, to supply smart casual wear for women. Austin Reed also pioneered the modern concept of the retail outlet, in 1929 famously opening a small store on the prestigious Cunard transatlantic liner the *Aquitania*, which reflected its position as a premier brand name for menswear. In its heyday Austin Reed counted among its customers Hollywood stars famous for their English style such as Gary Cooper, Cary Grant, and Douglas Fairbanks.

Austin Reed's strategy for competing in the 21st-century fashion market does not follow the American-inspired model of a Burberry or a Mulberry company with their lavish programmes of store refits and deployment of high-profile designer ranges. Instead, Austin Reed has expanded

its market through the introduction of additional product categories, with the focus on men's and women's casualwear. These included in 1998 the Reed label for contemporary smart casual wear in a range of quality fabrics, such as wrinkle-free cotton yarns for shirts, moleskin, linen, and cashmere; in 2001 the Signature Collection, a luxury brand offering tailoring and accessories; and in 2002 Golf Reed, a collection of high-performance sports clothes and accessories. Austin Reed's strategy to rebrand its image is less high profile than that of its competitors, but its update on the classic British look has proved extremely successful in the foreign market.

Aquascutum

Another British company with a long history and new brand image is Aquascutum, which celebrated its 150th anniversary in 2001. Like Burberry, the company was founded in the 19th century and established a reputation for outdoor sporting clothes which continued into the next century. In 1953 Edmund Hillary and Tenzing Norgay reached the summit of Mount Everest wearing D711 fabric made by Aquascutum.

The company's founder was a gentlemen's tailor and entrepreneur named John Emary, who opened his first shop at 46 Regent Street; in1890 he moved to 100 Regent Street, which remains Aquascutum's flagship store. Emary registered a patent for shower-proofing wool fabric for outdoor coats, and to exploit the commercial opportunities of this technique he chose a new name for his company, Aquascutum, combining the Latin words for "water" and "shield". At first he concentrated on developing this waterproof fabric for military and workwear markets. From Aquascutum's waterproof fabric were made the trench coats that were worn by officers during the Crimean War (1853–6) and by soldiers of all ranks during both world wars.

Domestic and fashion applications of the fabric followed, promoted in the 19th century by royal fashion leader King Edward VII. Edward was Aquascutum's first royal client, ordering an Aquascutum cape coat in the Prince of Wales check. In 1897 Aquascutum was granted a royal warrant, the first in a series that would mark the British royal family's long patronage of the company. The Aquascutum trench coat as a fashion garment was introduced in 1918, and is still manufactured at the Northamptonshire factory that the company opened in 1908.

In 2001, as part of its anniversary celebrations, Aquascutum commissioned a major advertising campaign to launch its new collections, highlighting its house check designed in 1976 and now reworked in the colours of black, fawn, and saxe blue, and used both on clothes and on a range of handbags and travel accessories. Aquascutum also appointed two new designers: Ian Garlant to head menswear and Michael Hertz for womenswear. Garlant, who graduated from Kingston University in 1985, had previously worked for the English couture house of Hardy Amies and brought to Aquascutum those traditions of English tailoring and luxury couture. His new range offered the key classic elements of an overtly English eccentric look – grey flannel suits with large purple overchecks or houndstooth checks, Derby camel coats, herringbone ties, and leather driving gloves. For womenswear the inspiration was more modern: Hertz's brief was to update the company's somewhat dowdy image for women and offer a more European sense of sophistication

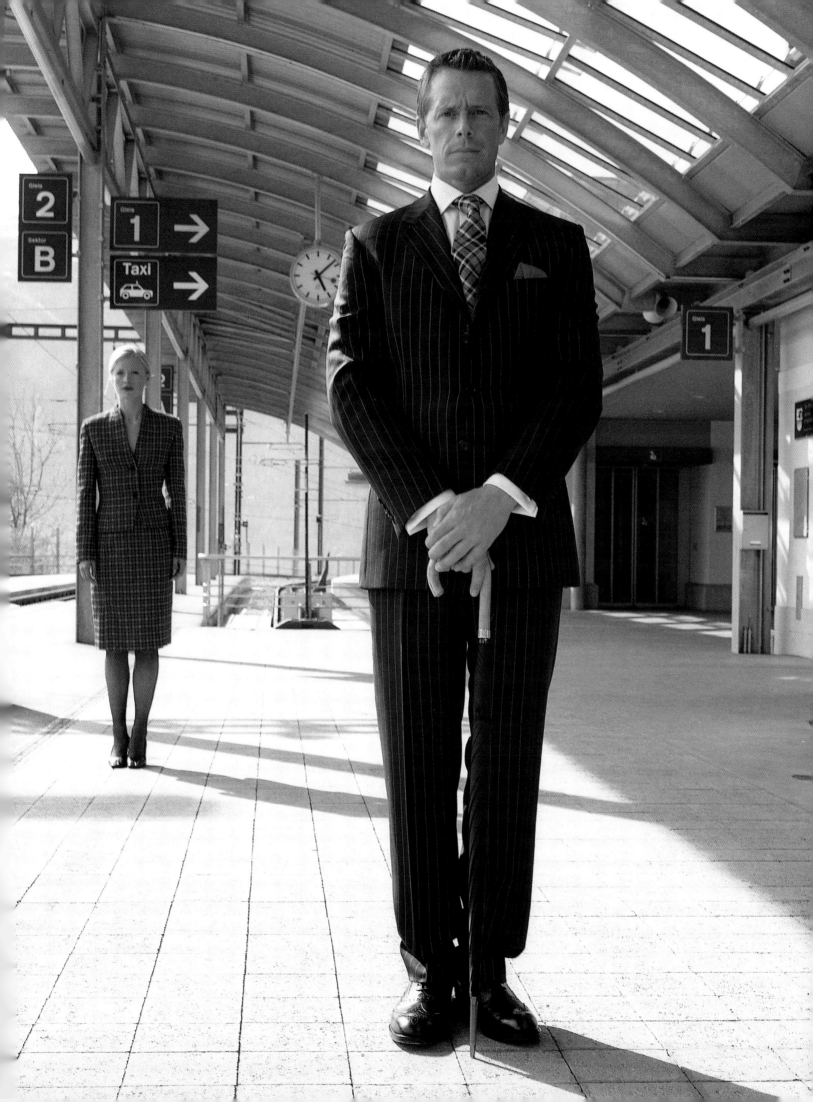

LEFT *A late 1930s advertisement for Aquascutum's world-famous storm coat. Trademarks were the raglan sleeves, deep storm collar, strap cuffs, yoke back, and inside leg straps for riding. The coat, with its distinctive check lining, has since been simplified and redesigned as a fashion classic.*

RIGHT *Aquascutum's spring/ summer 2001 campaign celebrated 150 years since the founding of Aquascutum, looking to the future and updating the classics. The aim of the new head of womenswear, Michael Herz, was to continue the Aquascutum tradition of quality while injecting new creativity.*

and style with a more international focus. A graduate of the Royal College of Art in 1991, Hertz had previously headed womenswear for French companies Daniel Hechter and Guy Laroche. His womenswear line looked to the Pop chic of 1960s London for a range of tube dresses, narrow trench coats, blouson jackets, stretch trousers, fluorescent prints, and tank dresses with drape detailing. The challenge for Aquascutum, as for all these companies, was to retain the company's existing customer base at the same time as appealing to a wider, more youthful market. Aquascutum has now to balance the traditions of its powerful brand image with the demands of a more international appeal.

Jaeger

Jaeger is another English company that has repositioned itself, moving away from its traditional image of sensible clothes bought by middle-class, older women to a younger image of fashion and stylishness. Its history dates back to the 19th century and reflects the British obsession with practical, comfortable outdoor clothing, in this case aimed at the women's market. Jaeger was also influenced by a 19th-century movement that held the view that clothes were not just about fashion but should be part of a rational, healthy lifestyle. Such clothes became a statement of social beliefs and attracted individuals who felt fashion to be a distraction from more important issues. Such motives inspired German-born Gustav Jaeger to invent a new open-weave fabric for under-

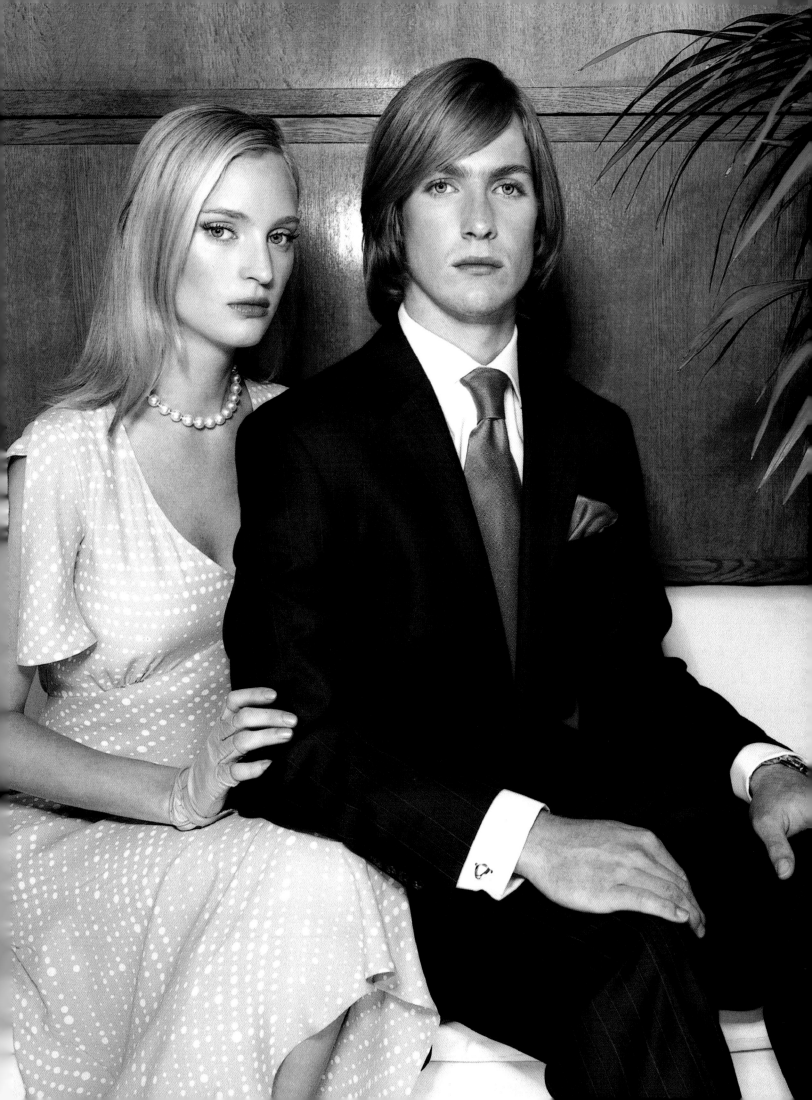

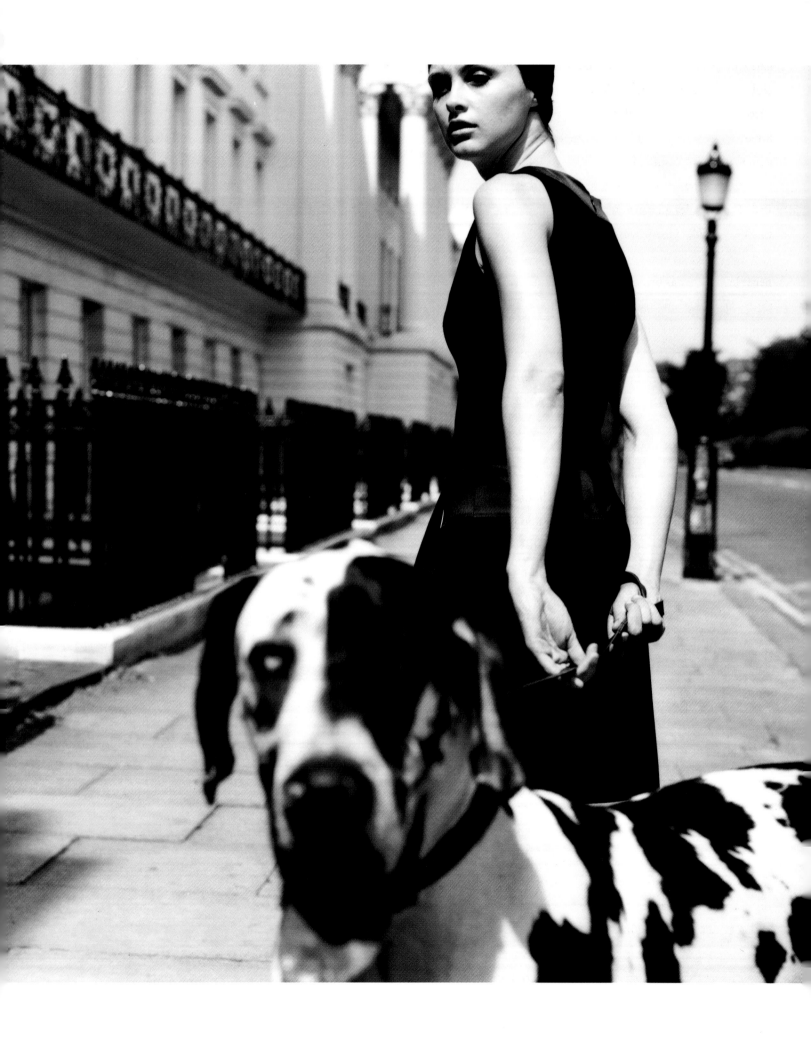

garments, which in his view was healthier and more comfortable. He went on to build a range of clothing along traditional British lines, under the name of Jaeger, which became a commercial success. By 1923 Jaeger had expanded into a national fashion chain with a flagship store in Regent Street. However, by the 1980s, although its reputation for quality was still intact, it was no longer seen as a leading fashion brand.

Jaeger was determined to revitalize itself, and in 2000 brand director Nigel Ling appointed Bella Freud as design consultant. Freud had worked for Vivienne Westwood in the late 1980s and, like Westwood, appreciates the traditions of classic English dress, although always giving them a sexy twist, such as using prim white collars and cuffs on an incredibly short minidress. Freud saw her role at Jaeger as bringing about a return to its original values – making things stylish, making things of quality, and using good colours and fabrics. Using this as a basis she could, for example, combine schoolgirl influences and traditional fabrics in miniskirts in enlarged hounds-tooth check. In an interview in 2001 Freud said that "Jaeger's about the bastions of Britishness: tweeds and knits and colours that come alive in bad weather". Knitwear is also a key feature of her collections for Jaeger, typically using brightly coloured sweaters in blue and pink with *trompe l'oeil* ties knitted in. Her sense of humour is often apparent. "Everyone says that the English are cold, but underneath there's all this kinky humour, and I wanted to make the collection like that – so the outside is proper and the inside is daring and tongue in cheek." Freud has neatly illustrated the change in attitude she is bringing to the house: when her first collection featured sweaters with "Jaeger" written across the front, she was told by the company that Jaeger did not put their logo across ladies' busts. Freud simply replied: "They do now."

Designers on the high street

The companies discussed above reflect one of the strongest international directions for British fashion in the 21st century. They represent the qualities of British tradition repositioned in the new market, and the future of a significant portion of the British fashion industry will depend on their success. However, there is another important facet to fashion retailing in Britain, and that is the new collaborations between major high-street retailers and contemporary designers. These designer–retailer lines offer British fashion on the high street a unique identity.

Britain has a history of making high fashion available to a wider market, from the Utility scheme of World War II to the boutique revolution of the 1960s. In the 1990s the experiment of designer–retailer became much more central. The benefits of such collaborations are obvious: the retailer gains from the kudos attached to designer names and the designer benefits financially, with the fees generated often supporting more experimental directions. The relationship between shop, designer, and customer is vital: the policy is easy to get wrong. Wallis, for example, successfully introduced a range designed by Rachel Robarts, capturing its market by using former supermodel Linda Evangelista in its campaign. Less successful, for the chain store BHS, was a range of suits designed by Owen Gaster: aimed at the wrong market, it simply did not sell. The high street is well aware that as in couture, as in the rest of the fashion world, not just any designer will do.

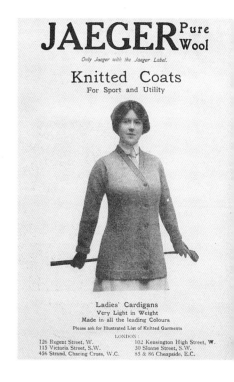

ABOVE *An advertisement for Jaeger dating from May 1912. In 1884 Dr Gustav Jaeger opened a clothing business near Moorgate in the City of London under the name Dr Jaeger's Sanitary Wool System; notable patrons included the playwright George Bernard Shaw. After 1902 the company commissioned an in-house designer, Charles Dawson, to work on modern store interiors in the Art Nouveau style and also to oversee publicity for the company.*

FAR LEFT *In the 1990s, to overcome the middle-aged and sensible image it had acquired, the company appointed Bella Freud to combine high-fashion styling with the Jaeger traditions of quality and tradition. The result of this repositioning is seen here in a satin trimmed dress from autumn/ winter 2001, photographed for a magazine advertisement campaign that placed the image in a London street context and with a British dog as the model's companion.*

RIGHT, CLOCKWISE FROM
TOP LEFT *Black opaque bead-
trim kaftan, spring/summer 2002,
by Maria Grachvogel for
Debenhams; striped shirt and
cream wide-leg trousers, spring/
summer 2002, by Gharani Strok
for Debenhams; silk-chiffon gypsy
skirt and ruched vest, spring/
summer 2002, by John Rocha for
Debenhams; white trouser suit,
spring/summer 2002, by Jasper
Conran for Debenhams.*

DEBENHAMS

Debenhams is one of Oxford Street's best-known department stores and a nationwide chain, with 95 stores and a mail-order website. The company played a leading role in using high-profile fashion ranges. In 1994 the store – then part of the Arcadia Group (see pp.103) – began to introduce specific designer lines, starting with Philip Treacy hats and Ben de Lisi evening wear. Now an independent company, Debenhams has pioneered an ambitious programme of new fashion called "Designers At Debenhams".

Much of the store's recent success can be attributed to the importance it has placed on bringing designer labels to the shop floor, commissioning the first major collection, "J" by Jasper Conran, in 1996. Since then Debenhams has introduced more than 50 designer brands in an on-going programme of bringing affordable designer fashion to the high street, a move that has transformed the fortunes of the shop, which not so long before had been struggling to attract customers. The philosophy behind the Designers at Debenhams project was to provide customers with the opportunity to buy from exclusive, labelled designer collections at high-street prices – a scheme by which, the hope is, everyone benefits.

Debenhams' initiative has provided the designers with a platform to reach a wider customer base and in some instances to design collections in areas that they have not explored before, including accessories by Lulu Guinness, Neisha Crosland, Orla Kiely, Stephen Jones, and Antoni & Alison. Evening wear in the Designers at Debenhams range has included lines by Pearce II Fionda, Gharani Strok, and Anthony Price, as well as Maria Grachvogel's "G" range. Daywear lines include Tristan Webber and Ally Cappellino, and "OZ" menswear by Ozwald Boateng. The John Rocha range called "ROCHA. JOHN ROCHA" spanned five major divisions: womenswear, menswear, childrenswear, home, and accessories. Designers at Debenhams now offers exclusive collections across womenswear, menswear, accessories, lingerie, and the home, as well as a line of children's clothing for girls by Elspeth Gibson called "Sweet Pea".

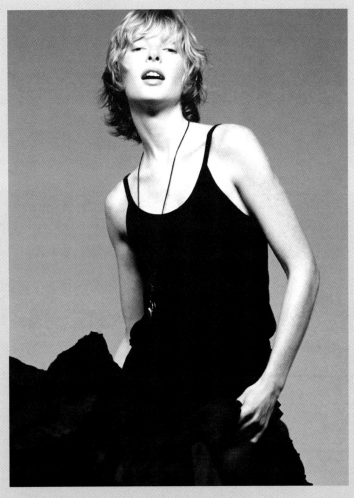

TOPSHOP

TopShop, famously located on Oxford Circus, is aimed at the younger consumer. In 1997 it made a substantial contribution to designer fashion with the launch of its "TS Design" programme. In 2001 it was named Fashion Retailer of the Year at the British Fashion Awards for its support of new designers including Hussein Chalayan, Sophia Kokosalaki, Clements Ribeiro, Tracey Boyd, Markus Lupfer, and Marcus Constable. The relationship between the designer and the high-street fashion retailer is criticized as being balanced in favour of the all-powerful retailer; however, such support is often vital to young designers. Markus Lupfer, for example, now designs a diffusion line for TopShop and this supports his more experimental studio. TopShop also supports new British fashion on a wider platform, funding the 2001 New Generation scheme, and sponsoring the autumn/winter 2002 catwalk shows of Blaak, Hamish Morrow, Michelle Lowe-Holder, Russell Sage, Sophia Kokosalaki, and Tata-Naka.

TS Design was launched with Markus Lupfer, Marcus Constable, and Clements Ribeiro, and is retailed within TS Boutique, created as a shop within a shop. TS Boutique also retails "Unique", TopShop's in-house design label, as well as one-off vintage and customized pieces, accessories, and shoes. New ranges were commissioned from Sophia Kokosalaki and Wale Adeyemi. Kokosalaki's collection focused on the recent 1980s revival, with draped jersey dresses and tops in the colours of flesh, chocolate, red, and black. Adeyemi, a graduate of the Kent Institute of Art and Design, is primarily known for his work with Puff Daddy, the Spice Girls, and the Brand New Heavies. His collection for TopShop remains firmly rooted in the London street scene with a fusion of graffiti-printed denim and jersey pieces, and cool leatherette cut-away miniskirts and dresses. For 2002 Luella Bartley's tassled leather bags and pink suede bomber jackets offer her vision of London chic to the high street.

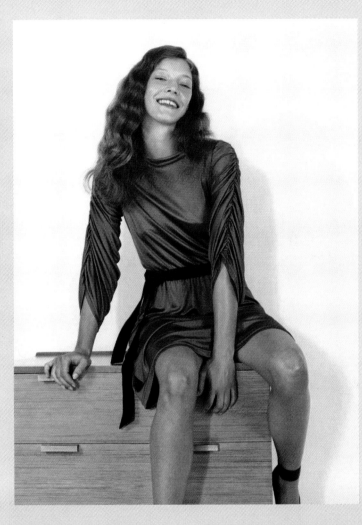

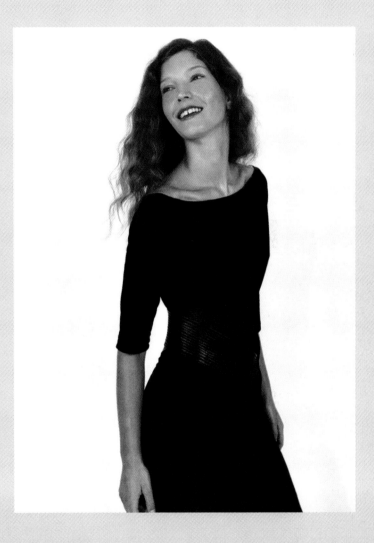

ABOVE, LEFT TO RIGHT
Sophia Kokosalaki for TopShop TS, spring/summer 2002. Sophia Kokosalaki has reworked her themes of Grecian drapery for this belted toga-style dress, with elaborately gathered sleeves, in olive green viscose.

Sophia Kokosalaki for TopShop TS, autumn/winter 2001. The simple black dress is detailed with another Kokosalaki hallmark of pleated and stitched leather detailing shown here in the double crossed belt which shapes and profiles the bodice and waist of the dress.

LEFT, CLOCKWISE FROM TOP
LEFT *Lurex sleeveless top by Betty
Jackson; Prince of Wales check suit
with navy floral wrap blouse by
Sonja Nuttall; long-sleeve lace-type
bow top by Sonja Nutall; Bordeaux
trilby by Philip Treacy, worn with
rose floral skirt and sleeveless
knitted jumper. All for Marks
& Spencer's Autograph range,
autumn/winter 2001.*

MARKS & SPENCER

The most controversial and high-profile example of a high-street retailer entering into partnership with British designers is perhaps Marks & Spencer. Marks and Sparks, as it is affectionately known, was long the brand leader on the high street for reasonably priced, well-made clothes, dominating the market for middle-class, middle-aged, middle Britain. By the 1990s, however, it was losing money, sales, and its reputation, unable to compete with the international newcomers to the market, including The Gap and the Spanish company Zara.

Marks & Spencer looked to specially commissioned designer ranges as a way forward, notably one called Autograph, under the supervision of a new creative director, former brand director for Warehouse Yasmin Yusuf. It was a return to the dependable democratic design that had underpinned the best of Marks & Spencer, but marketed at a customer with new aspirations. Yusuf began the Autograph range with a series of commissions from British designers including Hussein

Chalayan, Matthew Williamson, Katherine Hamnett, and Philip Treacy to introduce designer labels to the store, initially for womenswear. They offered the customer an opportunity to buy into designer fashions at a much lower price point but reflected a commitment to high quality and good fabrics.

Yet in the late 1990s the Marks & Spencer designer programme failed where others were succeeding. The reason was simple. Rather than highlighting the designer pieces with labels and signage in the stores, they made it virtually impossible to distinguish them from the normal range. The Autograph line was criticized as an uneasy mix of designer as consultant and designer as label. The company learned some hard lessons, and in 2002 turned the range into a success by profiling what the customer wants: the designer brand label.

Marks & Spencer has now commissioned an inspiring stable of British talent. For the Autograph collection its menswear range by Julien MacDonald offered crystal-printed

T-shirts with "Gorgeous" slogans and dress-silk shirts; Timothy Everest explored modern British tailoring with shirting in exaggerated checks, dogtooth and stripes, cord waistcoats, tailored jackets with stab-stitch detailing, and town coats with bound seams; Oliver Sweeney redesigned traditional British footwear producing contemporary pointed shoes, boots, and loafers.

The Autograph womenswear range balances the needs of the older, more traditional Marks & Spencer customer with the younger consumer. Betty Jackson has been a strong influence in the business for more than 20 years with her elegant feminine designs, bridging the gap between the smart and the casual. Tactile, interchangeable separates in simple silhouettes using jersey knits are the basis of her best-selling collections for the store. Sonja Nuttall, who graduated from Central St Martins in 1993, represents a younger generation and is known for her bold use of print and pattern and her innovative way with colour and fabrics. The emphasis of her collection for Autograph is on balance and proportion in the overall silhouette, using sharp masculine lines with feminine touches. Anthony Symonds is another success. He was nominated in 2001 for a New Generation Award at the British Fashion Awards, for details that make up deceptively simple garments that are exemplary in fit and finish. For his Autograph womenswear collection these details are seen in stab stitching, leather trim on collars, cuffs, and seams, and pinstripe shirts cut on the diagonal with puff sleeves and deep cuffs.

At the beginning of the 21st century collaborations between high-street retailers and designers have grown to represent an extremely important element of British fashion, opening up new British fashion design to both men and women consumers and offering an affordable match between design, price, and quality.

getting

dressed up

In the Western world, at the end of the 20th century, the themes of money and consumption once again came into sharp focus. Led by the United States, the 1990s saw a steep upturn in the international economy, which in America translated into a steady rise in the number of households with net worths of $5 million or more, and a growing demand for branded luxury fashion products. What also became apparent in the 1990s was a trend in spending patterns that began to reveal a strong desire in consumers for products, experiences, and services that allowed them to share (or to believe that they shared) in a new celebrity or upper-class lifestyle. And so was born the powerful cult of celebrity-led fashion, in which more consumers, with more money, wanted to buy into brands that reflected perceived values placed on how one uses wealth and lives one's life. In Britain, the sartorial extremes of Victoria Beckham, the Posh Spice member of the world-famous girl band, and her husband David Beckham, superstar footballer for Manchester United, more than any other individuals represented this trend, making them fashion's undisputed royal couple: what they wore and what they endorsed sold products.

Important in our understanding of the modern shaping of celebrity is the impact of the late Diana, Princess of Wales. She, and the intense media fascination that surrounded her, brought about fundamental changes in the way fashion was to market and present itself and which continue to influence British fashion. After Diana's death in 1997, there was no one who came close to her profile that showcased mainly, though not exclusively, British fashion on the covers of magazines and newspapers throughout the world. It was a gap that the media attempted to fill with the creation of celebrity style. English aristocrats such as Stella Tennant, Honor Fraser, and Lady Victoria Hervey; British actresses including Joely Richardson and Anna Friel; and "it girls" such as Tamara Beckwith, Caprice Bourret, and Tara Palmer-Tomkinson became media "personalities", styled by, and linked with, the world of fashion. For some critics it was too much. Fashion threatened to become, as Julie Burchill wrote, the "rapture of the dullard, the ecstasy of the castrated".

Like it or not, the new rules of media image presentation were to have wide-reaching effects and resulted in increased media attention in other spheres. Even the fashion choices of figures in political life were closely observed, including Cherie Booth, and indeed her husband, the British prime minister Tony Blair. If not previously out of bounds, such figures had only been of marginal interest; now the fashion image of almost anyone in the public eye was subject to intense scrutiny.

Diana as fashion icon

The life of Diana provides very interesting readings of British fashion history and trends, from the 1980s when her clothes reflected very separate directions from cutting-edge street style to the 1990s when the fashion mainstream began to move back towards the themes of dressing up, glamour and femininity that would emerge strongly in the 21st century.

When Lady Diana Spencer married the Prince of Wales in St Paul's Cathedral on 29 July 1981 it is estimated that more than a thousand million people across the world watched the wedding on television. Diana's dress was designed by the relatively unknown partnership of Elizabeth and David Emanuel, who combined historical references with traditional British fabrics

PAGE 113 *Dressing up is a constant theme in British fashion, expressed in very different ways in the last 20 years, from traditional eveningwear to the theatricality of street style. At the end of the 1990s, however, dressing up became more mainstream, more high street, and more international in its look.*

FAR RIGHT *David and Victoria Beckham arrive at Donatella Versace's party to launch the new Versace Jeans couture store on New Bond Street in London in 1999.*

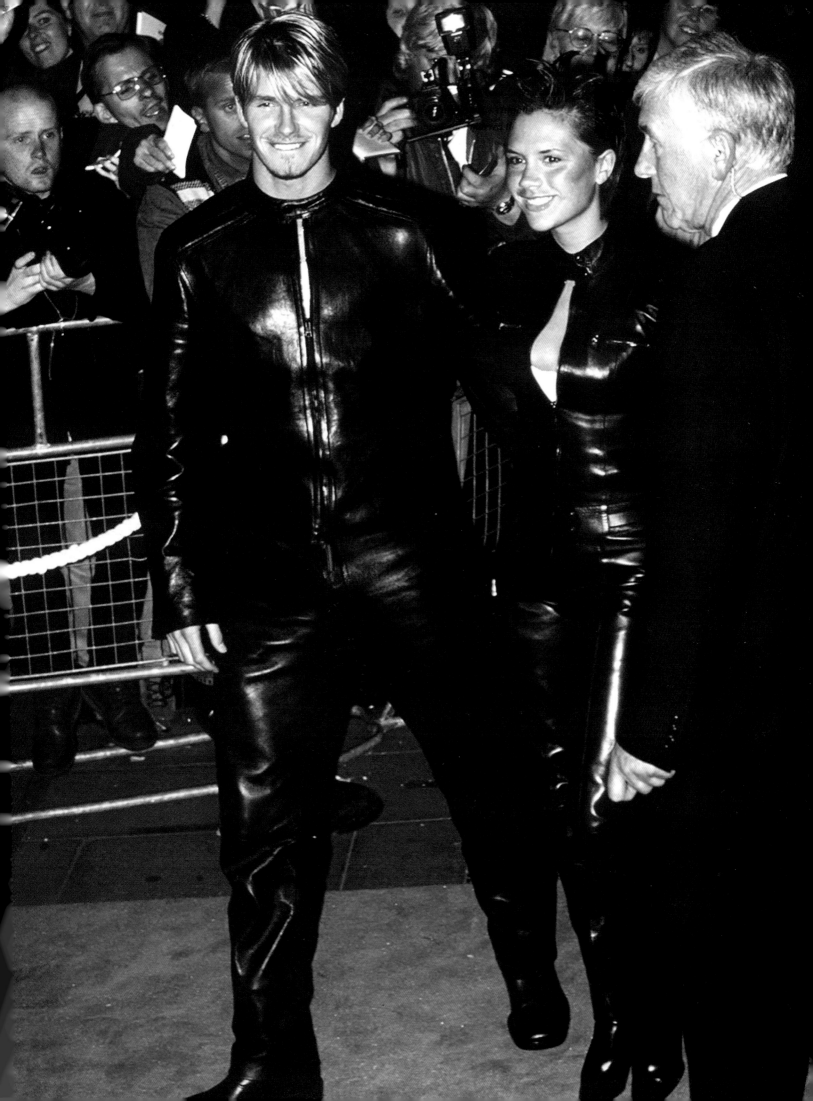

LEFT *Princess Diana at the Royal Gala performance of* Swan Lake *at London's Royal Albert Hall in June 1997 wearing a Jacques Azagury dress in silk georgette with hand-stitched bugle beads and shoulder bows. Her choice of dress, made by a British designer, reflects her move towards a more internationally glamorous and overtly sexy style. It was an image that provided a blueprint for celebrity dressing in the following years.*

RIGHT *Diana attends the 50th Anniversary of VJ (Victory in Japan) Day commemorations in London, August 1995, wearing a white wool suit with navy trim by Tomasz Starzewski and matching Philip Somerville hat. While the outfit reflects a more traditional style, for a formal royal occasion, Diana uses accessories – matching two-tone navy-and-white shoes with pearl earrings and necklace – to express her personal style.*

in a dress that was a romantic evocation of the Victorian era. The Emanuels were a personal choice; but Diana's hope that she might follow an individual style got no further than the revealing black taffeta ball gown they designed for her. The colour was felt to be inappropriate and the press published pictures of its plunge neckline, suggesting that it was a risqué choice.

As a member of the royal family her wardrobe requirements were fixed; outfits were needed for overseas trips, charity work, and the many functions and galas that required evening wear. Diana was steered towards a group of designers, Victor Edelstein, Murray Arbeid, and Gina Fratini, who essentially represented an unbroken line stretching back to the 19th century in British couture for the aristocracy, whose idea of fashion remained outside the mainstream but who kept alive the notion of glamour and luxury evening wear using sumptuous fabrics in dramatic colours and classic shapes from a prewar age. It was an image, continued by a younger generation such as Caroline Charles, Bruce Oldfield, and Arabella Pollen, for romantic evening wear whose conventions dated back at least 50 years.

Diana was also an important vehicle for formal daywear, for the official engagements and events such as Trooping the Colour, Royal Ascot, and the Chelsea Flower Show that required her to wear items of clothing such as matching hats, gloves, handbags and shoes, which had all but

disappeared from the modern woman's wardrobe. But Diana was to show how modern and stylish such accessories might become and to play a key role in returning them to the fashion agenda. She was to make dressing up a possibility for a new, younger, fashion-conscious generation. In this context her relationship with the French-born fashion designer Catherine Walker was particularly important. Walker's Chelsea Design Company, set up in 1976, had a reputation for elegant, easy-to-wear tailored clothes, and her signature coat-dresses provided the princess with lightweight and flexible clothes suitable for royal engagements. Walker collaborated with Britain's leading milliners, including Philip Somerville and Stephen Jones, who designed matching hats using distinctive picture and saucer brims trimmed with interesting details such as grosgrain bows and veiling. With Walker's help Diana helped to transform the potentially dowdy into something chic and contemporary, and at the same time encouraged the revival of hats, handbags, and heels.

In the 1990s, after her separation from Charles, Diana had the resources, the independence, and the experience to create a unique personal style. The effect was all in the details that became her hallmark: superb cut and materials worn with coordinated accessories, handbags, jewellery and shoes. She began to explore more cutting-edge designers, wearing in 1997 a Prince of Wales check trouser suit by John Galliano for Christian Dior, and several outfits from the young Ronit Zilkha including a bright orange bouclé suit with black velvet collar that she bought from the designer off the peg. Her look developed a more sophisticated and simple silhouette. Particularly important here was the Italian designer Gianni Versace, who dedicated his 1997 spring/summer collection to Diana, calling it *Conservative Chic*. Diana wore a white asymmetrical silk evening dress from the collection with silver and gold beading by the jewellers Swarovski. The July 1997 cover of *Vanity Fair* magazine, photographed by Mario Testino, became one of the defining fashion shoots of the late 20th century and a seminal image in the cult of celebrity fashion.

The impact of Diana's personal look, particularly the short skirt, was to have immediate repercussions on British fashion. In 1996 she appeared in figure-revealing clothes by Jacques Azagury. Azagury had moved to London from Casablanca in the early 1960s, graduating from St Martins School of Art in 1977, and was introduced to Diana by the fashion editor Anna Harvey. His clothes had an international feel, combining rich fabrics such as Chantilly lace with sleek, sensuous shapes, luxurious embroidery, and a flattering cut. For one of her last public engagements in 1997 Diana wore a short, revealing Azagury blue shift cocktail dress in silk georgette: an explicitly modern image that was to define a fashion look of the late 20th century.

The rise of celebrity fashion

After Diana's death the new fashion heroes were the self-made actors, pop stars, and sports personalities whose glamorous and opulent lifestyles were reported relentlessly by the media. The cult of celebrity fashion reached a peak in 2002 with the signing of footballer David Beckham to design a range of boys' clothing for Marks & Spencer. Victoria Beckham had agreed to endorse one of the most bizarre stories in the 21st-century world of dressing up, the Voyage fashion shop on London's Fulham Road. Voyage launched the "haut Bohemian chic" look of the 1990s, with its

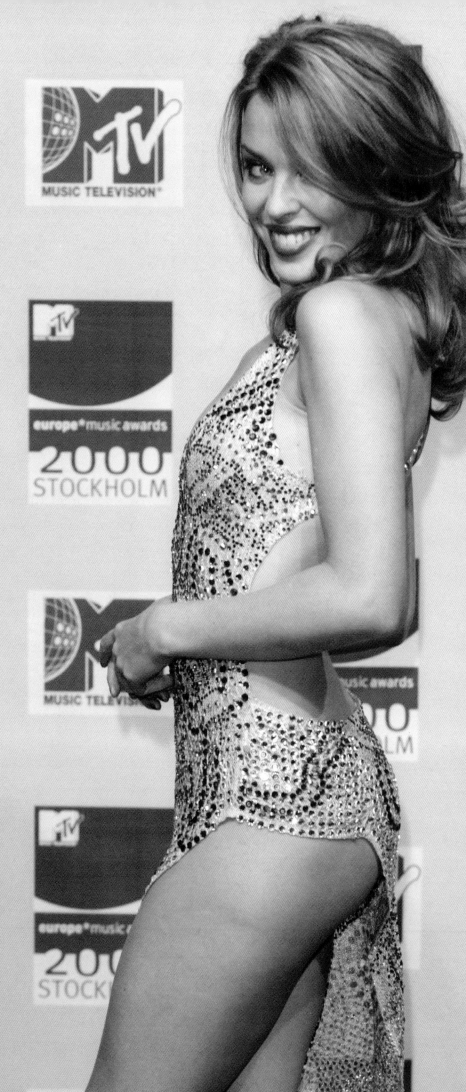

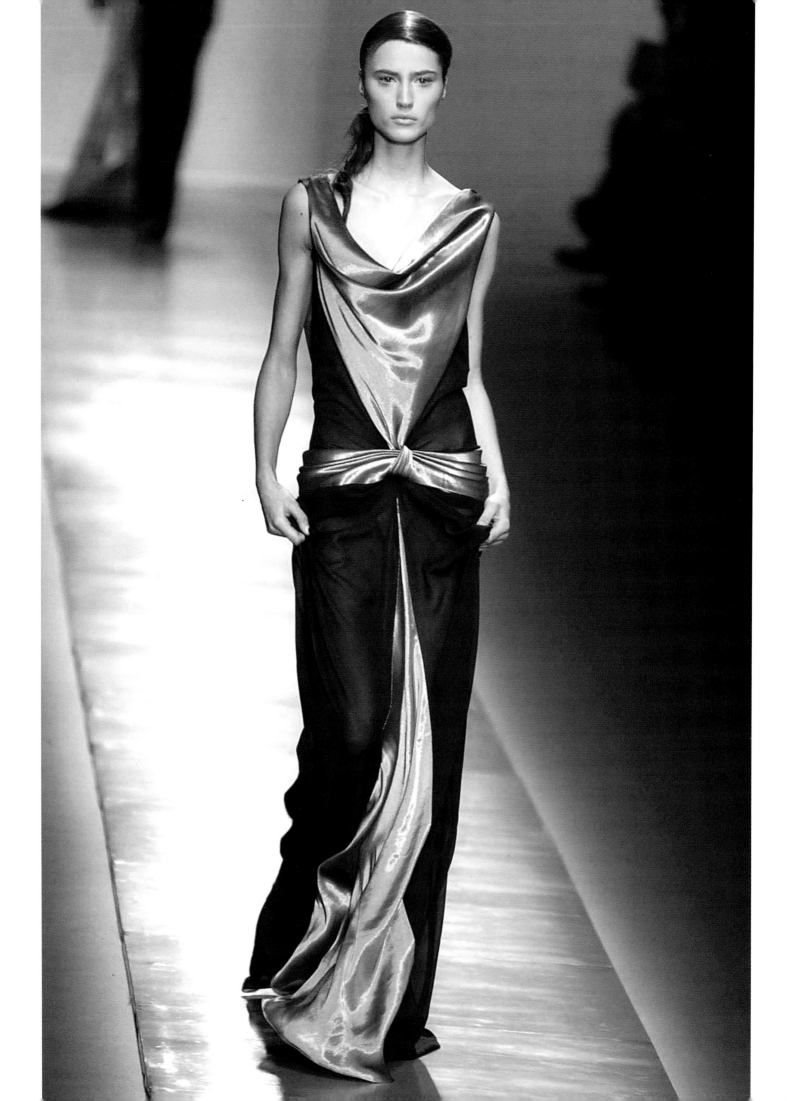

own label and expensive feminine clothes which offered an alternative to minimalist chic and updated an English taste for faded antique clothes. The brainchild of an Italian family, the Mazzillis, Voyage became a retail phenomenon: the shop was kept locked, and to gain entrance you had to belong to a membership club. Voyage became famous for turning away celebrities without a membership card; legend has it that this list included the Hollywood actress Julia Roberts and the doyenne of fashion journalists Suzy Menkes. When the company expanded its range into menswear and opened new retail outlets it overreached itself, and went into receivership in February 2002.

Voyage marked an extreme moment of exclusivity and fashion consumption which suggested that it was no longer talent, status, or achievement that mattered: it was fashion, the cult of the celebrity, and a special relationship with design that ensured publicity. The English actress and model Elizabeth Hurley had set the ball rolling at a film premiere in 1994 with a revealing Versace dress that stole all the headlines. Hurley was to be "famous for being famous", becoming better known than the products she promoted. Celebrity glamour had now become a fashion in itself and it was a lesson many designers quickly learned. No British designer was to develop that direction more successfully than Julien MacDonald.

Julien MacDonald

From a close working-class Welsh family in Merthyr Tydfil, MacDonald studied at Brighton University and then took the MA course at the Royal College of Art. It was there that he became known for a radical approach to knitwear, achieving delicate cobweb effects with shredded lace, tattered chiffon, and tulle. His work attracted the attention of the London fashion patron Isabella Blow, who championed his knitwear dresses, and the designer Karl Lagerfeld, who offered him work in his Paris studio. In 1997 MacDonald started his own collection and was quickly established as an outrageous showman, both with his catwalk collections, typically using superstar lookalikes, and with the placing of his outfits. His reputation in the UK was based on celebrities who appeared in his "barely there" outfits at London premieres. He targeted his clothes at the media arena, and his look took trashy and tacky to the limits, using soap-opera stars for his catwalk shows, and placing celebrities in clothes that revealed more and more of the body, flashed with diamonds and rhinestones. Inspired by the exuberance of Versace, the Julien MacDonald clothes worn by Kylie Minogue and ex-Spice Girl Geri Halliwell were provocative and sensational. For MacDonald it is simple: "I am about glamour … Women look best in high heels and sexy skirts." Two outfits express the limits of this style: the skimpy sparkling pink dress worn by model Kelly Brook to the film premiere of *Snatch*, and the micro gold fringe outfit worn by actress Joely Richardson to the film premiere of *Maybe Baby*, now in the collection of the Merthyr Tydfil Museum.

In 2001 Julien MacDonald was appointed as artistic director of the House of Givenchy Haute Couture, the third consecutive British designer to take over at Givenchy, after John Galliano and Alexander McQueen. It is a notoriously difficult job. Givenchy is one of the most prestigious of the French couture houses, owned by Bernard Arnault's conglomerate LVMH (Louis Vuitton Moët Hennessy). MacDonald had no experience of couture or its demanding requirements of cut

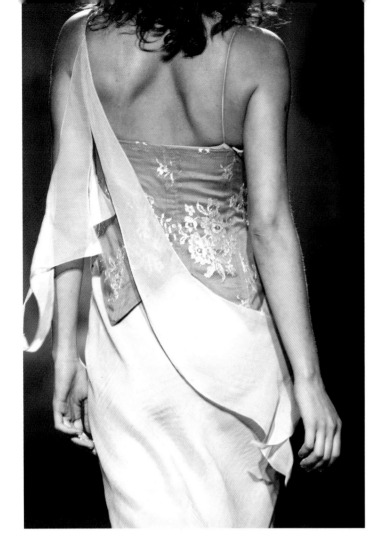

and construction – and in his new role he toned down his extremes of style. His collections for Givenchy are feminine but more sophisticated, his first couture collection revisiting Givenchy's classic archive for semi-sheer silk organza blouses with exaggerated sleeves worn with high-waisted, fishtail skirts. It was a more mainstream look that won MacDonald the contract to design uniforms for British Airways and a commission from high-street retailers Marks & Spencer for a series of collections for their designer Autograph range.

With his move to Givenchy MacDonald became an international designer. Glam frocks – such as luxury evening wear embellished with glass bead fringes, black lace, and crystal embroidery – remain his speciality, and he has continued to show his own line at London Fashion Week. In 2002 his own collection saw a return to ostentation including a snakeskin-edged jacket worn over a panther-print minidress.

Evening glamour

In British fashion, redefining femininity and glamour remains a theme for other designers, including Maria Grachvogel, Roland Mouret, and the Tata-Naka brand designed by Tamara and Natasha Surguladze. The Surguladze sisters, identical twins who grew up in the former Soviet republic of Georgia, customize antique fabric sourced in Russia to create expensive one-off evening wear.

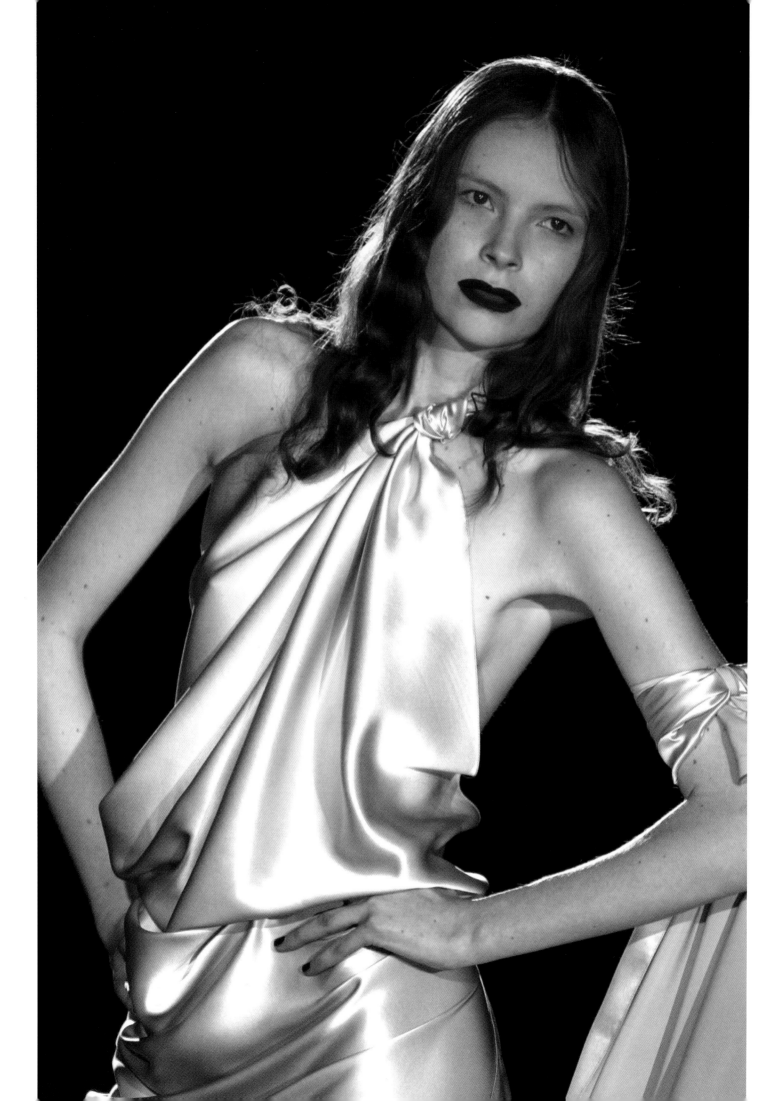

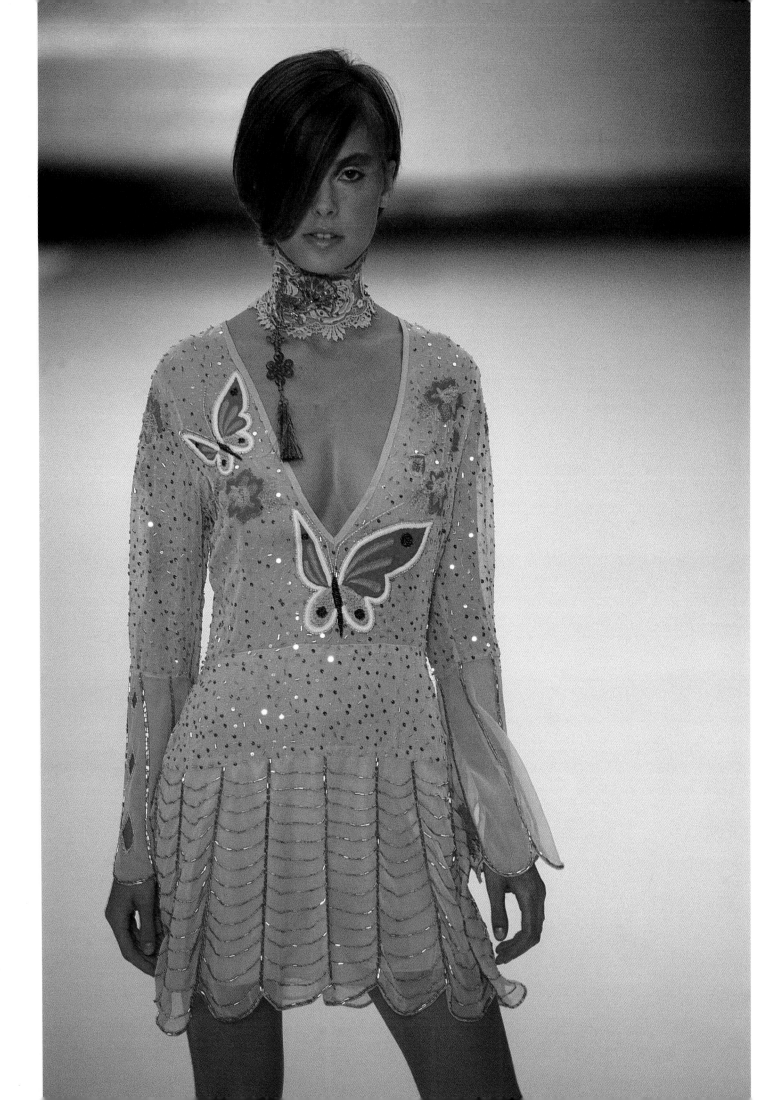

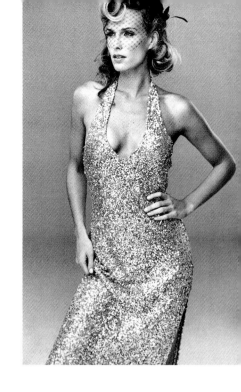

Maria Grachvogel (see p.122) is famous as the designer who in 2000 lured Posh Spice, Victoria Beckham, on to the catwalk wearing a tiny pair of olive satin hot pants. She also specialized in glamour gowns, including her signature 1930s-style bias-cut dress, high-cut to the thigh, with a revealing corset for the bodice. Grachvogel's work repositions Hollywood style, typically using fishtail gowns in satin, chiffon, and devoré velvet, which are often decorated with crystal beading, and white fur. As a fashion designer Grachvogel is self-taught, with no formal training. Born in 1969, of Irish–Polish extraction, she initially pursued a career as an investment broker in the City of London. This may have been an unusual beginning for a fashion designer, but Grachvogel's financial training helped her win a fashion industry Best Small Business award for her fashion house.

Roland Mouret (see p.123) is a French-born, British-based designer much admired for his fluid and sensual evening clothes, which are beautifully crafted in soft draped fabrics, often decorated with laser-cut appliqués and inlays; flower pins often hold the material together, or chiffon may be fastened with crystal. Mouret worked in Paris as a fashion model and stylist before launching his own label in 1998, presenting his début collection in 2000. Mouret designs simply draped chiffon and satin dresses, arranged directly on the mannequins rather than cut flat, which curve and shape to the body as if they were just about to slip off. The effect is edgy and glamorous combined with just a touch of the seedy and illicit.

Dresses for the modern girl

The theme of "dressing up" in British fashion includes a softer, less sexually aggressive focus on feminine dress with the work of British designers Stella McCartney and Phoebe Philo for the French house of Chloé, and in London the work of such designers as Matthew Williamson, Elspeth Gibson, Tanya Sarne, and Sophia Kokosalaki.

Matthew Williamson is the epitome of Notting Hill "boho chic" – the kind of look that combines an exquisite beaded shirt with a pink scarf bought on a discovery trip to Morocco. His style is a combination of urban and sexy traits, which led his clothes to be featured on the popular American sitcom *Sex and the City*. It is a style that is about looking incredibly hip without trying too hard. His approach is colourful: his 1997 *Electric Angels* collection introduced shocking pinks, tangerines, and yellows. Williamson represents a low-key kind of glamour that includes an element of fun, as seen in his pink spray-painted T-shirt with a pearl print pattern. He has made halter-dresses recut from vintage lace shawls and covered with fabric roses, layered baby-doll dresses fastened with bows across the cleavage, and best selling graffiti-print minidresses. The *Exotikarma* collection of 2000 showed fragile beaded bags, and, to set the mood, Williamson sent his invitations out complete with incense sticks. His *New-topia* collection of 2001 showed fairy-tale combinations of psychedelic butterfly-patterned cardigans and lace miniskirts. Williamson has projected his vision of girlish cool via muses such as Jade Jagger and more recently Kelis, the flamboyant young British R&B star, who herself has built on Williamson's style by mixing old and new: vintage pieces with sportswear, and cashmere sweaters with glamour dresses.

Elspeth Gibson (see p.125) has earned a reputation for dressing the "modern woman", and has pioneered cashmere and beaded separates and her signature strappy, chiffon dresses with frills and ribbons, broderie anglaise, and lacy inserts. Born in 1963, Gibson trained as a fashion designer at Nottingham and Mansfield College of Art and Design and worked for ten years as an assistant designer with Zandra Rhodes. In 1995 she launched her own label and became adept at designing clothes that are feminine rather than suggestive; whose silhouette is simple and the fabric luxurious, including silk, satin and embroidered georgette, often with delicate beading in pale pinks and silvers. Gibson's use of traditional fabrics is given a sense of individual style by the introduction of quirky touches, including uneven hems, unusual fabric combinations, and interesting detailings, further developed in her Gibson Girl range of casual pieces to work alongside the main collection. In 2002 her autumn capsule collection, inspired by the Tolkien saga *The Lord of the Rings,* was an installation using real models as nymphs and fairies dressed in her current theme of delicate silk tulle in the window of the famous London boutique, Browns.

The French fashion house Chloé is synonymous with the "girly", feminine tastes of a generation of women who sought a new image and style to reflect their sexuality, independence, and attitudes. The Chloé approach to dressing up blurs the distinction between day and evening wear and its trademark piece became the lace-trimmed silk camisole. Founded in 1952 by two French designers, Jacques Lenoir and Gaby Aghion, the House of Chloé offered women an alternative style of dressing in a postwar period dominated by tightly tailored silhouettes and tight corsets. The Chloé vision, looking towards softer and more fluid dresses, still predominates today, and was brought into the fashion mainstream in the 1960s when Karl Lagerfeld was appointed chief designer. It was Lagerfeld's floating, fluid shapes, in printed floral chiffon and silks, that helped create the bohemian look of the 1970s that continues to inspire the label, including Lagerfeld's own work from 1992 to 1997 when he once again led Chloé's design department.

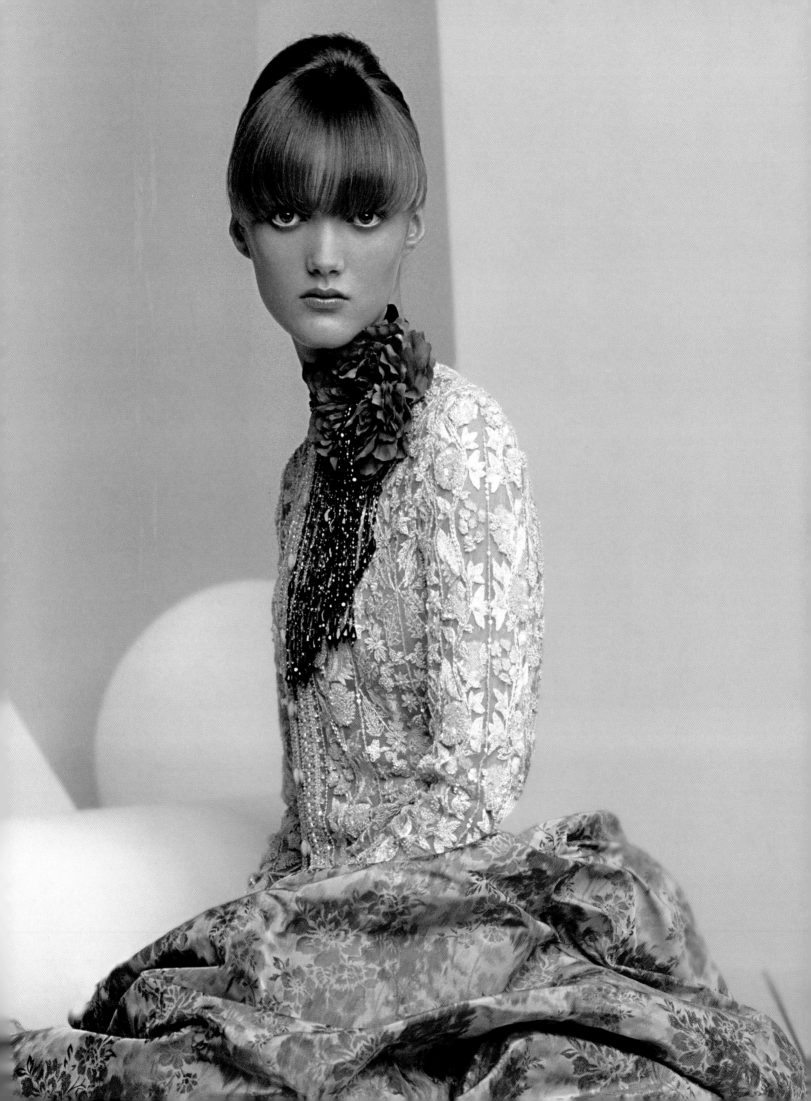

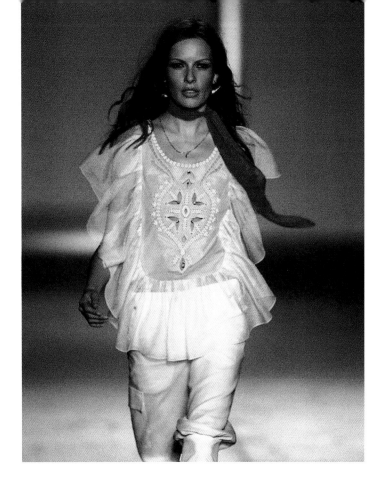

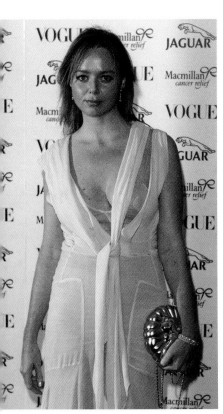

Chloé now belongs to the Swiss-based Richemont Group, one of the largest international luxury groups in the world, whose brands also include Cartier, Montblanc, Jaeger, and Alfred Dunhill. With Lagerfeld's retirement in 1997 the Richemont Group set about placing the brand as modern and contemporary with the appointment of two young British designers, first and most famously Stella McCartney, and then Phoebe Philo, both of whom trained at Central St Martins in London. Stella McCartney, then only 26, offered a way of combining Chloé's tradition of Parisian craftsmanship and quality with a distinctive London sense of style. For a new generation of customers, McCartney represented not only her own fashion vision but also a highly desirable lifestyle. She became the brand's greatest publicist, famously wearing her own clothes at fashionable parties and openings, her photograph appearing in magazines all over the world. McCartney developed the classic Chloé pieces – revealing blouses, lacy camisole tops, silk slip-dresses – and combined these with London-inspired tailored jackets and suits, low-slung tight-fitting flared trousers, and high-heeled shoes that reflected the aspirations and taste of her own generation.

In 2001 Stella McCartney left Chloé to establish her own label, and was replaced as creative director by Phoebe Philo, formerly her assistant. Born in Paris in 1973, Philo was given the specific challenge of expanding the label into swimwear and accessories together with developing a less expensive line named See by Chloé. For her spring/summer collection 2002, Philo built on the Chloé look with themes inspired by 1970s' playboy extravagance, drawing on influences from the narrow-shouldered jackets designed for Bianca Jagger by tailor Tommy Nutter to the hippy chic of St Tropez and Brigitte Bardot. The end result was tailored pants with beaded tops and leather boots combined with exotic North African-inspired accessories.

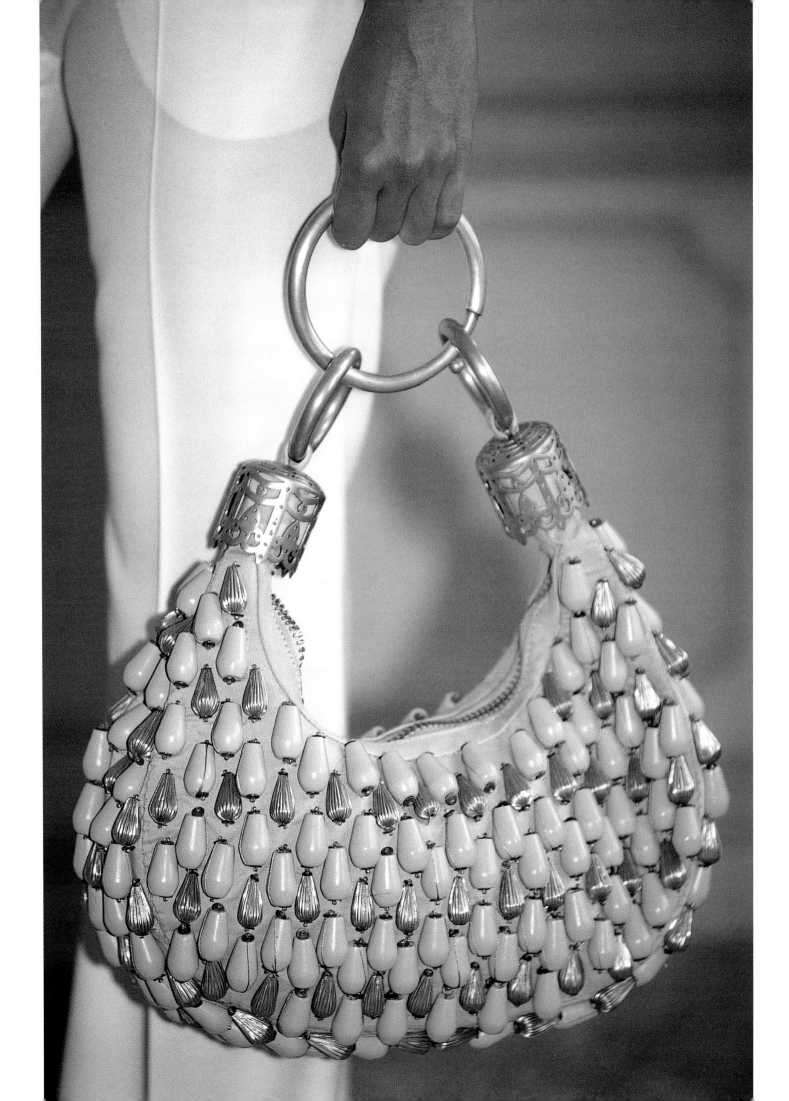

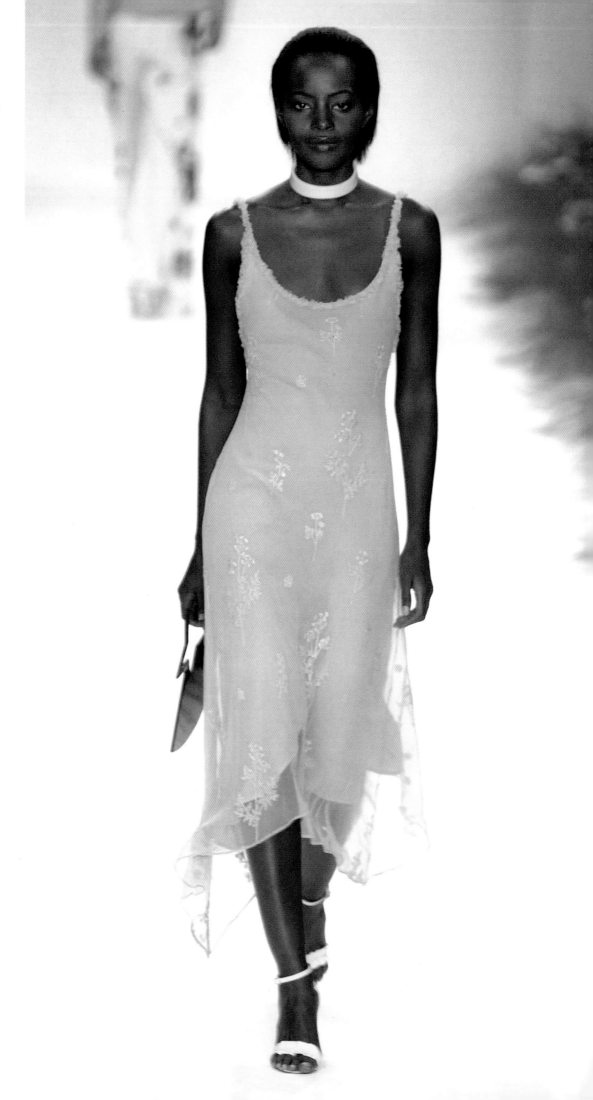

RIGHT *This layered Ghost dress from spring/summer 2002 shows the commercial appeal of the label's clothes. This simple and easy-to-wear shape is designed to flatter all figures. The beaded chiffon outer layer enhances the Ghost signature hemline.*

RIGHT *Ghost, autumn/winter 2001. Typical of Ghost is the double layer, here in black chiffon with applied embroidered flowers, which are also reflected in the floral detail of the bodice.*

Feminine frocks in lightweight fabrics were developed at Ghost by Tanya Sarne. Sarne, born in 1945, had no formal training as a designer, reading History and Psychology at Sussex University in the late 1960s. In the spirit of hippy culture her first venture into fashion was a shop importing Peruvian alpaca knitwear. Sarne launched her own range, Ghost, in 1984 – the name inspired by a remark from a friend who commented that she only had a ghost of a chance of success in such a competitive market. Her signature design is a soft dress made in textured uncrushable fabric, a type of viscose that can be shrunk and dyed to create the consistency of vintage crepe. This fabric forms the basis of an interchangeable wardrobe of crease-resistant, washable garments from jackets to skirts. Her fluid viscose dresses are cut to skim rather than cling to the body and often draw their inspiration from vintage fashion, which appeals to a wide age group. Now designed by Amy Roberts, the Ghost collection includes denim corsets and chiffon playsuits alongside the vintage-look viscose, satins and velvets. Ghost has become a rare example of a British independent label that has attracted international success, most notably in America.

From a much younger generation comes Sophia Kokosalaki who studied fashion design at Central St Martins, graduating in 1998. Her native country is Greece and the clear inspiration behind her clothes is Grecian drapery, which she reinterprets as modern femininity. Significantly she chose the aesthetic of the loose garment as a conscious move away from the tight, body-conscious profile. Her approach to fashion is best known for her gently draped dresses using silk jersey. Kokosalaki's spring collection of 2001 was a show that was feminine, romantic, supple, and strong, showing Grecian dresses in white jersey and leather. It was a collection that referred to the past but was contemporary, for example in the way the fluid light jersey was interwoven with leather constructions to help the silhouette emerge. Along with the silk jersey Grecian drape, Kokosalaki also brought baggy boots and batwing sleeves into fashion. Kokosalaki avoids new-technology fabrics and works only with natural fabrics such as silk, jersey, and cotton. She also

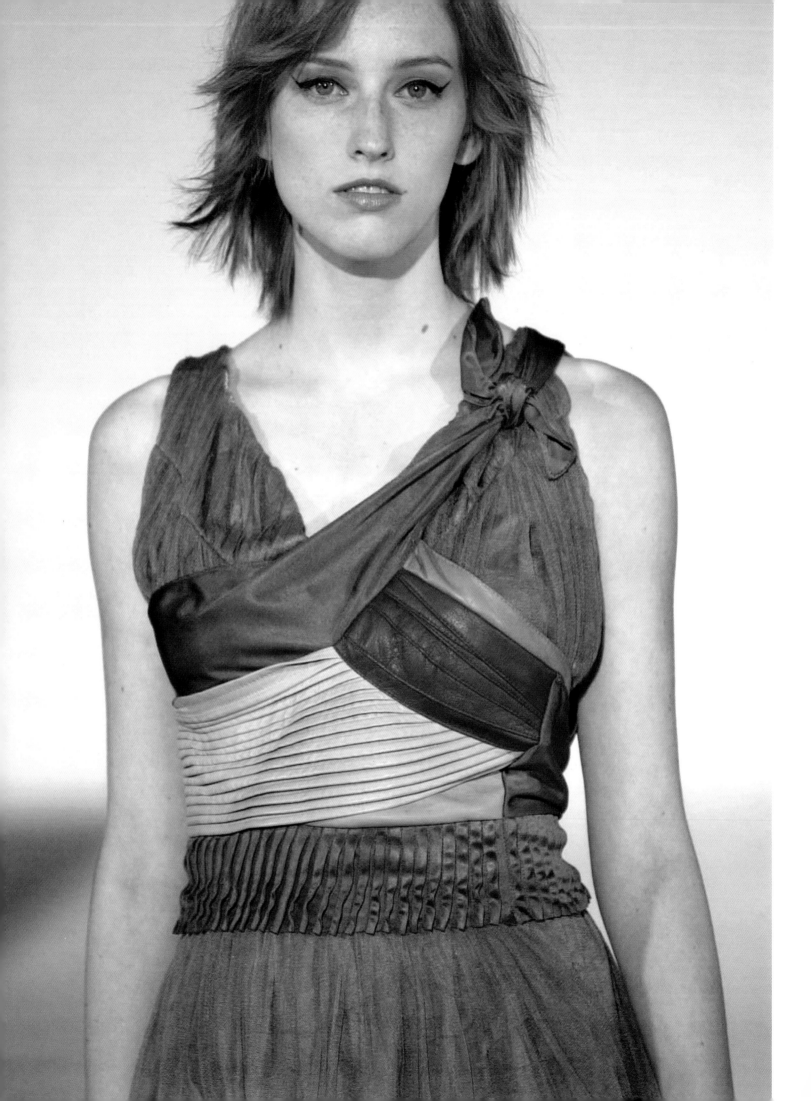

works extensively in leather. As a graduate she was offered a place as a resident young designer with the Italian leather clothing manufacturer Ruffo Research which was a significant experience for Kokosalaki as it gave her the expertise that would later allow her to introduce leather constructions into her garments, such as her 2001 Julian dress in tulle with a complex leather harness top. Her Greek heritage is also expressed in the way her work uses handwork and crafts. Her use of lace crochet and macramé, seen in her signature piece of 2001 using a keyhole neckline and hand-worked macramé in black, develops a Greek tradition of threading and handwork. Kokosalaki's talent is for assured and sophisticated detailing using tucks, gathers, and pleats in languid, muted colours, achieving a balance between the delicate and the tough.

Accessories

The notion of dressing up centres around another important aspect of British fashion talent: accessory design. The strength of that British talent lies in hats, bags, and shoes. Many of the new British "rebrands" such as Burberry and Mulberry are famous as much for their accessories as for their clothing. In the UK, designer fashion companies are disproportionately oriented to womenswear as opposed to menswear, in roughly a 70:30 balance; in Italy, France, and the United States that balance is more even, while a greater proportion of company turnover is in licensed products such as perfume and accessories. Financially successful models that lead this field are Italy's Gucci empire and the French LVMH Fashion Group which includes Louis Vuitton, Givenchy, Christian Lacroix, and StefanoBi. Britain's attempt to establish a rival luxury goods conglomerate is still in the early stages with the establishment of the Luxury Brands Group, whose first collection is a mens and womenswear line of ready-to-wear designed by the Hardy Amies couture house.

Accessories have become more and more important to the fashion industry and it is a fact that more people can buy into the accessories of a brand than can buy into the clothing. Access is the important theme in current millennium fashion alongside the new fusion between two previously separate worlds, those of fashion and craft. These days hat designer Philip Treacy, shoe designers Jimmy Choo and Patrick Cox, bag designers Lulu Guinness and Orla Kiely have profiles to match their peers in British fashion – a situation that was not a reality ten years ago. These designers suggested a new development in British fashion: that a hat designer like Treacy or a shoe designer like Cox might become as influential as a dress designer, if not more so. Accessories are no longer the sideshow: they have come to occupy centre stage. This new wave of talented accessory designers focuses on different areas and markets.

Shoe design

Shoe design is an area of longstanding traditional British craft skills. British shoe design is usually associated with men's bespoke shoemaking from companies such as John Lobb and Church's, producing shoes that are traditional, durable, and well made. Since the 1990s, however, British shoe design, like British fashion, has diversified. Two designers, Jimmy Choo and Manolo Blahnik, lead the way with their development of the sexy glamour shoe.

Jimmy Choo is the master of the highest and most delicate stiletto and mule heels, and he is also one of only a handful of British fashion names, including Burberry and Paul Smith, that have successfully gone global. When Choo sold his ready-to-wear business to Tamara Mellon, the former *Vogue* accessories editor, the business deal formally ended the connection of Jimmy Choo with the line he founded, and the range is now designed by Sandra Choi. However, Choo will continue to design and hand-make his couture range from his Connaught Street studio in central London. His 2002 range explored ancient Chinese ideas about the healing properties of crystals, incorporating stones into shoes for individual needs, a blue crystal, for example, into the shoes of those seeking calm.

Manolo Blahnik is the founding father of British hand-crafted women's shoes that appeal to the high-fashion international market. Born of a Czech father and a Spanish mother in the Canary Islands, Blahnik established his business in 1971 in Chelsea. He quickly became celebrated for his high-heel shoes. Blahnik's high, delicate heels offered an alternative to the flatter, heavier look of the 1980s. His designs used narrow ankle straps, wet-look leather, and elaborate cutouts in bright colours such as fuchsia, emerald, and tangerine. Blahnik's designs are blatantly about sex and a certain kind of fantasy and theatricality. Asked what will happen to his brand when he retires, Blahnik is matter-of-fact: "They're just shoes. I'll make as many as I can, and when I die I suspect the world will survive."

British shoe design has seen a revival of young independent makers since the 1980s, including Emma Hope. Her early designs for shoes focused on simple flat shapes, typically the

LEFT *A selection of Emma Hope boots from her* Ballet Russe *autumn/winter 2001 range, made with tarnished gold and silver thread on silk velvet with cut chenille jewel-like flowers. The range also included matching mules and handbags.*

RIGHT *Natasha is the style name for this high-heeled mule made by Gina Shoes, and Blue Britannia is the colourway; traditional gingham fabric is used to evoke the summer.*

embroidered satin mules and beaded designs that Hope describes as "regalia for feet". In the late 1990s she developed a more eclectic range including fine strapped sandals with tiny diamanté buckles, knee-length paisley-patterned Jimi Hendrix boots, and hand-painted Persian mules, as well as pretty panne velvet slippers made in collaboration with Paul Smith. Hope's sculptural designs with their elongated lines perfectly complement his work and together they have created a range of edgy shoes.

Gina Shoes, named after the glamorous 1950s' Italian movie star Gina Lollobrigida, have always aspired to making quality sculptured shoes that could compete with a more sophisticated Continental look. Established in 1954, Gina is a London-based shoe company owned by the brothers Attila, Aydin and Altan Kurdash, who are involved in the design as well as in the manufacturing of the footwear. Both shoes and handbags are made at the company's East End factory, with the lasts and the heels still crafted by hand. Each Gina shoe is reliant on the cut and quality of the material used in the manufacturing process, which, unusually, allows as many as 20 stitches per inch (eight stitches per cm) to maintain Gina's reputation for outstanding quality.

Within this group of independent shoe makers is a designer who has stepped out of the confines of accessory design into the wider arena of fashion: Patrick Cox, who has established himself as an international designer and now sets, rather than follows, trends. Born in Canada in 1963, Cox arrived in London in 1983 to study footwear design at Cordwainers College, one of the few technical colleges that taught, and still teaches, traditional English shoemaking techniques. In the 1980s the industry was still divided on gender lines, but in 1984, while still at college, Cox designed the shoes for Vivienne Westwood's *Clint Eastwood* collection, for which he introduced the platform sole. On graduating later that year, he set up his own business and began to sell

wholesale to shops. In 1986 Cox unveiled his first collection, to critical acclaim, and in 1991 he opened his first London shop. Cox began to customize the traditional shoe, for example stripping back Dr Marten's boots to reveal the steel cap, or raising the heel and extending the laces of a suede desert boot. His original contributions to the collections of John Galliano, Katharine Hamnett, John Rocha, and New Yorker Anna Sui, also earned him a high profile in the fashion press.

What established Patrick Cox shoes as the footwear for a generation of young Britons was his 1995 Wannabe range. He took the name for his unisex loafer from the legion of Madonna fans who aspired to that image and style – her "wannabes". As with so much of his work, Cox subverted a classic – the loafer – using a tubular moccasin construction in which the leather wrapped under the foot forming a seamless base. The style of the construction allowed great flexibility in the details, which Cox exploited to design a high-cut shoe with an extended tongue and broad toe shape. London's Victoria and Albert Museum later exhibited a pair of his Eiffel Tower jelly sandals which revitalized the classic cheap plastic "jelly" beach shoe. In 1994 and 1995 the British Fashion Awards recognised Cox's achievments by naming him Accessory Designer of the Year.

Handbags: modern classics and British quirkiness

Based in London's Notting Hill district, Bill Amberg is an independent accessories designer whose famous contribution to the cult of the must-have luxury accessory was a sheepskin baby papoose bought by the Beckhams for their baby, Brooklyn, in 1998. Amberg represents classic British craft expertise with a new feel, having learnt his trade in the 1970s and 1980s working in the European leather industry. In 1983 he returned to England and started making leather bags, selling these at Liberty's, then at Paul Smith and Joseph. He also designed accessories for high-profile international fashion designers, including Donna Karan and Romeo Gigli. Amberg specializes in the look and styling of a particular English bag, a look that expresses solidity, durability, and sound workmanship. His approach looks back to the Edwardian tradition of British leather goods as expressed by Aspreys in around 1900 and reinvented in the 1990s by Hermes with the iconic Kelly

handbag, reflecting the techniques of the English saddle tradition. Amberg reclaimed and updated that tradition, using British leathers and materials and a long-thread stitch associated with saddlery. The leather edges of his bags are cut rather than turned to exaggerate their feeling of solidity and strength. Amberg's approach is not to produce fashion bags that reflect new collections and seasons but to offer new classics. Two best-selling designs, Rocket, a men's briefcase, and Labyrinth, a women's handbag, express these ambitions for a modern classic.

The handbag is one of the most intimate and personal of accessories. For a generation of women born in the postwar years, accessories did not reflect their aspirations to a new freedom and the handbag was fixed as the mark of middle age, almost a formal badge of office, as worn by the Queen or Prime Minister Margaret Thatcher. From the 1960s, accessories gradually fell out of fashion. Bags and gloves, previously hallmarks of the smartly dressed woman, were seen as a hindrance to their new independence. Womenswear became more casual and, while the bag remained a functional essential, it became more low-key. The popular handbag of the 1990s was epitomized by the simple black shoulder bag. With the return of the accessory over the last decade, the designer handbag in particular has seen a rise in popularity. Leading design companies such as Prada, Gucci, and Fendi hyped the return of the bag, but a specifically British look was achieved by three British designers, Lulu Guinness, Anya Hindmarch, and Orla Kiely. These designers have targeted a niche, making eccentric, covetable, very British designs aimed at a specific taste and sensibility rather than the international consumer.

For more than ten years Lulu Guinness has pioneered the fashion revival of the handbag and, specifically, of the tiny evening bag carried as a personal style of jewellery. Her signature designs are floral handbags – satin buckets of roses and violets such as the Picnic Rose Basket, the Floral, and the Violet Hanging Basket, which is now in the collection of the Victoria and Albert Museum. Guinness had a background in fashion modelling but no formal training, when in 1989

LEFT AND RIGHT *Lulu Guinness Poodle clutch with detachable strap handle, and Lulu Guinness Drip With Jewels decorated bag, both from the autumn/winter 2001 range. Lulu Guinness is heavily influenced by a certain kind of 1950s' glamour and style, reflected in these two bags with the use of poodle prints and stylized period graphics. The style is reminiscent of early 1950s' Vogue-style fashion illustrations, and is decorated with Guinness's familar use of text and silver ric-rac decoration.*

PAGES 142–3 *These Anya Hindmarch bags from 1998 exploit the graphic use of black-and-white period photographs in a style that owes a debt to new artists from the 1980s such as Cindy Sherman .*

she started a small business selling handbags from her house. At the time few individual designers focused on bags but for Guinness they offered an outlet for her passion for dressing up. Famed for her personal style, she favours a look that combines the contemporary with the retro glamour of vintage clothes from the late 1940s and 1950s. Her influences include the kitsch flamboyance of Texan handbag designer Enid Collins and the work of Elsa Schiaparelli and Diana Vreeland. Guinness plays with kitsch, reworking, for example, the Surrealist lip motif into a red silk satin lip handbag with Swarovski crystal accents. Her red cotton canvas handbag with a poodle print is based on an antique German toy used as a prop in her first shop. "A small miracle happens when you put a dog, or any kind of animal, on a bag or a dress," she says, "people have to have it." Another influence is the visual tricks and architectural devices of the Italian postwar designer Piero Fornasetti, which have inspired bags such as the House as well as Guinness's distinctive packaging. Guinness's original focus was on evening bags, but her ambition is now to become a brand. She joined Jasper Conran, Pearce Fionda, and John Rocha as a designer at Debenhams, for which she designs a range of prints for homewear products, and in 2002 she started a range of shoes for Lambert Howarth, a leading manufacturer of British women's footwear.

Anya Hindmarch started her career in design after the success of a bag commissioned by the fashion magazine *Harpers & Queen* in 1987, when she was just 19 years old. Hindmarch makes bags that subvert famous brand logos, such as Roses Lime Juice, Lurpak butter, and Hershey's chocolate bars, into beaded accessories, which have influenced the high street. She uses exquisite fabrics and skins, blending the classic with the quirky, as in her use of metallic Napa leather. Her Blue label, a lower-priced collection, also developed another of her trademarks: print bags depicting images from American popular culture of the 1950s and 1960s. In September 2001 Hindmarch launched her "Be a Bag" charity where people paid to have their own photograph emblazoned on a nylon tote, in aid of worthy causes. Hindmarch famously customized photographs of celebrities, including a 1950s image (donated by the actress) of Joan Collins lounging in a negligée, which went on to be a big commercial success.

In contrast Orla Kiely bags follow a different direction. Orla Kiely is an Irish-born designer trained at the Royal College of Art. She started her career as a fashion designer for Esprit and Paul Costelloe and as a design consultant for companies such as Habitat. Her training in textiles is reflected in her work, which explores different fabrics, that have not traditionally been used for handbags before. For autumn/winter 2000, for example, her range of bags was tactile, using warm wools and leather, including a sheepskin bag made from long-haired Mongolian lamb. Her pieces often call attention to themselves, and bold colour and print are another Kiely hallmark. Her bags are large and practical: typical are printed canvas shoulder bags using her signature spot design in fuchsia and turquoise colourways. Her large canvas totes for summer combine bright colour with funky optical prints and have defined a certain kind of urban utility.

Led by so diverse a range of individual designers, British accessories have achieved an international reputation for their originality and style. These designers have repositioned accessories as significant items in their own right which, as a fashion statement, are as important as clothes.

LEFT, CLOCKWISE FROM TOP LEFT *Orla Kiely, spring/summer 2002. Embroidered leather handbag; appliqué check tote bag; bubble print leather tote bag; appliqué check shoulder bag. This selection of Orla Kiely bags typically combines the use of leather and wool with graphic prints derived from the geometric and colourful shapes of 1960s Pop decorative patterns.*

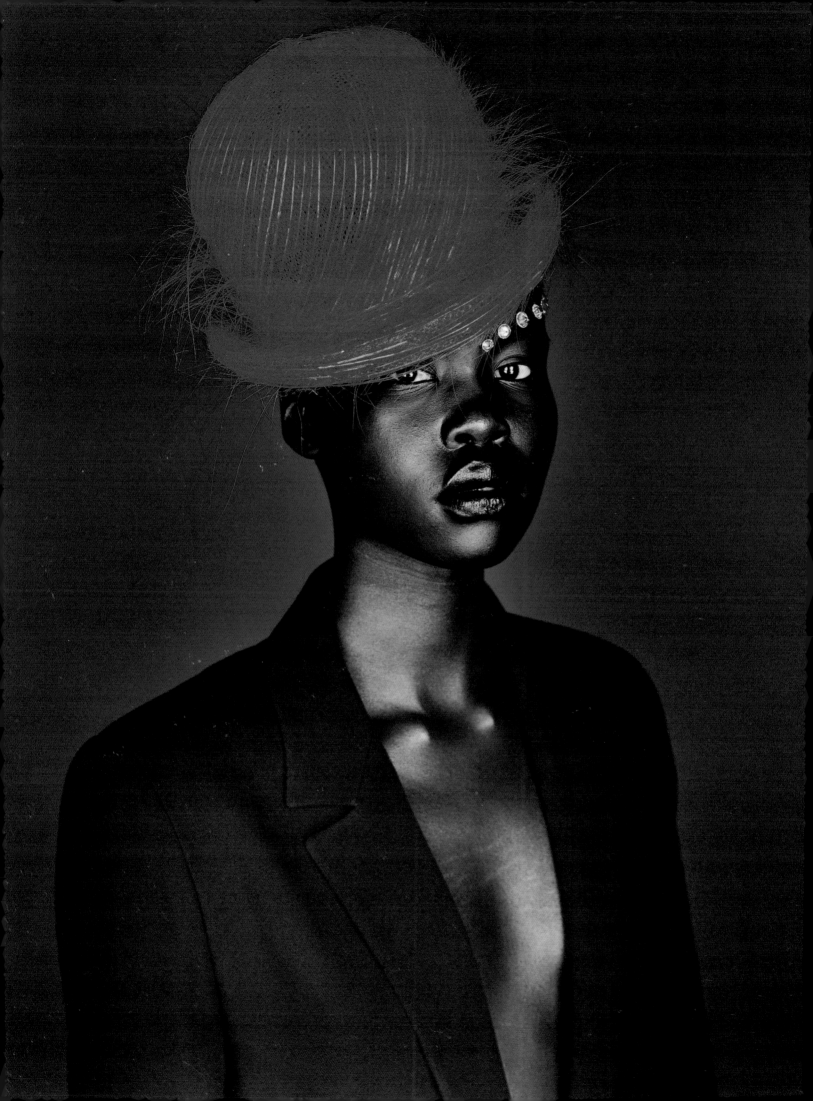

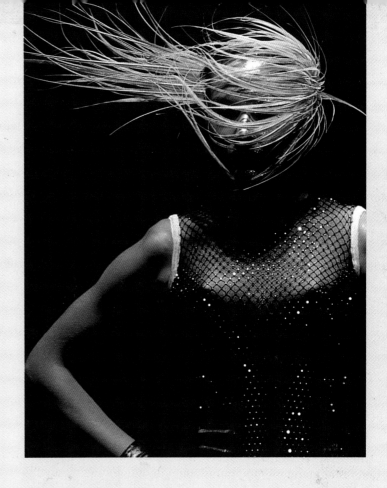

PHILIP TREACY

In the 1990s Philip Treacy single-handedly reinvented the hat as an important contemporary fashion accessory. He transformed the hat into an independent object that could lead rather than follow new style directions. Furthermore, his innovative and surreal work introduced the idea that a hat designer might become as influential as a dress designer, and in 2000 he staged the first Philip Treacy haute couture hat show, *Stages*, in Paris. Born in County Galway, Ireland, Philip Treacy studied fashion design at the National College of Art and Design in Dublin before winning a place at the Royal College of Art in 1988. With materials sourced from local flea markets his graduation show in 1990 caused a storm of interest. At the college Treacy met his longstanding friend and patron, the creative director Isabella Blow, famous for championing new designers. Treacy's first showroom and workshop for couture hats opened in the basement flat of Blow's family house on Elizabeth Street, Belgravia, and the originality of his work attracted the attention of international fashion designers. These have included Valentino, Christian Lacroix, Gianni Versace, Karl Lagerfeld for the Chanel haute couture collection, and Alexander McQueen for Givenchy in Paris.

Treacy is famous for his fantastical and surreal sculptural creations, hats generated from forms and shapes inspired by nature, history, and personal memory. They include the Ship, an astonishingly realistic replica of an 18th-century French ship with full rigging made from miniature buttons; the Castle, inspired by Blow's ancestral home in Cheshire and Ludwig of Bavaria's magnificent palace; and the Horns, a black satin replica of the horns of Blow's flock of Soay sheep. In the collection of the Museum of London is the pink satin Sundial, shaped

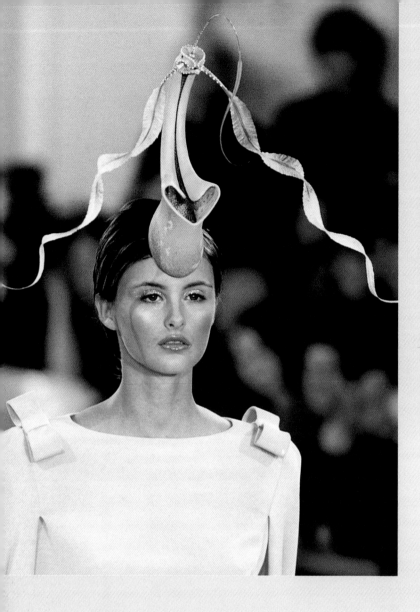

like a pin-cushion, which perches on the head with a sharply-angled lone feather protruding vertically from the crown. Another hat uses white stripped feathers like skeletons, swirled around to create a large brim with pointed crown. More radical abstract shapes were explored in the spring/summer 2001 collection *Severe Beauty*, with face-covering gauze helmets and caterpillar forms that grew straight out of the tops of the model's heads and spiralled down around their bodies.

Treacy's hats are not simply theatrical costume: his talent is to make his fantastical vision into something eminently wearable – hats that frame the face and alter its shape and proportions in an entirely modern way. His approach combines exciting new sculptural forms with experimental materials – feathers, artificial flowers, straw, gauze – and interesting details such as a steeply sloping crown to frame and flatter the face.

Treacy's work successfully crosses borders between different areas of fashion, from a high-street range for Marks & Spencer, to couture, to designs for ballet, film, and theatre productions.

An exhibition of Treacy's work at the Palazzo Pitti, Florence, at the 1997 Biennale di Firenze, explored his hat blocks as sculptural forms in their own right, a concept developed by the Irish Museum of Modern Art for a show in 2001 called *Unlikely Sculpture: Hat Forms by Philip Treacy*. These exhibitions focused on the process by which Treacy's hats are visualized and made, including the preparatory drawings and the carved wooden blocks of moulds that are the base on which the hats are built. An interesting development in 2001 was a collaborative installation with the artist Vanessa Beecroft for the Biennale di Venezia. In this way Treacy's original talent remains part of the fashion world but also crosses into visual art.

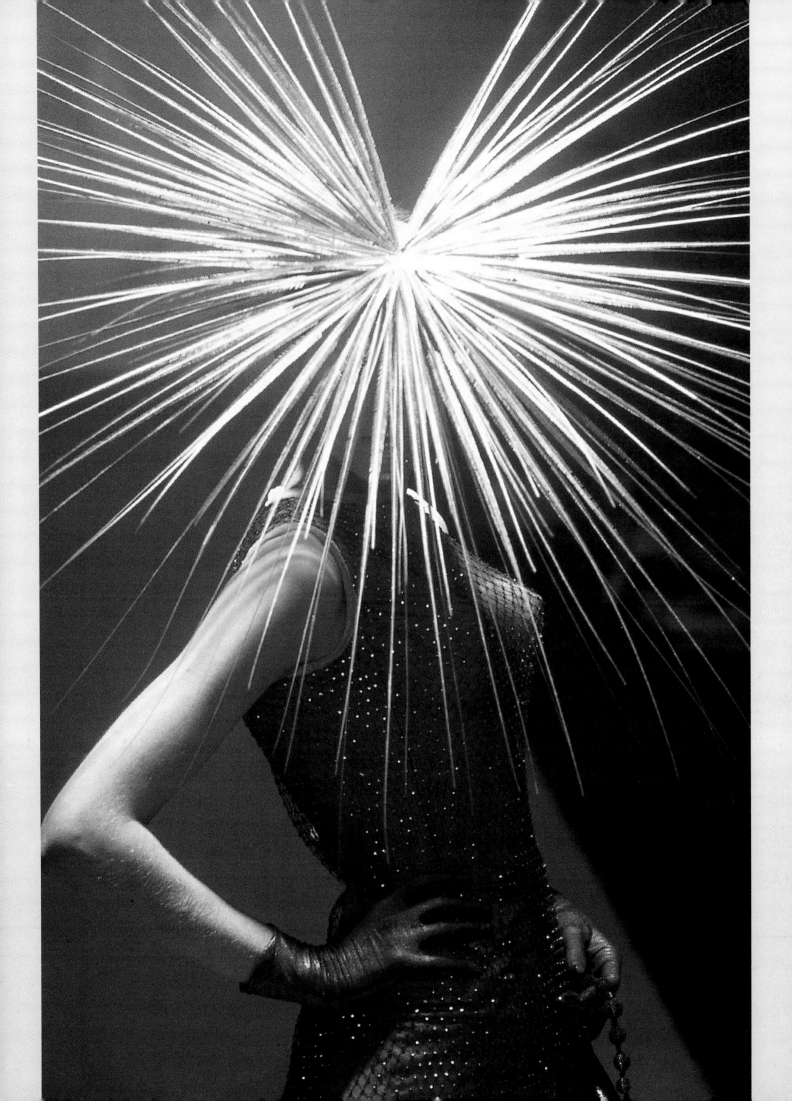

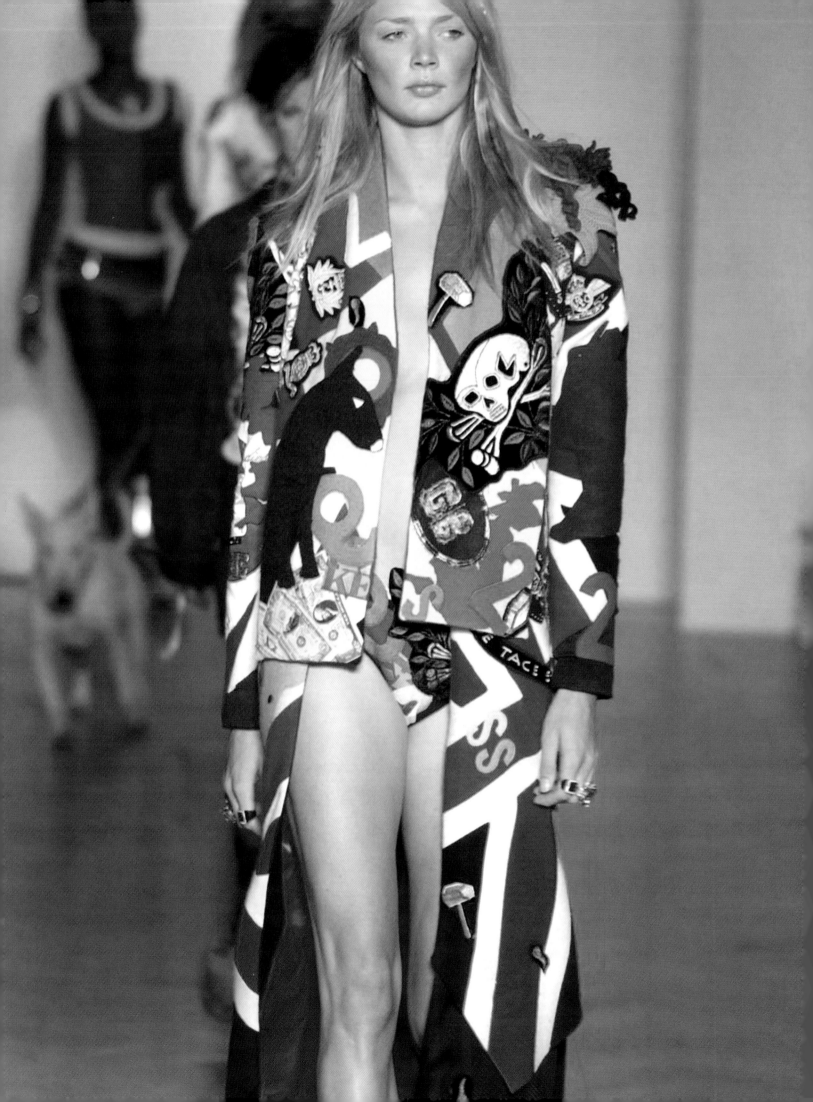

rebel
lion&
s u b
version

In the 21st century British fashion enjoys a high-profile international reputation for the diversity and creativity of its design. Yet it presents something of a paradox. On the one hand British fashion education is admired and respected throughout the world, and British fashion designers work for, or head, many of the world's leading brands and couture houses; on the other hand, the UK has no fashion manufacturing industry to call its own. It is a heritage that has proved to be both a strength and a weakness.

British fashion, so the argument goes, is all art and no industry. The debate came to a head in February 2002 during London Fashion Week, when Paul Smith, the UK's most financially successful designer, Colin McDowell, a leading fashion journalist, and Nicholas Coleridge, chairman of the British Fashion Council, battled out some of the issues in the media. Paul Smith accused British designers who had chosen to show their collections in Paris of failing to support British fashion. Colin McDowell blamed the British Fashion Council for creating a culture of media hype around fledgling talents who had little hope of going on to sustain a career in fashion. Nicholas Coleridge defended the Council as a vital platform with which to showcase what the world expects from London: new ideas and directions. Finally, the government announced that it would fund a report into the structure and problems of the industry and attempt to point the way forward. The debate about how best to support and develop the British fashion industry looks set to continue.

A complex heritage

The background to this complex picture is reflected in the history of British fashion over the last 50 years. During this period the profile of British fashion has undergone a tremendous change in status. In the postwar years, British fashion designers were hardly visible on the international stage; they could not compete with the prestige of French couture, with America, or with the glamour of the new wave of Italian style. A change came in the 1960s, with the explosion of creativity that underpinned the image of "swinging London". At this time the historical framework of British industry was under a sustained attack from which it would never recover. Britain, once the world's great industrial nation, was forced to confront the uncomfortable reality that its manufacturing infrastructure was rapidly disappearing. In this period of uncertainty a distinctive cultural vision emerged, led by young people and centred on urban life. Ideas about style and fashion from the streets, the dance halls, and the clubs led to the development of a very different culture in Britain.

British fashion, at least the kind the wider world was interested in, was principally focused in this era on small independent boutiques targeting a young consumer at a medium to low price point. It was seen as the work of designer–retailers such as Mary Quant, Jeff Banks, and Barbara Hulanicki for Biba, but in terms of the overall market their impact was small. The profile of British fashion was set along two parallel and separate lines, involving on the one hand the independent entrepreneur–designers who set the agenda for the "youth revolution", and on the other, designers within the fashion industry, such as Jean Muir, whose skill was recognized and admired but only within the UK. Overall, Britain had not produced any fashion designers who could feature on the world stage and challenge the supremacy of American, Italian, and French fashion.

PAGE 151 *It sometimes takes an outsider to bring a fresh eye to the traditional motifs of British identity. Desiree Mejer, the Spanish-born designer behind the Fake London label, offers clothes that rework the Union Jack flag and elements of regalia that have helped brand a certain image of Britain, and British fashion, for the 21st century. This outfit is from her spring/summer collection for 2002.*

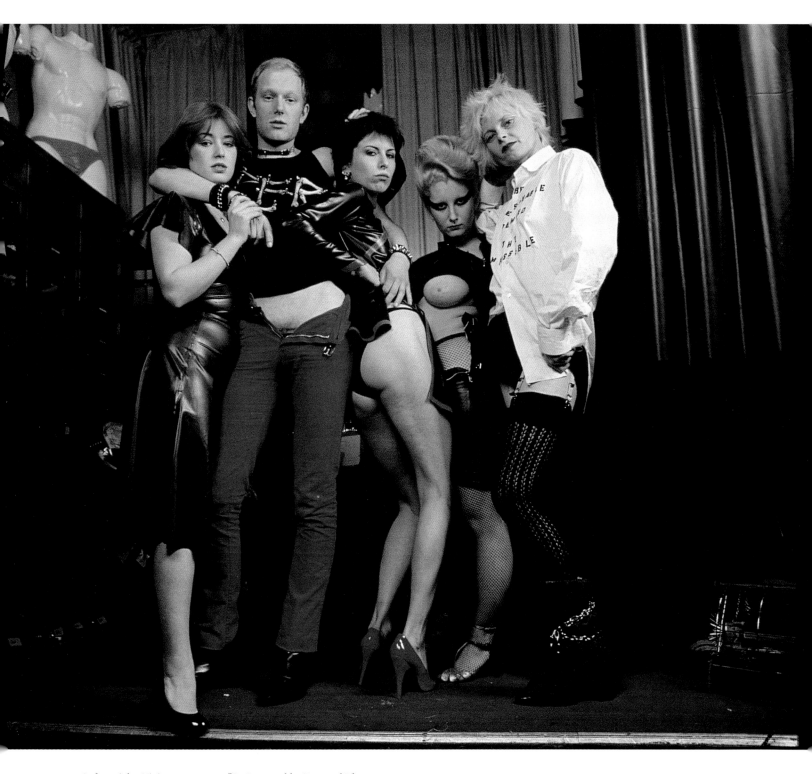

ABOVE *Left to right: Vivienne Westwood, shop assistant and Punk legend Jordan, and the rock singer Chrissie Hynde, photographed in 1976 at the Westwood-McLaren shop, SEX, on London's King's Road. Westwood is wearing a printed shirt bearing the slogan "Be Reasonable. Demand The Impossible". The rest of the group are wearing rubber dresses, skirts, and jackets that took their inspiration from the fetishistic world of soft pornography, including Hynde's vivid red stiletto shoes.*

In the late 1970s and early 1980s, however, that situation was set to change. British fashion was about to take a leap on to the international arena with the work of the now legendary Vivienne Westwood, the first British fashion design superstar, together with the new generation that would follow her lead.

Vivienne Westwood and British street style

By the 1980s creative British fashion, indeed a whole style of product and graphic design, was fixed into a profile tellingly described by cultural commentator Peter York as "punk and pageant". This style drew on a unique combination of history, tradition, and street culture, which was to shape ideas of creativity and national image in Britain for the next 20 years. Street style, pop music, art, and change lay at the heart of this culture-not-couture vision of clothes for the rich and famous, whose most famous protagonists, Malcolm McLaren and Vivienne Westwood, born in the 1940s, both reflected and contributed to this moment of historic change.

Important in this context is the story of British art colleges. No other institution has done more to shape the overlap of art, music, and fashion, industries which have interacted in Britain in a way that is impossible to identify anywhere else. Art colleges were at the centre of 1960s pop culture and at the heart of the punk revolution a decade later. They were a reminder that punk was much more than a working-class youth culture – its ideas and agenda of individual creativity were profoundly to influence both the visual imagery of British culture and ways of working within the creative industries. It was at art college that McLaren (at Hornsey School of Art) and his co-conspirator Jamie Reid (at Croydon School of Art) learned how to subvert the status quo with a use of humour, irony, and wit that they learned from art history and the powerful strategies of Dada and Surrealism. Art college culture, with its emphasis on ideas, was a powerful force that shaped the unique nature of British fashion design.

The central figure in this picture is Vivienne Westwood, who has come to embody the powerful, subversive elements of British creativity, the ideas of anarchy, history, irony, and sex, that have inspired fashion. Westwood entered the 21st century as one of Britain's greatest and most innovative fashion designers, who more than anyone else helped place London at the centre of leading-edge fashion. Her work has always been directly concerned with rebellion and subversion, a theme that can be traced back to the start of her career with Malcolm McLaren. In 1971 they opened their first shop on King's Road, Let It Rock, which sold Teddy boy clothes. They moved on to SEX, selling their own clothes, borrowing styling ideas from the subcultural world of soft porn and introducing the rubber and fetish details that are now widely accepted in mainstream fashion. SEX was an interesting experiment, but when McLaren and Westwood relaunched the shop in 1975, under the name Seditionaries, they effectively launched the punk movement in Britain.

From the beginning their work set the agenda for key themes in British fashion, which continue to be explored. These included challenging sexual boundaries, borrowing ideas from street culture, and the raiding of history as a way forward for contemporary fashion. Westwood's plunder of visual sources from the past was wide-ranging, including 18th-century French Rococo,

ABOVE *Vivienne Westwood* Buffalo Girls *collection shown in Paris, March 1982 in which models danced on the catwalk to the new sound of New York "scratch" music. This outfit shows Westwood's famous use of underwear that later inspired Gaultier's bra outfit for Madonna. The clothes were Peruvian-style layered outfits cut large in a gesture of display that Westwood developed in these early collections.*

LEFT *Katherine Hamnett photographed with Prime Minister Margaret Thatcher at a reception at 10 Downing Street in 1984 to celebrate the British fashion industry. Hamnett used the opportunity to wear one of her famous political slogan T-shirts, here protesting against the use of nuclear weapons. Mrs Thatcher reportedly commented on seeing her, "At last! An original".*

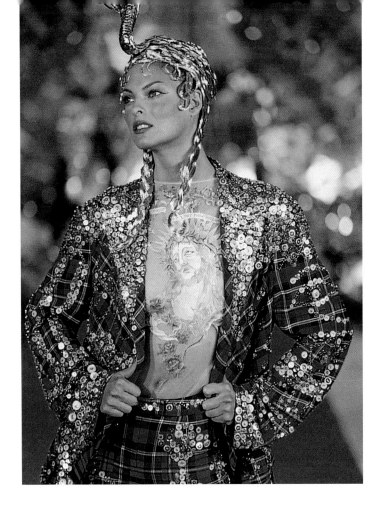

Aztec culture, and African traditions. She also created the template for what has become another archetypal British fashion event, the fashion show as performance theatre and platform for experimental ideas and outrageous spectacle. In the early 1980s her unique fashion vision attracted international attention with a series of seminal collections in Paris. American critics were particularly enthusiastic when the work of Westwood and a new generation of Brits was shown in Suzanne Bartsch's *New London in New York* show, held in Manhattan's Roxy Roller Rink in 1982.

The work of the then young designer John Galliano is a case in point. He developed Westwood's ideas of reworking traditional shapes and materials into something of his own. His interest in historical themes was evident from his final degree collection at St Martins in 1983, *Les Incroyables*, which was inspired by Napoleonic and Regency styles. His early collections went on to develop the theme of the show as art event. Developed in collaboration with the stylist Amanda Grieve, now Amanda Harlech, who collaborates with Karl Lagerfeld at Chanel, his shows including the 1985 *Fallen Angel* collection were notorious for excesses, such as models with headdresses of string and broken clocks, and the audience's being showered with white powder.

Other fashion directions

Even in the 1980s, however, street fashion and the outrageous were never the sole British fashion choice. The hallmark of successful designers such as Betty Jackson was then, and still remains, the production of fashionable but easy-to-wear separates using print and classic fabrics. Jasper

Conran was also moving in an interesting direction. His inspiration was Coco Chanel and his collections pulled together references to classic couture, updating the look by paring down to all but the essential details, an approach to fashion that his work has continued to extend and refine.

Another important British designer with a more commercial approach to fashion was Katherine Hamnett, who, with an astute eye for the sharp edge of style, began to evolve a collection that redefined easy-to-wear clothes to suit life in the consumer culture of the 1980s. Hamnett mixed styling ideas from army surplus and specialist fitness clothing using crushed parachute silk and basic cotton tracksuiting. What also marked her out was a collection of slogan T-shirts with political messages (see p.154), in support of the women's peace movement at Greenham Common, and the environment.

Other individual voices at this date also used fashion to express political concerns. In the late 1980s Rifat Ozbek established a reputation as a British designer of note. Ozbek flagged up political concerns – in one of his collections, for example, he used unbleached cotton as a protest against the destruction of the environment by the fashion industry – but his more mainstream work explored the rich influence of his Turkish background, using exotic fabrics and distinctive breastplate patterns on simply-tailored black suits.

British designers in Paris

Underlying British fashion during the 1980s was a simple reality. Then, as now, it was not enough to have an authentic, original, or provocative voice to ensure commercial success. By 1987 many of

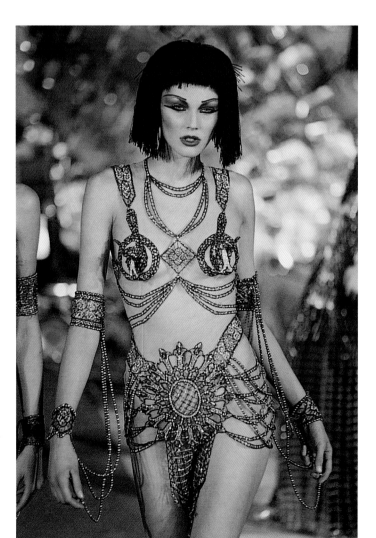

LEFT *From the same 1997 collection this flamboyant piece by John Galliano is designed with the catwalk in mind. It looks for inspiration to the world of 1920s cinema, and the historical films of Cecil B. de Mille. The Egyptian theme of the collection is continued here with an elaborate jewelled body piece, wig, and eye make-up that reinforce the image of an exotic Cleopatra.*

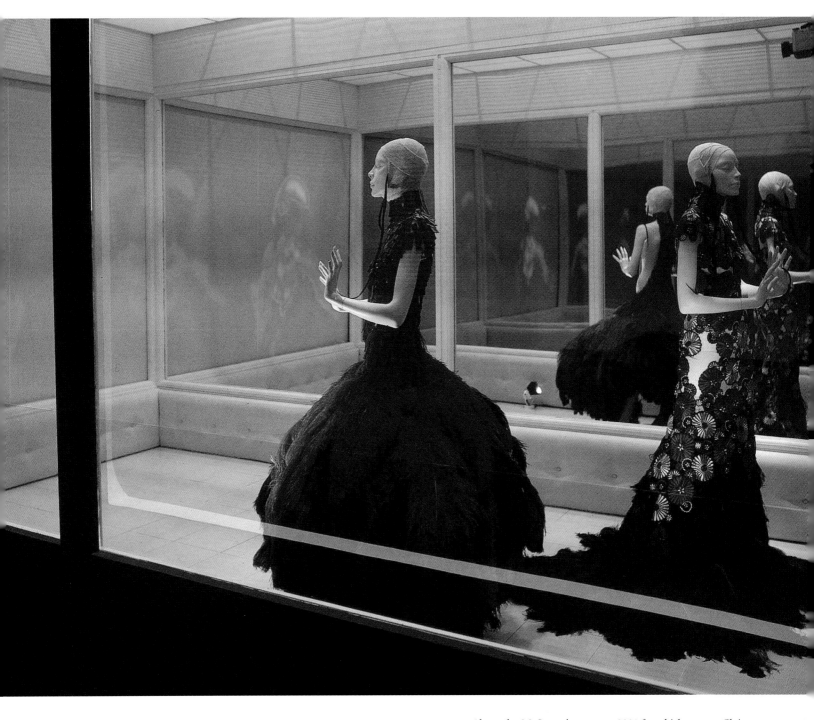

ABOVE *Alexander McQueen's Samurai Dress (right) and feather dress (left) which was made from 2000 microscope slides ordered from a surgical supplier, which have been individually hand-drilled and painted red. The dresses were shown at the V&A exhibition* Radical Fashion *in 2001 for which curator Claire Wilcox allowed each designer to decide how their clothes were displayed. McQueen showed his dresses in a mirrored glass box with changing light so that the viewer saw the dress and also themselves, playing on McQueen's interest in fashion display as art installation.*

the key designers who had shaped street style were facing bankruptcy, including both Westwood and Galliano. Yet in the world of the 1990s it was these same two designers who first bridged the gap between British street style and the world of high fashion.

John Galliano began his career with a series of innovative collections focused on intriguing but largely unwearable clothes, and Galliano as a fascinating individual talent might have ended there but for a surprising turn of events. In the 1990s French couture faced an economic downturn, and it was also looking old-fashioned. To the surprise of the fashion world, the historic couture houses of Paris looked to London to revitalize their image. In 1996, at the age of 36, Galliano was appointed design director at the couture house of Givenchy. The following year he moved to Christian Dior, thus confirming his shift from maverick to mainstream. Galliano helped transform Dior from a traditional couture house into a huge financial empire, stamping his influence and personal vision on everything, from perfume bottles to advertisements to the style of Dior concessions all over the world, creating a total vision in fashion that reflects his flamboyant personality. He is an impresario who turns his fashion shows, which began as experimental "happenings" in London, into fantastic and lavish visual experiences.

At Dior Galliano became famous for his exquisite evening gowns. But his genius was to place alongside these sumptuous gowns simpler dresses that could be easily and quickly translated on to the high street, such as the revival of the simple bias-cut slip-dress. Galliano has a fantastic capacity to renew fashion each season, which is combined with a passion for research that enables him to seek inspiration in a wide range of sources. He offers high couture alongside the freedom to subvert it, to mix denim dungarees with pieces from his collection.

The other dominant personality of late 20th- and early 21st-century British fashion is Alexander McQueen. When Hubert de Givenchy, who founded the house half a century ago, retired in 1995, he was replaced first by John Galliano and in 1997 by Alexander McQueen. McQueen now designs his own label, backed by Tom Ford and the Gucci empire. Nearly ten years younger than Galliano, his personal image is the direct opposite to that of his rival. The son of a London cab-driver, McQueen is famously rough and tough, aggressively East End working class, with shaved head, violent language, and studied contempt for the press. At the age of 16 he was apprenticed in Savile Row, then he studied at Central St Martins, where his collection was bought in its entirety by the influential stylist Isabella Blow. His early collections, such as *Highland Rape*, a title that refers to the Scottish Highland clearances of the 18th and early 19th centuries, combined controversy with the skills of bespoke tailoring that remain central to his vision. Like Galliano, Mc Queen has contributed to the crossover between two extremes in fashion, the international high end and British rawness. The same designer who gave us the low-slung "builder's bum" trousers also created some of the most exquisite couture creations of the 1990s for Givenchy.

McQueen is legendary for his strongly themed collections that mix extremes of masculine and feminine, violent eroticism, whimsical romance, and nostalgia. His ability to combine honed tailoring and fantastical creations has redefined fashion. His strategy is to show beautifully crafted clothes as theatre and spectacle alongside clothes that are wearable and commercial. In 1999

ABOVE *This image comes from one of Alexander McQueen's most important early shows,* Highland Rape *in March 1995. His theme was the brutal Highland clearances of the 18th century. Heather and grass are strewn on the catwalk, providing a backdrop for an outfit that uses traditional tartans combined with a strikingly erotic transparent dress worn over contrasting tartan knickers.*

Stella McCartney's CND coat from her spring/summer 2002 ready-to-wear collection shown in Paris, October 2001. For this wedding outfit in white satin McCartney has returned to traditional British sporting themes, reworking the womens riding skirt and jacket with matching white satin top hat. She has combined this tailored outfit with a large-scale graphic slogan reading "Trouble and Strife" – the Cockney rhyming slang for wife – and a CND (Campaign for Nuclear Disarmament) logo on the jacket.

McQueen transformed a warehouse in London into a Victorian fairground, with giant teddy bears and china dolls set around a merry-go-round. In 2001 he showed *Voss*, a terrifying vision of a lunatic asylum, in a bus depot in the East End of London: models with their heads bandaged were trapped in a cell made of one-way mirrors; for the finale, the inner glass box was shattered, releasing hundreds of moths and revealing a masked, naked model. McQueen strives towards the consummate balance between the clothes and the art concept. From the *Voss* collection his red embroidered dress, layered with painted microscope slides and ostrich feathers, remains a perfect expression of his poetic vision. In 2002 his own line continues to lead the fashion agenda, retaining a strong sense of his own identity at the same time as picking up on current themes: red ruffled chiffon dresses, bodega frills, and plunging necklines are his homage to the new interest in flamenco or Latino style in contemporary fashion.

The third of the high-profile Brits taken on by the Paris fashion world is Stella McCartney, who was appointed creative director of Chloé in 1997. In McCartney, daughter of the former Beatle Paul, Paris acquired a pop princess. She offered Chloé a way of opening up their traditional womenswear to a new and younger generation. McCartney herself represented, as much as her clothes offered, a desirable celebrity lifestyle, wearing clothes that translated lingerie into sexy

RIGHT *Hussein Chalayan dress from the spring/summer 2000 collection shown at London Fashion Week, September 1999. Chalayan has constructed this dress from hundreds of tiny silk tulle rosettes, delicate and soft to the touch, yet assembled in such a way as to create a visually-strong sculptural form that demonstrates the architectural quality of Chalayan's designs.*

outerwear – an image typified by the strapless ivory gown with a corset bodice and long train that Madonna wore for her wedding to the new-wave British film director Guy Ritchie in 2000. In October 2001 McCartney left Chloé and launched her own new label, whose raunchy theme was expressed in a series of printed Cockney rhyming slang slogans, such as "whistle" (for "whistle and flute", suit) down the leg of a trouser suit, and "trouble and strife" (wife) on the hem of a long fitted cream riding-coat. The collection combined her interests in Savile Row-style tailoring with her trademark lingerie detailing and confirmed her status as a British fashion designer whose clothes continue to shape a sense of individual British style.

New British designers in the 21st century

British fashion designers have learned from four decades of pioneer experimentation. They are fluent in the language of subversion, anarchy, and media exploitation. Yet new fashion graduates face a more difficult career choice than their counterparts abroad. Young British designers are less likely to be apprenticed in major brand houses than those in Italy, and the high cost of domestic production puts British-based designers at a disadvantage; in Italy, manufacturing companies can take on young designers and produce their clothes inexpensively. British designers can, and have,

become brands within a bigger company, but what French, Italian, and American design firms offer are vast manufacturing, distribution, and marketing operations that can out-perform even successful British names such as Paul Smith. Young British designers still aim for their own label and Britain's inability to sustain medium-sized designers, somewhere between a fashion protégé and a Paul Smith, remains a problem for the industry.

The British blueprint is often to focus young talent on a fast track to media exposure, based on an expectation that a certain kind of British fashion is about being quirky and weird – an expectation fulfilled by, for example, Marjan Pejoski. Born in Macedonia, Pejoski is a graduate of Central St Martins and his style is for theatrical and colourful fashion statements. He is known for his knitwear – giant plunging mohair sweaters in vivid colours, decorated with sequined peacocks and swans and worn belted over flouncy miniskirts. His work also includes pink chiffon baby-doll nighties, skirts made of swinging multicoloured beads, and shocking-pink dresses with deep empire necklines, caught up at the side with discs of glittering cartoon characters; his string bikini was made up of pictures of a grinning Felix the Cat. Pejoski's style will forever be associated with his outfits for Björk, which match the singer's own highly-individual personal style and music.

Robert Cary Williams is another strong and individual voice in British fashion, with a personal agenda towards experimentation in fashion forms and presentation. Born in 1965, he studied fashion at Central St Martins as a mature student in the mid-1990s. In 1999 he was awarded the British New Generation Award, which funded his experimental *Victorian Car Crash* collection, in which garments were peeled open to reveal zips and pleated fabric. He has

ABOVE *For London Fashion Week, November 2001, Julian Roberts took the interesting decision to show his collection as a filmed installation projected onto the façade of the Natural History Museum in South Kensington. Screened in the evening, it was a successful exploration of alternatives to the traditional catwalk show.*

continued to push the boundaries of fashion with his subsequent collections. For his *Hung Drawn, and Quartered* show in 2000 he combined inspiration from 1940s French couture with found objects including metal roses, broken umbrella prongs, and brutal industrial materials. Cary Williams likes to use basic fabrics such as cotton, poplin, tent canvas, denim, and leather, which he dyes himself in muted colours of mushroom, chinchilla, and green-black. Details include his trademark use of zips with a double end. Another signature technique is moulded leather, for which he uses conventional jacket shapes stretched into new forms and fixed in a high-temperature oven. He showed these distorted leather suits at his *Café de Paris* collection in 1998. The processes of experimental art remain important to him: in his *Sex With Strangers* collection for 2002, garments were placed into moulded ice to create a series of frozen dresses inspired by the film *Dr Zhivago*.

Another young British designer who has explored ways of redefining what fashion might be and how it might be presented is Julian Roberts. Roberts graduated in menswear from the Royal College of Art in 1996 and worked for two years with Jasper Conran before setting up his own label, "nothing nothing". His initial entrance into the world of fashion was with the idea of beautifully designed invitations, specifying no venue, "inviting" buyers and press to a series of nonexistent fashion shows. His first conventional show, at the Atlantis Gallery, won a New Generation Award from the British Fashion Council. Roberts has also used the idea of repeating styles from season to season in different fabrics and colours from what he describes as his archive. His work in 2001 featured dresses in new transparent synthetics and leather in a palette of pink, black and fluoro-yellow, as well as featuring the faces of 20 people who shaped the fashion industry embroidered on individual garments. Like that of many of his peers, Roberts' work explores the creative process, the construction of new forms, and the materials and techniques used in designing clothes. The process of his work is something that he strives to make visible rather than hidden from view. He places as much value on the paper patterns, the prototypes, the images and writings that he collects, as on the finished work.

LEFT *Roberts' show was a brave experiment. The Natural History Museum, designed by Alfred Waterhouse in the Gothic style in the 19th century, is architecturally complex, which made projection difficult. The gardens of the Natural History Museum were the site for the London Fashion Week tents.*

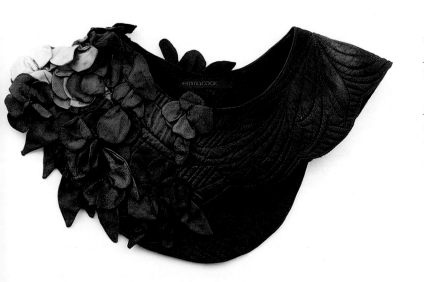

In 2001 Roberts took such ideas a stage further with the launch of his label Julian And. The "And" was an attempt to escape the tyranny of labels and to offer the possibility of partnerships with other creative people. The result was a 14 m² (150 sq ft) film of his collection projected across the façade of London's Natural History Museum. The film, art-directed by Roberts, was shot in North London over two days and sprang from a collaboration with different stylists and photographers. It was a creative and technical *tour de force* that positioned Roberts as a fashion designer with the talent to work across disciplines to produce something quite new.

Reworking, recycling, and re-use

Rebellion and subversion, or the radical and the anarchic, continue to be important themes in British fashion, but they are also explored alongside the deeply felt social concerns of this generation. Using found objects and recycling materials are ways in which some new British designers have come to express a social agenda and address issues such as globalization.

Using recycled fabrics, the work of Emma Cook has a certain thrift-shop quality to it and is unique in that the individual pieces could never be replicated. Cook's vision is compelling and exciting, but it is far from commercial. Each piece is made from fabric that she personalizes using felted wool with found objects such as pieces of chain, leaves, lace, or bits of jewellery; faded felt mess jackets hung with fake medals; ghostly Pierrot jumpsuits stamped with white polkadots; musty shell-tops stuck with fur balls and rhinestones. Using unconventional means, her pieces often achieve an extraordinary beauty, such as a pair of suede jeans scribbled all over with little stencilled stars in Biro, shown at the Jerwood Space fashion event in 1999.

Russell Sage, a graduate of Central St Martins, is a pioneer of "salvage chic" whose clothes combine new and antique fabrics. He designs fitted jackets with appliqué panels of old fabrics, coats made from salvaged blankets, and multi-layered dresses with exposed dressmaker's seams. His work often carries messages, and questions the issue of "value" in fashion: does the value of a

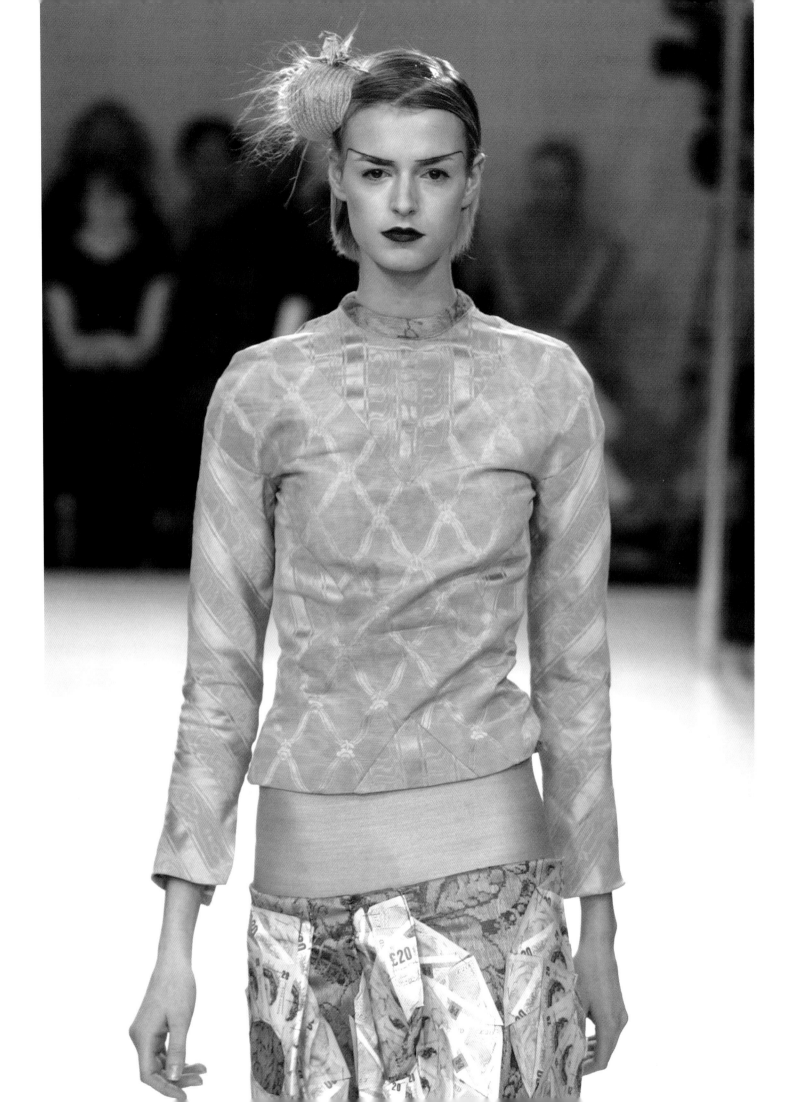

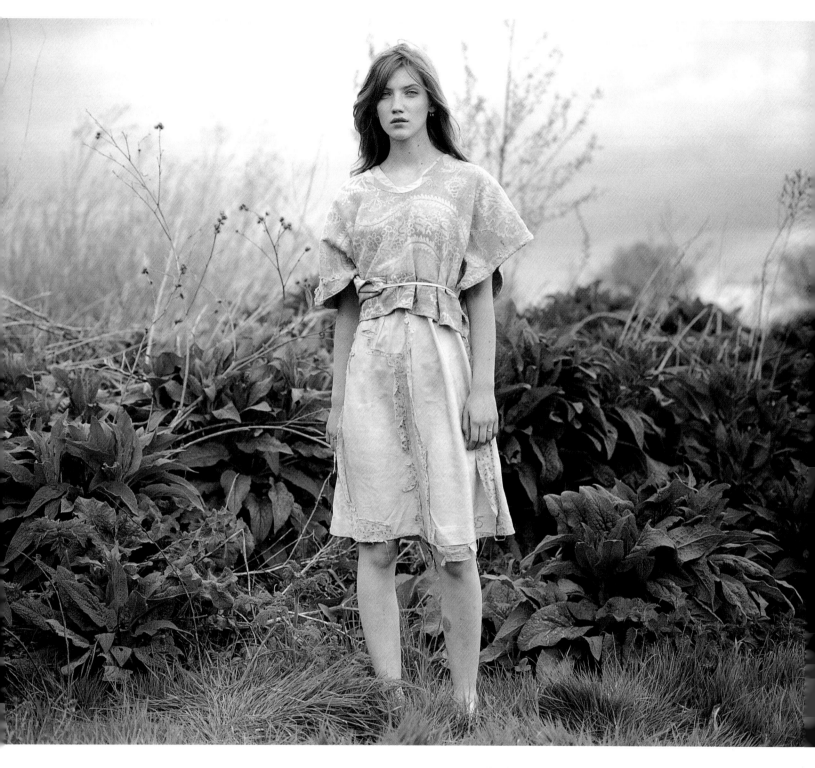

ABOVE *For this dress from spring/ summer 1999 Jessica Ogden has worked with antique and distressed textiles that she sources herself. Her technique uses layering and stitching details seen here in the skirt which overlays "torn" fabric onto a printed floral cotton. The cape from her spring/summer 2000 collection is a simple square shape of brocade fabric. In a quiet yet profound way Ogden's clothes offer a strong statement about women's lives and values.*

garment lie in the brand, the craft, or the wearer? For his 2001 collection, sponsored by the UK financial company Britannia, Sage's subversive take was to stitch £10 and £20 notes on to a simple outfit as a couturier might normally attach beads or lace. This dress was later acquired by the Victoria and Albert Museum for its permanent collection. For spring/summer 2002 Russell Sage produced dresses printed with photographs of Alexander McQueen, John Galliano, Stella McCartney, and Julien MacDonald, making an observation on designers who have been head-hunted by the mighty Parisian couture houses owned by all-powerful luxury groups.

For Jessica Ogden, the issues of recycling and fabric wastage were a starting point from which to explore a personal agenda for clothes that reflected her experience of growing up in Jamaica. Ogden started out in the early 1990s for NoLoGo, an eco-friendly design collective whose ethos was to re-use pieces found in charity shops. Ogden now makes one-off pieces that adhere to a personal vision, working with antique and distressed textiles that she sources and engineers herself. Texture is a key element; she uses layering and stitching techniques to produce a form of deconstruction. Her vision was in part shaped by being the child of creative parents who encouraged in her a sense of the beauty in old things and the awareness that age brings with it stories of experience, history, and emotion. Educated as a sculptor at the Byam Shaw School of Art in London, art practice underpins Ogden's approach. In one collection she develops hand-printing on fabric, using simple repetition of abstract linocuts. In her studio are stocks of "old" fabrics sourced from markets and second-hand dealers, collected for their "life history": the interest lies in the unique tears and patches mapped out on the fabric surface, the random nature of natural and evolving wear and tear. The structure of Ogden's one-off clothes focuses on very

RIGHT *Simple forms derived from traditional Japanese kimonos often form the starting point for Jessica Ogden's work. Shown here is a detail of a belt that takes its form from the Japanese* obi *used to wrap around the waist. This detail shot reveals Ogden's way of working, exploiting very visible, even crude, hand stitching and a collage of recycled fabrics. Small holes and "staining" on the belt ties add a history and a value to the piece.*

simple geometric forms that refer back to the kimono, with non-tailored silhouettes, typically seen in wrap skirts, pinafore dresses, apron dresses, and smocks. She integrates antique and distressed fabrics into her designs, often using patches, layering, and hand-stitching to create a consciously home-made look. Using materials that fall within the domestic sphere – old jacket wadding, rose print, and pieces of aprons or dishcloths – together with techniques of hand-stitching and embroidery, Ogden's approach is a highly personal response to each piece of fabric she uses.

Contemporary textile design in British fashion

Textile design is another creative theme that runs through British contemporary fashion. Textile design enjoys a long and rich tradition in Britain, from the naturalism of chintz to the geometric abstraction of Pop design. The importance of contemporary print is given special focus by two design studios, IE Uniform and Eley Kishimoto.

IE Uniform is the partnership of fashion designer Roger Lee and textile designer Lesley Sealey, who met as students at the Royal College of Art. They work on the garment and the textile design simultaneously and strive to keep the separate identities of those two elements, with Sealey on the prints and Lee (who went from the RCA to work with Karl Lagerfeld in Paris) on the design of the garments. Their work has focused on customized textiles, such as laminated Lurex thread in knitted mohair, and embroidery. They also concentrate on interesting finishes to fabrics, such as Scottish tartan treated with laser-cut patterns, or lamination processes on jersey, denim, and polyester. Other effects have included mesh layers over floral cotton prints, aluminized fabric lining, glitter prints, and reflective fabrics. Sealey's final collection at the RCA explored the strong colours and techniques of beaded and embroidered Indian prints, fabrics that have given a very distinctive feel to the IE Uniform label.

ABOVE *Eley Kishimoto hand-printed wallpaper design* Landscape, *2001. Wakako Kishimoto and Mark Eley have established a reputation for contemporary pattern and surface decoration. Although they produce a range of clothes they are best known for fabrics commissioned and used by designers including McQueen, Chalayan, and Givenchy, and for print design used for ceramics and wallpapers.* Landscape *combines a Japanese feel for abstraction with a suggestion of 1930s British Art Deco.*

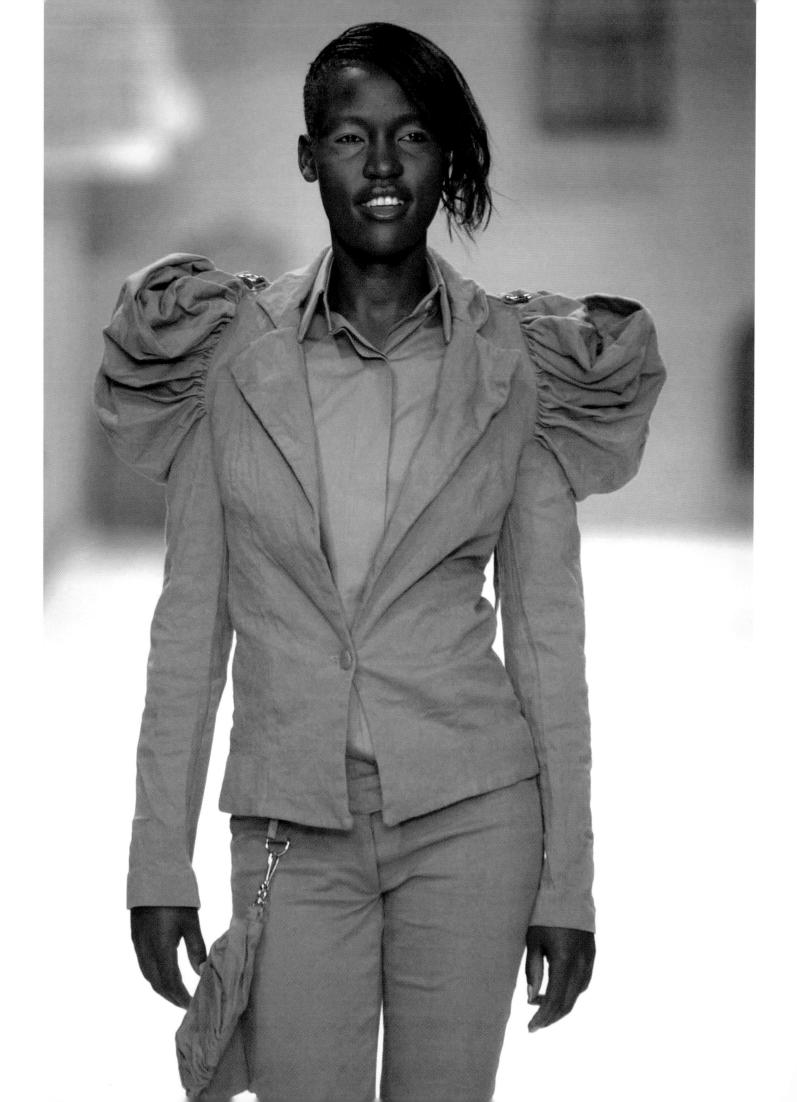

LEFT *This trouser suit from Preen's spring/summer collection for 2002 shows the duo's talent for one of the strongest themes in contemporary British fashion: a reworking of Victorian historic fashion. Preen favour washed-out cottons and sharply cut modern shapes that include vintage details. Seen here are elaborate puffed sleeves and a gathered waist bag inspired by a 19th-century chatelaine purse, originally used to hold household essentials, and updated here for use as a simple purse.*

RIGHT *A black ruched dress from Blaak's spring/summer collection of 2002. Central St Martins graduates Aaron Sharif and Sachiko Okada worked with stylist Andrew Davis on this collection called* Blaak Magic. *The show drew inspiration from Africa and brought together an eclectic collection. This black jersey evening dress shows off Blaak's talent for providing an overall silhouette and shape to their designs.*

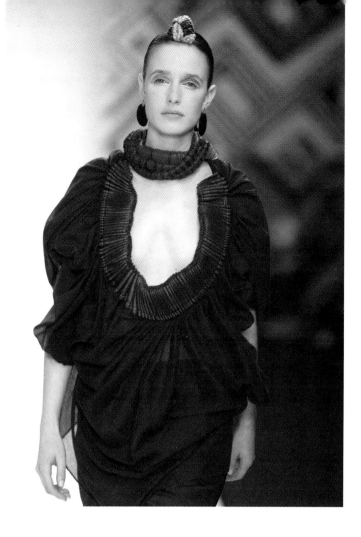

Mark Eley and Wakako Kishimoto form the husband and wife team of Eley Kishimoto (see p.171), one of Britain's most creative print and fashion studios. They met in the early 1990s when they were both students, Eley studying woven textiles at Brighton University and Kishimoto on the printed textiles course at Central St Martins. In the late 1990s Eley Kishimoto prints helped create collections for Hussein Chalayan, Nicole Farhi, Alexander McQueen, and Clements Ribeiro. Their aesthetic is not dramatic, but simple and accessible in its approach to colour and themes. Using no more than five or six screens, their prints have a clean graphic intensity that reflects the process of short-run screen printing. They have retained an independent voice and see print as a technique that can be applied to any surface, whether it be their own simple fashion range, soft furnishings, or ceramics. Eley Kishimoto also work to avoid a recognizable style, creating patterns as diverse as Flash, from 2001, which is a vivid repeat flash motif in red and black that has been converted into a wallpaper design, to Sunny, a dress and furnishing fabric from their 2002 collection, which is printed with nautical ropes, sailing regatta stripes, and seagulls.

Historical eclecticism

Preen are best known for their interpretation of Victorian details, notably leg-of-mutton puffed sleeves, and for a fashion style that is more innovative than radical. The team are Justin Thornton and Thea Bregazzi, who both grew up as children on the Isle of Man. Thornton began his career

working for Helen Storey on a range made entirely from second-hand fabrics and garments. In 1996 Thornton and Bregazzi launched their own label, Preen, and a boutique of the same name in Portobello Road. The shop became known for its fusion of Victorian styling with a modern look, which attracted international commercial success. *Spectacle*, their collection for 2002, built on similar themes – the signature puff sleeves, Victorian shoulder features, and straps that pulled up, contorted, and accentuated the silhouette. Preen use a colour range of khaki green, grey, and charcoal in fabrics that are often washed to give a casual un-ironed feel, as well as using battered leather and glazed cotton, sometimes combined with an eclectic mix of sequins, feathers, and tulle layering. Antique lace teamed with tight trousers, tops with shoulder fins, and asymmetric spills of fabric that fall from the hip have ensured success for a recognizable Preen look that is literally a fusion of the old and the new.

Political ideas underpin the brand image of Blaak (see p.173), the husband and wife team of Aaron Sharif, who designs the menswear, and Sachiko Okada, who concentrates on the womenswear, producing clothes that are based on traditional forms but expressed in bold modern shapes. They trained at Central St Martins, where they also met, and started the brand in 1998, choosing the name "Blaak" because for them black was any colour, as the vivid use of blues, yellows and reds in their work demonstrates. Blaak disapprove of "fashion culture" at the shallow end – the constant pressure to produce new shows – but they do produce commercial clothes

BELOW *This political image for Boudicca's spring/summer 2002 collection* Transition: The Corporate Deserter *depicts a seemingly homogenous "corporate" group. The unconventional cut of the clothes and the use of commonplace details that have been stretched and misplaced are used here to assert the non-conformity of the individual.*

RIGHT *Slogan T-shirts from Antoni & Alison's spring/summer 2002 collection* At last I've found you, I was almost going mad *that was presented on a stage covered with bottled milk and cookies. Antoni Burakowski and Alison Roberts have made the printed T-shirt something of their own, offering a quirky commentary on 21st-century life.*

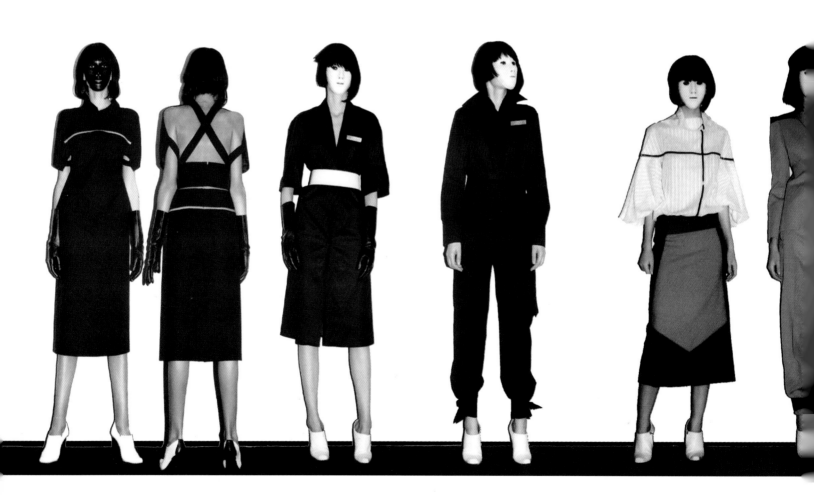

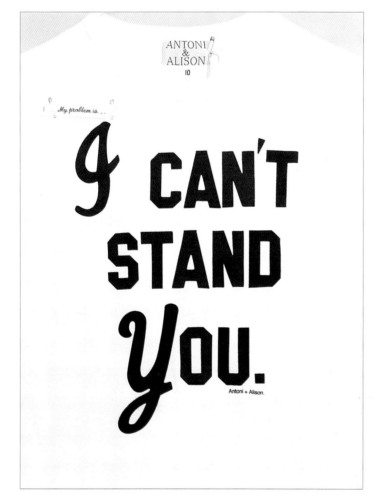

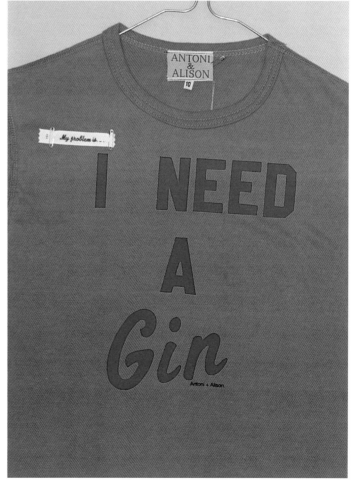

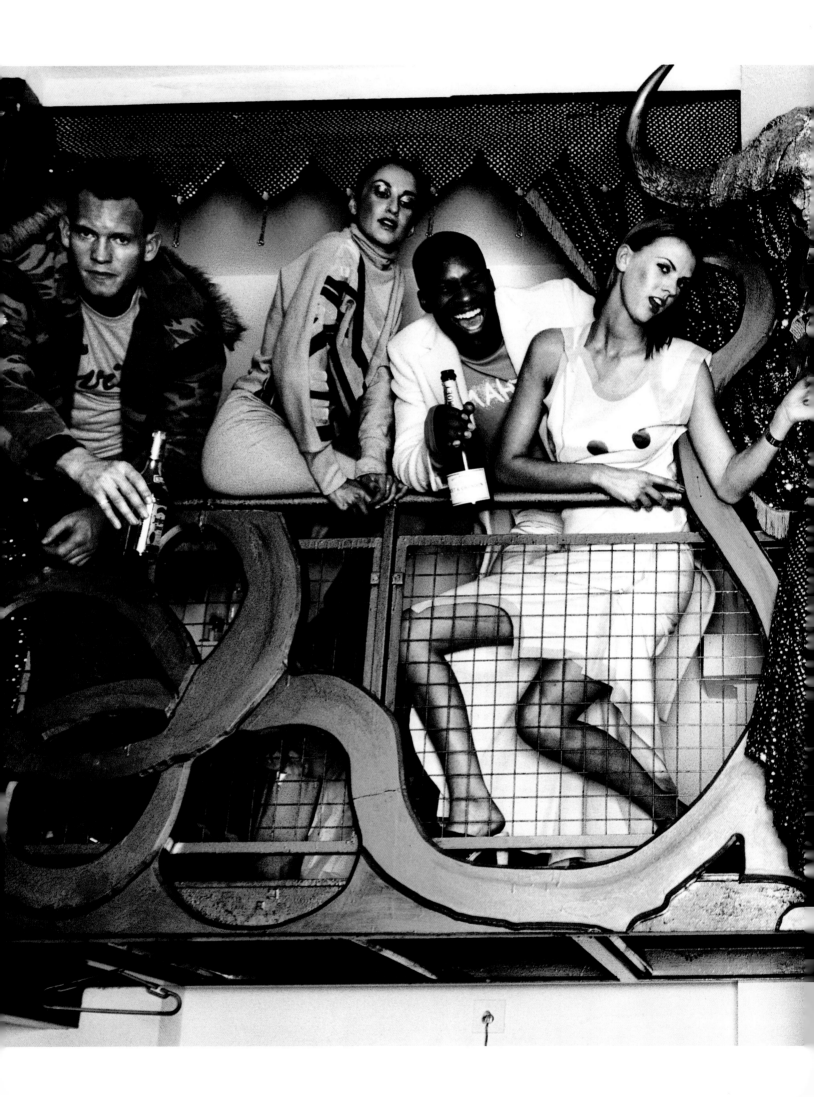

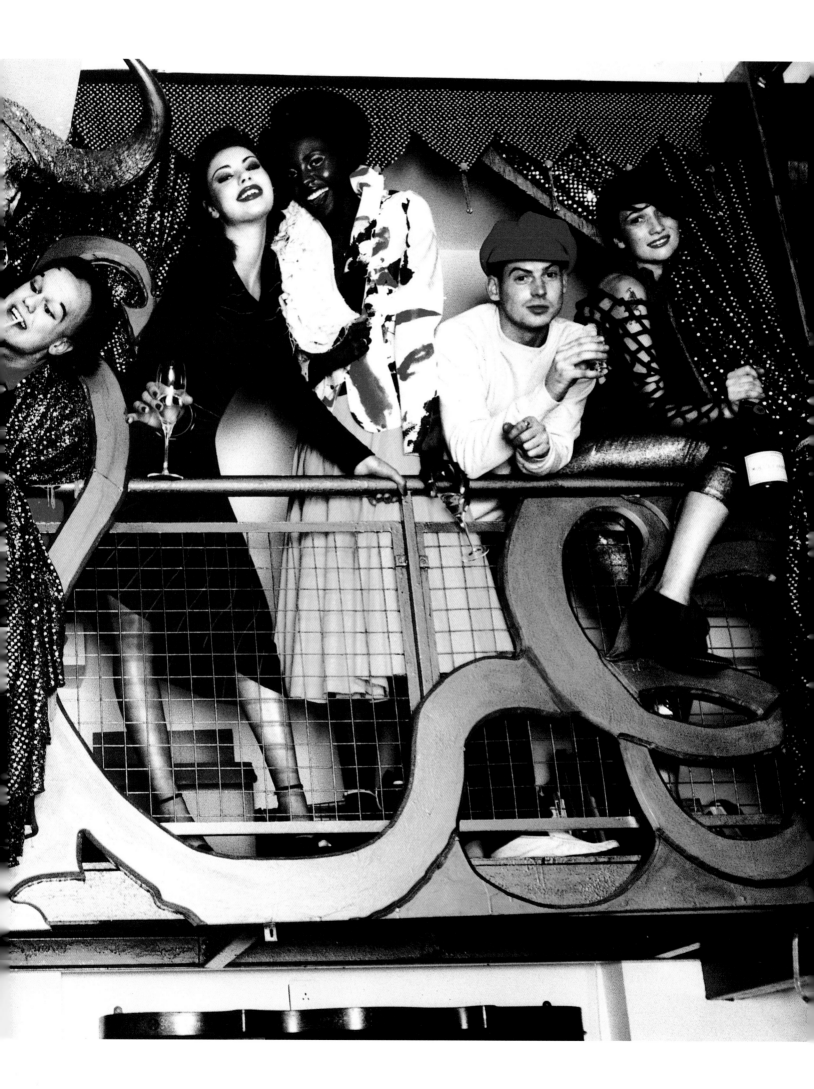

PAGE 176–177 *This fashion shoot was taken for* The Guardian *and shows a selection of contemporary British designs. The outfits include, from left to right, a Camo parka by Fake London, pink sweat dress by IE Uniform, turquoise Eltham top by Maria Chen, and cream hand-painted jacket by Hamish Morrow.*

RIGHT *This image,* Still Life, *was used to promote Olivia Morris' spring/summer 2002 collection of shoes sold in her Notting Hill shop. Morris uses found objects to decorate and customize her collections. Here she has used tape measures to form shoe straps, and zips to decorate purses in horizontal stripes.*

rather than concepts, for example they explored the strong contemporary interest in the 1980s with brilliantly coloured puff skirts. In 2001 they won the prestigious VS Sassoon Award for Cutting Edge Talent, recognition from the judges of their commercial potential, with a strong signature look shaped by conceptual ideas to produce wearable clothes that still push at boundaries.

Zowie Broach and Brian Kirkby named their design company "Boudicca" after the heroic 1st-century queen of the Britons who defied the Roman occupation of England. Both designers trained at Middlesex University and Kirkby went on to complete an MA at the Royal College of Art under the soubriquet Brian of Britain. Like Preen, they use historical sources, but in a more abstract way. Their *Battle of Altruism* collection in 2000 included literary quotes from Shelley and Rimbaud printed on to clothes, while for the magazine *Dazed and Confused* the British artist Gillian Wearing was photographed wearing a Boudicca dress inspired by Victorian wallpaper.

Boudicca (see p.174) are passionate about trying to change the boundaries of fashion and the fashion industry. They guard an independent vision, wary of the way in which the media can all too easily appropriate rebellion as a marketing device. Kirkby reflected on their political agenda of opposing globalization and homogenized culture in a recent interview, commenting "Can fashion be anti-capitalist? … When I look back at all our collections, I see that each one is fundamentally a question. We're in a business that our political and moral viewpoints don't sit with very easily." Invitations to their 2001 collection *Transition: It Pays My Way But Corrodes My Soul* were printed on tear-gas canisters, inspired by their participation in the anti-globalization protest during the G8 summit in Genoa, Italy, in 2001. They produce clothes in limited numbers with no reference to fashion seasons, and explore tailoring and crafted leather suiting and coats. Each garment is named, offering a personal or an emotional idea. For the Embrace Me jacket Boudicca included shoulder pockets in which a partner could place his or her hands and hug the wearer, while in contrast the Tight Arsed Bitch skirt detailed a hand-cut leather belt winding round the hips.

Antoni Burakowski and Alison Roberts, better known simply as Antoni & Alison, have earned something of a cult following for their T-shirts displaying subversive and ironic slogans (see p.175). They are also known for staging fashion shows as performance events, typical of which was their autumn/winter 2000 show called *Be Careful Not to Bang Your Head*. This was a gentle parody of film and performance art in which they showed their clothes against a set inspired by the gritty realism of 1960s British films. The collection included A-line dresses and skirts decorated with prints of scrunched paper, pears, potatoes, and the slogan "I think you're great".

Antoni & Alison's collection for autumn/winter, quirkily called *At last I've found you, I was almost going mad*, was presented on a stage covered with bottled milk and cookies; the collection included the duo's signature T-shirts but also developed their range of ready-to-wear clothing, including knitwear and apron skirts printed with Alpine scenes, gingham skirts with mismatched hems, and dresses with elasticated waists and sleeves. The collection marks a new direction, broadening out from quirky accessories to fashion design.

Working within a 20-year tradition of rebellious punk T-shirts, this tradition of experimentation that can also be seen in the work of other accessory design, including shoes. In

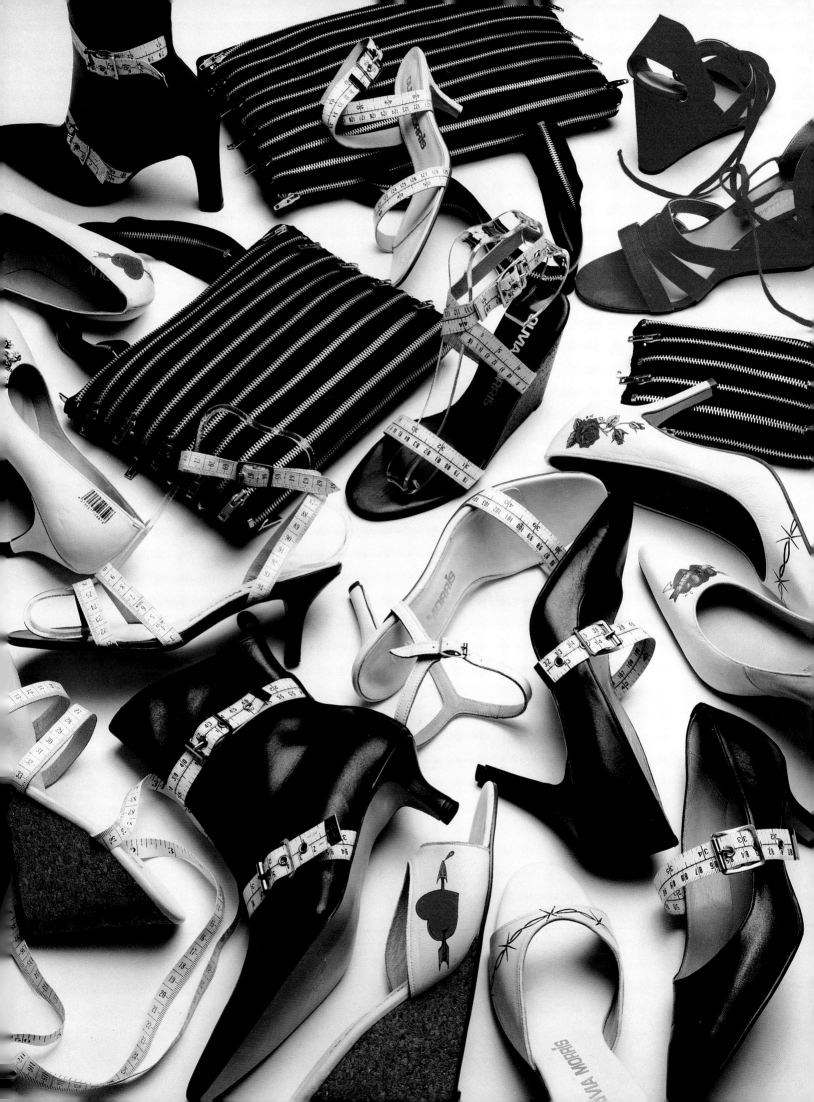

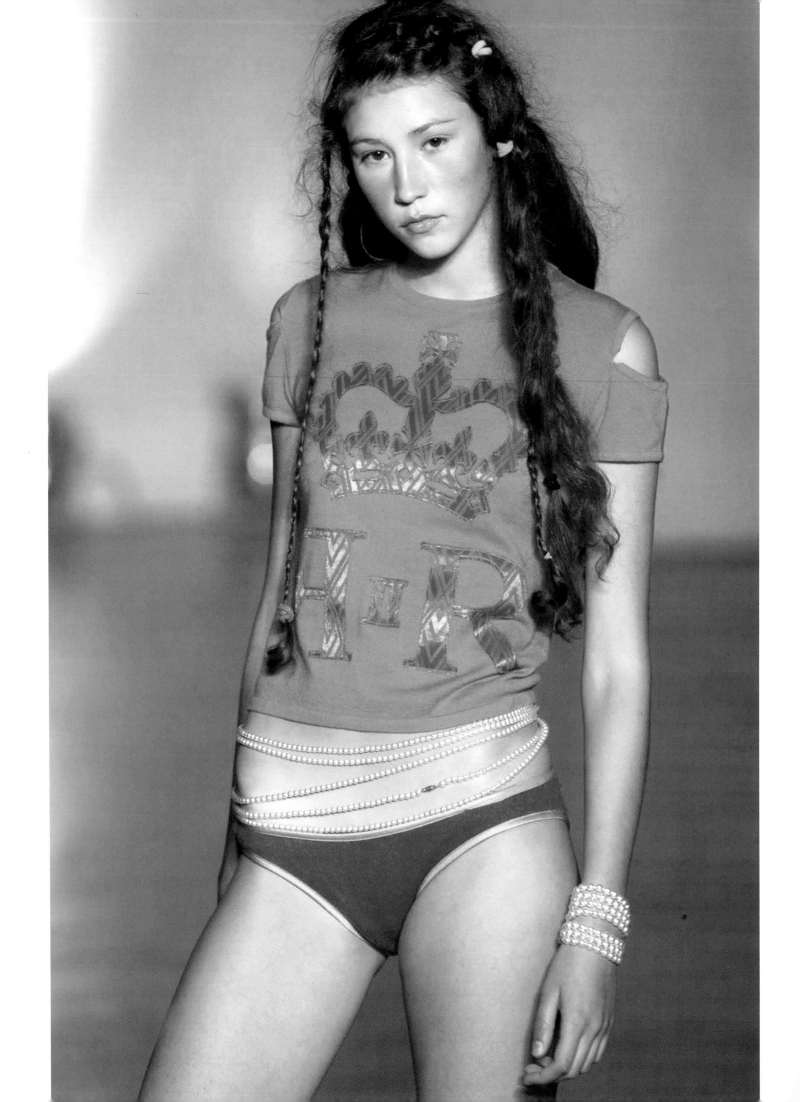

the 1980s Vivienne Westwood recognized the power of fetish stiletto heels as a device to subvert and challenge notions of female sexuality. Her famous high heels, with names such as "Nurse", gave the shoe an original take on tradition and invention, and other British shoe designers, most notably Patrick Cox, followed this lead.

A designer who continues to push the boundaries of conventional footwear design is Olivia Morris (see p.179). Morris graduated in 1996 from the Cordwainers College in North London and set up her own business two years later, finding work as a consultant for Donna Karan in New York and for British fashion designers, including Anthony Symonds and Preen. For the latter she designed floppy boots in earthy colours using glove suede, which helped to establish her reputation for shoe design. Her shop, situated in London's fashionable Portobello Green, attracts a great deal of interest from the fashion media and the fashion crowd, selling individual shoes, notably her Tattoo Boots and pierced leather shoes, that offer an alternative to the high street. Her collections include *Pierced*: boots and shoes with V-shaped cuts held together with single metal bolts, the *Tattoo* collection of vegetable-dyed nude leather shoes with tattoo motifs, and the *Made To Measure* collection (see p.179) whose shoes were inspired by a tailor's studio with straps made from authentic tape-measures.

Fashion and art

There is a significant group of British designers who position themselves between fashion and art: young designers who explore ways of reinventing what fashion design might be, who use video installations as the "garment" or whose collections have no clothes at all and exist only in beautifully designed show invitations. Over the last 30 years such crossover points between art and fashion have become a fundamental part of British style, linked to a longer history within the artistic and cultural revolutions of the last century.

Fashion that claims to be a real art form may, of course, deeply irritate, but it is worth pointing out that throughout the 20th century it was very often the crossovers and parallels between the worlds of fashion and art that helped modern visual culture move forward. Mapping out some of the most famous and significant points of contact between art and international fashion has been the subject of several recent books and exhibitions, notably *Addressing the Century: 100 Years of Art and Fashion* at the Hayward Gallery in London in 1998. This exhibition explored two worlds that enjoy many similarities but have fundamental differences. Fashion designers, in the main, have to address the needs of the market, the constraints of retail production, the requirements of seasons, and the process of endlessly renewing ideas and directions for each collection. Those realities, those constraints, which art does not on the whole have to confront, mark the essential difference in territory between fashion and art. However there are notable exceptions to the separation of the two disciplines: fashion designers whose work crosses the boundary between fashion and art or in whose designs fashion becomes an art form in itself.

One of the most original thinkers in contemporary British fashion is Hussein Chalayan (see p.161). For his final degree show in 1993 at Central St Martins Chalayan created one of the

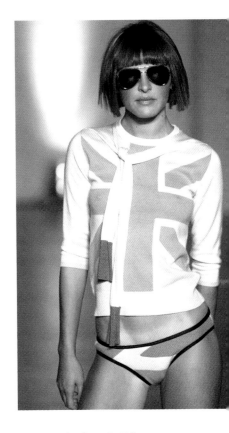

ABOVE *Also from the Fake London spring/summer 2002 collection is this knitted cashmere sweater and co-ordinated knickers that play on Fake London's recurring use of the Union Jack flag motif as a form of decoration, translated here from the patriotic blue and red to more muted pastel tones.*

LEFT *The Fake London label uses traditional British symbols as a source of inspiration. The spring/summer 2002 T-shirt shown here features graphic appliqué symbols of royal regalia in contrasting fabrics, and details borrowed from Punk history such as the cut sleeve. Fake London clothes often subvert symbols of tradition, including here the use of pearls as a belly chain rather than as a necklace.*

most memorable moments of recent British fashion. He famously buried his garments, dug them up, and showed the effects of decay and ageing to powerful effect, touching on deep human fears and experiences in a very real way. The manner in which Chalayan exhibits and presents his ideas continues to work both within and outside fashion. At the Tate Modern's *Century City* exhibition in 2001 he exhibited "dressed" chairs and tables within a formal art installation piece, and he collaborates with, rather than commissions, artists and film-makers, a notable example being his computer-game film to show his 2001 collection *Ventriloquy*. Among his peers Chalayan is highly regarded as a designer who extends the boundaries of fashion.

Important in this context is the strong profile and identity of British fashion-design education, which enjoys a tradition that goes back to the pioneer work of postwar fashion educators such as Madge Garland at the Royal College of Art. Fashion education is part of the art college system, so that in Britain student fashion designers are not placed in specialist technical institutions but in schools that might typically include the disciplines of art, furniture design, film, and music. Cross-fertilization between the genres is an enduring strength of this system.

Two London colleges have now come to dominate British fashion training, the Royal College of Art (RCA) under the direction of fashion designer Wendy Dagworthy, and Central St Martins led by Jane Rapley. The RCA, located in South Kensington, offers only postgraduate training. Central St Martins, located in Holborn, offers undergraduate training and both colleges enjoy an enviable reputation for the success of their alumni.

There has however always been a tension between fashion education and the fashion industry, centring on a debate about the need to nurture creativity versus the need to train for the specific skills required in manufacturing and business. Education will have to confront the widespread criticism that British fashion is becoming all art and no commerce. It is a dilemma that Phoebe Philo, Stella McCartney's replacement at Chloé, summed up when she was interviewed in *Vogue* about her own experience of Central St Martins: "I wanted to make a pair of trousers that made my arse look good, rather than a pair of trousers that represented the Holocaust."

Nonetheless the theme of fashion and art continues to exert a particular fascination over contemporary British fashion designers. Helen Storey, for example, a designer who first came to prominence in the 1980s British new wave, has pioneered a way of working in which she frames her output within an art context by showing her recent work exclusively in galleries and museums. Storey recognizes that certain designers can "place" their ideas more securely in the cultural context of art and in the mechanisms of the art world, rather than in the tough commercial world of fashion.

Hamish Morrow is another designer who invites his audience to experience fashion as art and takes them into a rarefied and exclusive cultural zone, enjoying something of a cult reputation among designers for his strong fashion vision. His reputation is based on a very small number of collections since 2000, which have each comprised about 16 exquisite but "unwearable" outfits. Subsidized by Morrow's design consultancy work for the commercial fashion world, these collections were not intended for sale but rather as statements of ideas and directions. The

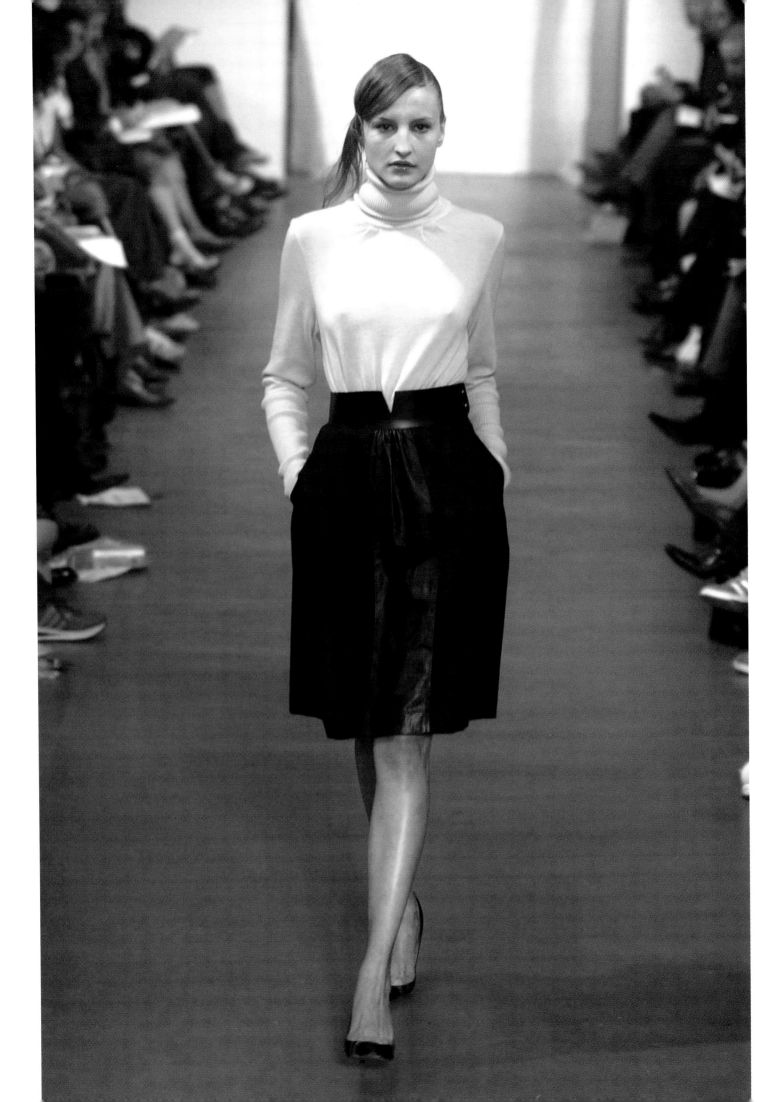

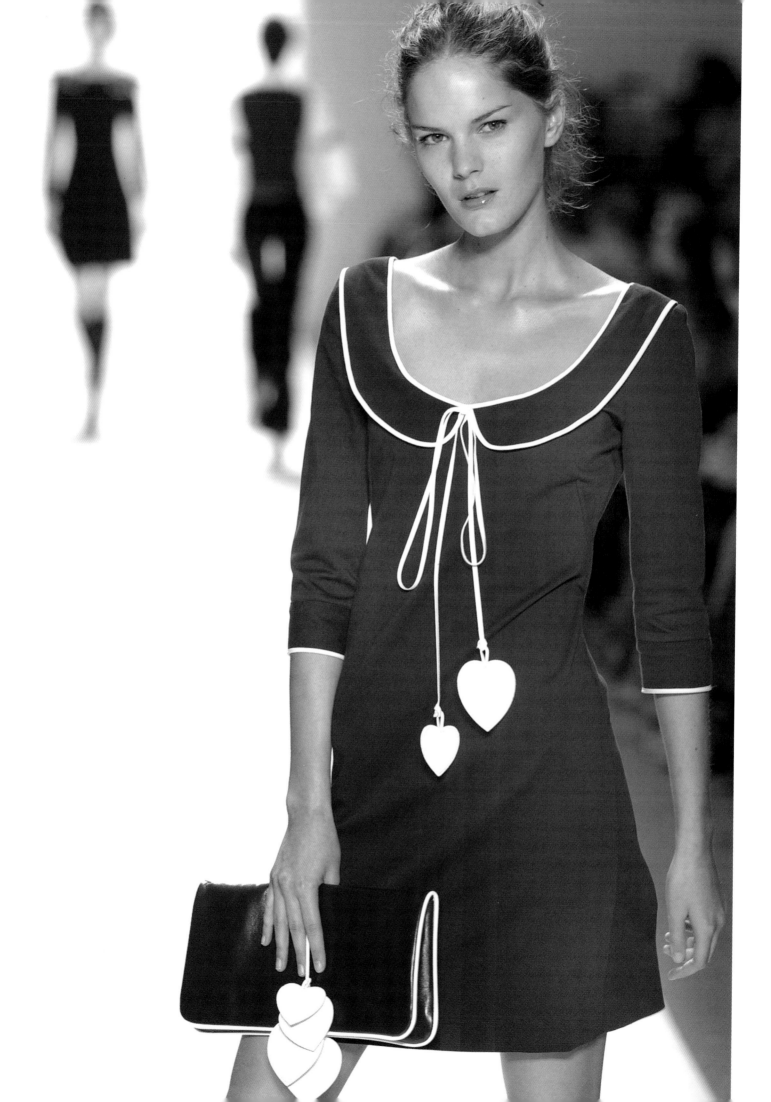

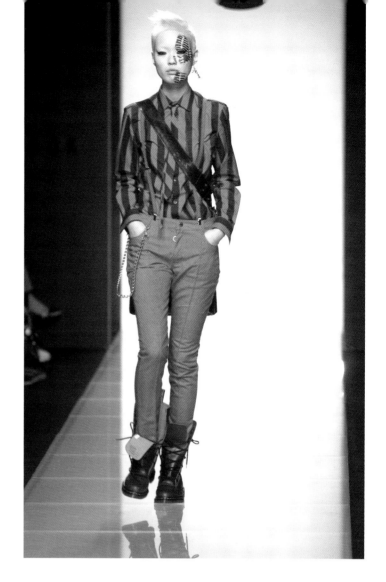

LEFT *This simple, feminine fitted dress is from Luella Bartley's autumn/winter 2002 collection. The white-trimmed collar details and matching clutch bag with heart motif give the outfit a girly, sexy look that is characteristic of Bartley's designs. Light make-up and dishevelled hair in a high ponytail reinforce the image.*

RIGHT *Luella Bartley showed this autumn/winter 2001 collection to great acclaim, demonstrating the edginess for which she is famous in the tight red jeans cut to fit, and the Dr Marten boots with open laces. The striped shirt and tattoo make-up evoke an early 1980s Westwood collection, and show Bartley's talent for offering a modern spin on modern classics.*

collection *The Life Cycle of an Idea* was presented in East London's Atlantis Gallery where, to the sound of thudding heartbeats, Morrow presented 15 outfits, each one at a different stage of completion – the designer's reflection on the rapid consumption of ideas in the fashion world. In 2001 *Angels* showed his models dressed in pure white walking through a shallow pond of violet ink that dyed the hems of their clothes, evoking the accidental chance encounter of Surrealism. Perhaps the best element with which to analyze the boundary between art and fashion is a designer's collection show. It was, after all, British designers in the 1980s who transformed the tradition of the fashion show from a formal parade of conventional models to a performance event that is only shown to a limited and exclusive audience. In the 21st century the fashion show must be a spectacle more thrilling than any theatre performance, an event that will astound and amaze the viewer. The final group of designers in this section are more engaged and focused on London, the city, and its lifestyle.

London city cool

Since the 1980s British fashion has offered a unique take on chic street clothes with a certain sexual edge, and this tradition from young British designers remains a strong theme in contemporary British fashion. In the 1990s one trend focused on the lively and fashionable

Notting Hill area of London, which includes the Portobello market, artist's studios, designer shops, and cafés, and is associated with a dress-down look that mixes vintage pieces with casual denim. Notting Hill is not only about clothes but also the new wave of specialist shops that retail the look, such as Jeff Ihenacho's One of a Kind in Portobello Road, which sells designer labels from the 1960s, and Marc Hare and Selene Allen's Something in Chepstow Road. Another trend, quite different from the Notting Hill style, is represented by central London and more specifically by a number of key boutiques and shops centred around Soho, which are documented at the end of this section. While Notting Hill is about a retro look within an affluent lifestyle, Soho is about working young professionals and is more edgy and club-focused. This group of designers makes clothes that express a certain kind of "London cool", an edge that marks out British fashion in the 21st century. They also express a notable focus on youth, a reminder that while in Italy, for example, style is about looking older, in London it is about looking younger. This London culture of urban cool, of clubs and city life, has been represented by designers such as Fake London, Lizzy Disney, Luella Bartley, and Maria Chen.

Desiree Mejer is the designer behind Fake London (see pp.180–81). Originally from Spain, but now based in London, she became infatuated by clichéd English images: her signature motif is a bulldog, and other details include Pony Club rosettes pinned to sweaters, parkas, and bondage trousers. Mejer started out with a collection of cashmere scarves and sweaters and slashed Chanel-style twin sets in bright colours, and moved on to using patching and appliqué with recycled cashmere chopped up – this is the basis of her most popular design, a Union Jack sweater. Her intuitive sense of colour and decoration is revealed in optic-print knits, and in a red-white-blue pattern that on closer inspection reveals itself to repeat little maps of England printed in those three colours. The Fake London range also includes a Fake jeans line incorporating pieced and stitched denim minis, jeans, and school-blazer type jackets.

Lizzy Disney (see p.183) is one of the most highly regarded young British designers, whose work enjoys a high international profile but is less well known in Britain. This in part is due to the fact that after graduating from Central St Martins in 1995 she chose to start her career in New York, not as a designer but working in the fashion industry for stylists and video directors. It was not until four years later that she launched her first collection, as part of New York Fashion Week. Disney offered New York fashion a style that combined a London influence with a relaxed elegance that appealed to an international market. It was a commercially successful approach to dressing women that has led to another of the celebrated fashion partnerships between London and Paris. In 2002 Disney was invited to join Fath, a French brand started by Jacques Fath in the 1950s. Fath is now part of FLG (France Luxury Group), which also controls Jean-Louis Scherrer, Emmanuelle Khan, and Harel. Jacques Fath, a contemporary of Dior and Balenciaga, was a flamboyant figure in postwar French fashion, noted for his audacious use of colour and use of masculine details, including short-haired models, to give a *gamine* look, elements of which are highly visible in Disney's work. Her powerful vision of women's fashion combines a clean silhouette with a feminine edge – particularly in her trousers – that enhance the female form.

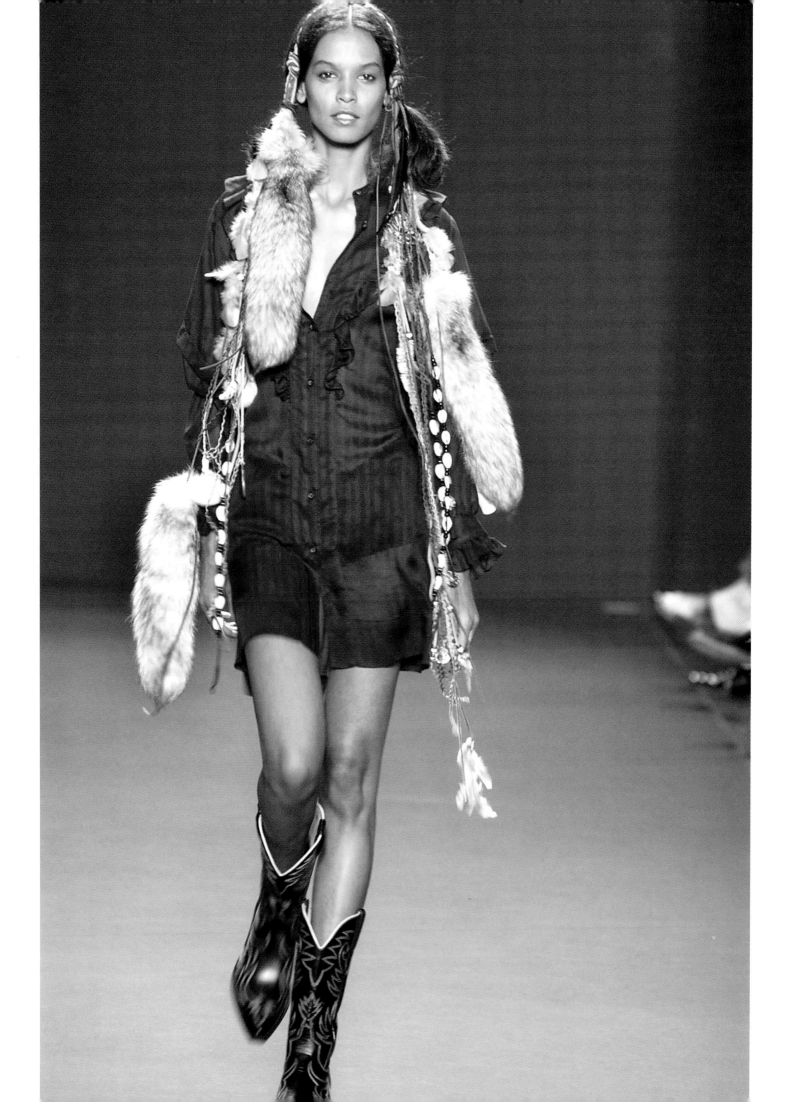

ABOVE *This promotional advertisement was used to introduce Maria Chen's spring/summer 2002 collection. A simple grid design of key pieces from her mens and womenswear collection, it was taken as a series of static images showing a group of models in their 20s who represented the market for her look. Since her marriage in 2001 Chen uses the name Chen-Pascual.*

It was a vision that made her the obvious choice for Fath, whose chief executive, Mounir Moufarrige, has been responsible for placing three graduates from Central St Martins in key posts in the French fashion industry. The first of these was his appointment of Stella McCartney as Karl Lagerfeld's replacement at Chloé, then Phoebe Philo as McCartney's successor there, and he has now appointed Lizzy Disney to return to Fath the original energy and vision of its founder.

Luella Bartley (see pp.184–7) began a fashion degree at Central St Martins but transferred to a course that focused on fashion journalism; she worked as a fashion journalist first for the London *Evening Standard* and then for British *Vogue*. Bartley claims to have moved into fashion design as a dare and made her successful début with her first collection in London 2000. She then moved on to show her collections, like Disney, in New York. She is perhaps best known for her famous sports blazer in bold, monochrome stripes which came to represent the chic trendy club look. Bartley is influenced by stereotyped aspects of "England" – rebellious schoolgirls, uniforms, ponies – and she has described her own sense of style as "amalgamating quite straightforward clothes with a bit of cool and a bit of sex". Her first collection, *Dial F for Fluoro*, included twisted skull and whip prints on biker jackets, graffiti-sprayed luxe leather minidresses, rockabilly coat-dresses in pastel shades, graffiti-print strapless swimsuits worn under tuxes, and a denim jacket adorned with the words "London's Burnt Out". Bartley's New York collections caught a mood of "clothes to get drunk and fall over in" and her designs in general reflect a rebellious schoolgirl streak, combining spiked heels, tight pencil skirts, and stretch drainpipe trousers with tight V-neck jumpers and bomber jackets. Her *Cowboys and Indians at Glastonbury* collection for spring/summer 2002 at Bryant Park, New York, combined cowgirl influences with Native American Indian style. With their 1970s faded candy colours, her clothes have a certain attitude that is girly, sexy, and fun. Bartley also works as a style consultant for the British fashion retailer New Look.

Maria Chen-Pascual is most definitely Soho, well known for clothes that reflect the London scene and that appeal to young people who want to buy into a recognizable look and brand. It is an image that Chen developed in collaboration with the stylist Jane Howell. Chen clothes are

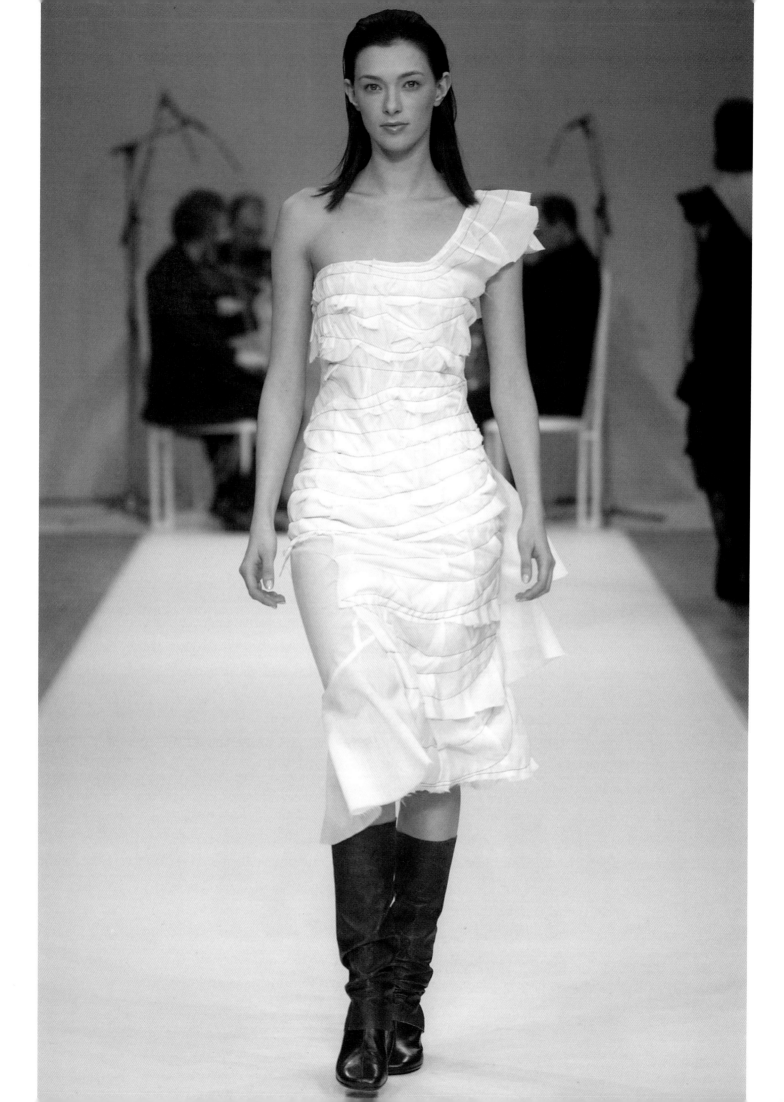

LEFT *A white static cling dress with overlaid decorative stitching from Maria Chen's autumn/winter 2002 collection* Shadow, *which explored unconventional techniques in print and fabric processing. The dress develops Chen's ambition to offer a vision of London urban chic: a simple shape, customized with a fashionable textural element.*

noted for their interesting shapes and quirky but not excessively complicated detailing, such as asymmetrical hoods and back-to-front tops. Her trademark look includes raw edges and cloth that has been hand-dyed and frayed, giving each garment a hand-made, unfinished quality. Individual pieces combine a femininity and softness with a hardness and edge, as shown in her Regency-inspired short muslin dress, ripped and torn to give it a distressed look.

Chen was born in Taiwan in 1971 and was educated in the United States from the age of 13. She studied fashion at Parsons School of Design in New York and then worked in the United States for the knitwear designer Joan Vass and for fashion designers Ruben and Isabel Toledo. Under their influence Maria learned to apply and adapt unconventional techniques for use in ready-to-wear. It was an approach that she built on in her work after she left New York, when she enrolled on a postgraduate course at Central St Martins. In 1998 she was shortlisted for the prestigious Jerwood Prize for her use of hand-printed, bleached, and shredded fabrics in muted colours. Other techniques include a long-standing exploration of dyeing, in which she uses limited quantities of fabric and clothes, densely packed into small dyeing vats to create a layered effect. In her current work she continues to develop innovative fabrics, to which she often applies print and hand-sewing in a form of surface manipulation. Customization is another important theme in Chen's work. She was asked by Jane Howell to recycle a pile of old Coca-Cola-branded T-shirts, which she used in her spring/summer 2002 collection exploring the themes of war and propaganda. She later applied the same technique to Adidas sportswear, cutting the pieces up into skirts and belts and printing over them to create different textures.

Maria Chen is committed to rigorous research and enrolled for a short time on a PhD programme, intrigued as much by the process of arriving at a collection as by the final outcome. Her research includes looking at old clothes, but her methodology is not straightforward fashion history: what interests her in men's tailoring details are the moments of crossing boundaries into women's wear, for example gentlemen's classic overcoats. Chen discovers clothes, like the objects that inspire her, accidentally. Important sources range from snapshots from her childhood to Victorian lace – both used as starting points to create screen-printed *trompe l'oeil* effects. Inspiration for her dresses has come from 1920s' lingerie, as she cuts, works, and twists chiffon fabric so that it falls off the body. In 2001 Chen explored the boundaries of art and fashion in an Amsterdam gallery, the Fan Club, where she used prototypes from her collection, overdyed black, to create an installation piece. She used toiles both as objects in themselves and as part of the designing process and the finished garment. Her approach starts with construction as she experiments with shapes to create the sculptural silhouettes for which she is best known.

Designers such as those profiled above continue to create exciting new British contemporary fashion, and their work ensures that London is seen as a city whose vision might offer a blueprint for the future, a way of signposting our complex world. There has always been a unique sense in Britain that fashion is more than simply clothes, underpinned as it is by ideas, by cultural diversity, and by intellectual richness. As Alexander McQueen has said: "It's to do with the politics of the world – the way life is – and what is beauty."

SOHO

Bounded by Oxford Street to the north and Regent Street to the west, Soho is a warren of alleyways and squares. Its markets and shops, sex boutiques and artist's studios, tailoring workshops and clubs, along with its high concentration of creative industries, offer a mix of the seedy, the glamorous, and the hard-working that is unlike anywhere else in London. Located here are some of the unique shops that offer new British fashion. Soho's tradition of cutting-edge independent retailing dates back to Vince, opened in 1954, and to Carnaby Street in the 1960s. Innovative shops include Concrete, Koh Samui, the Pineal Eye, and Kokon To Zai, fashion outlets that do not follow high-street trends but cater for those who seek original items.

Philip Stephens started Concrete PR in 1998 to represent young British fashion designers, and the shop, at 35 Marshall Street, acts as a showcase for the work of these designers. Concrete offers strong and interesting work that is not stocked elsewhere in the UK, including Maria Chen, Robert Cary Williams, Preen, Dave and Joe, and Hudson Shoes. It also profiles Tsubi from Australia and the new Belgian designer for Loewe, José Enrique Ona Selfa. The design of the Concrete interior is calculatedly ramshackle, with the eclectic feel of an upmarket charity shop, giving the effect of a home-from-home walk-in wardrobe. The shop offers customers the opportunity to talk through the ethos of the clothes and seek advice on how to wear more complicated pieces. Concrete also offers one-off commissions to customers from its in-house designers.

Koh Samui, at 65–67 Monmouth Street, was established in 1994 by Talita Zoe Dalmeda and Paul Sexton, originally in Covent Garden. Koh Samui is considered a landmark retailer by many commentators, and in 2000 was invited by the British Fashion Council to join its Select Committee. Dalmeda and Sexton describe their clothes as feminine and edgy, bought to

ABOVE *Koh Samui, 65–67 Monmouth Street, London W1, March 2002. The palm print pieces and the Hawaiian dancing girl top were designed by Iranian-born Nargess Gharani and Croatian Vanja Strok, well known for their mix of prints with retro shapes. They founded the label Gharani Strok in 1995.*

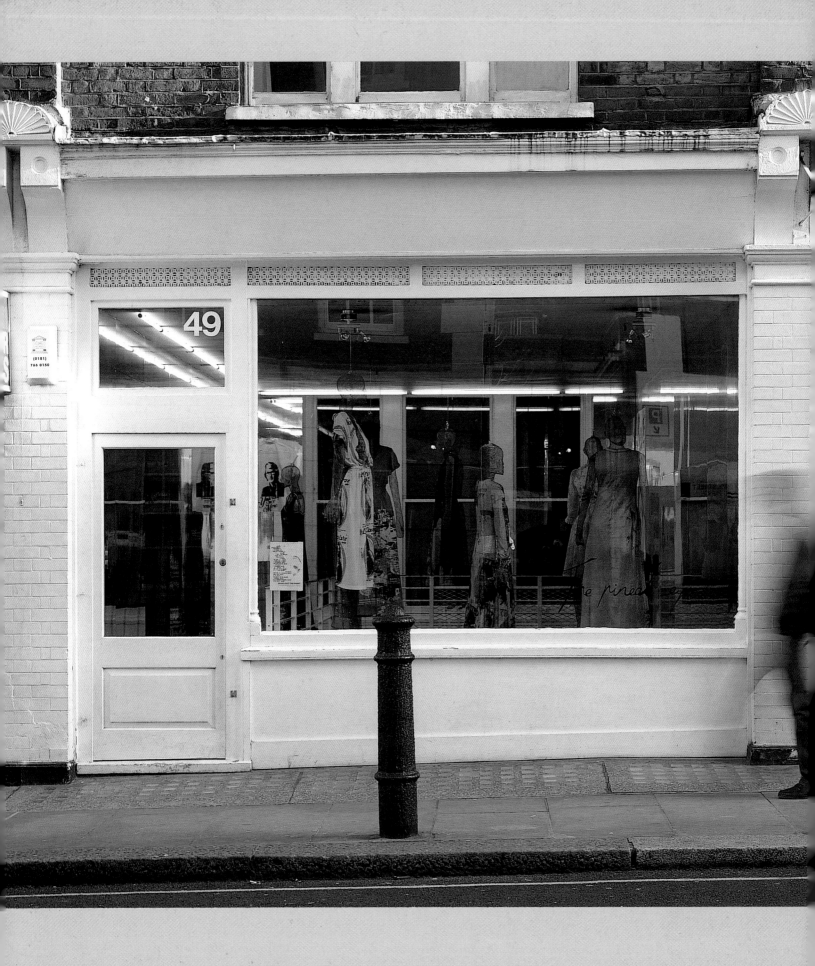

reflect their own taste. The shop interior projects a minimalist, modern look and their list of British designers includes Buddhist Punk, Camilla Staerk, Clements Ribeiro, Eley Kishimoto, Hussein Chalayan, Jimmy Choo, Julien MacDonald, Matthew Williamson, Preen, Roland Mouret, Scott Wilson, Sophia Kokosalaki, and IE Uniform.

The agenda of The Pineal Eye, opened in 1998 at 49 Broadwick Street, combines fashion with art. The exterior of the shop is discreet, minimal and white, while the interior has been opened up to give huge wall surfaces for exhibitions of fashion and design. The Pineal Eye is an independent business run by Yoko Yabiku which aims to offer an outlet to talented new designers, usually in the first years of their career, most recently including Beca Lipscombe, a young Scottish designer, and Kim Jones.

Kokon To Zai, at 57 Greek Street, was opened in 1996 by Sacha Be and Marjan Pejoski, who wanted to sell alternative style to fashionable and Londoners and to combine fashion with music. Half the shop is devoted to selling music. The approach is highly personal and the look is sexy and glamorous, attracting style editors, models, and young creatives. Kokon To Zai profiles the work of Pejoski, who also maintains close contacts with St Martin's College, encouraging young designers to show their work and participate in a programme of fast-changing installations. Kokon To Zai has become known for its window displays, which change weekly, using artists and designers to decorate the walls, and once memorably featuring Pejoski's installation of skeletons and crosses; such installations are one of Kokon To Zai's main attractions.

LEFT *The Pineal Eye, 49 Broadwick Street, London W1, March 2002. This window display is part of an installation by the young Japanese artist Waturu Komashi. In his work Komashi uses text messages, words, and graphic prints, printed here onto 1970s second-hand clothes. The upper space of the shop is a gallery for contemporary art.*

RIGHT *Kokon To Zai, 57 Greek Street, London W1, March 2002. The idea behind this window display by Marjan Pejoski was a 1920s Parisian brothel used as a setting for exploring people's perspectives on Egypt. The display was used as the set for Pejoski's spring/summer 2002 show in London; the gold lamé jacket is from the same collection.*

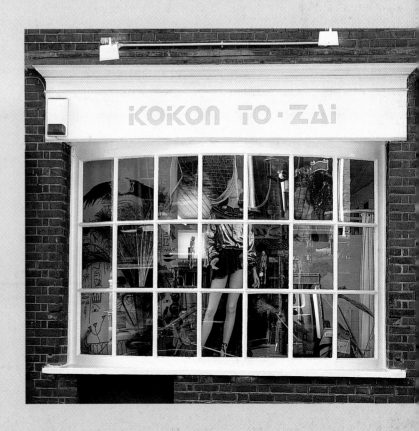

DESIGNERS & COMPANIES

ORGANISATIONS

British Fashion Council
5 Portland Place, London W1
www.londonfashionweek.co.uk

Industry Forum
5 Portland Place, London W1
www.industryforum.net

DESIGNERS & COMPANIES

Agent Provocateur
Joseph Corre and Serena Rees
b.1967, UK and b.1968, UK
Women's lingerie
Own label shop: 6 Broadwick
Street, London W1

Bill Amberg
b.1962, UK
Contemporary leather goods
Own label shop: 10 Chepstow
Road, London W2

Hardy Amies
Established 1946
Couture and ready-to-wear
Flagship store: 14 Savile Row,
London W1

Anderson & Sheppard
Established 1906
Gentlemen's Tailor
Flagship store: 30 Savile Row,
London W1

Antoni & Alison
Antoni Burakowski and
Alison Roberts
b.1962, UK and b.1963, UK
Slogan T-shirts and womenswear
Own label shop: 43 Roseberry
Avenue, London EC1

Aquascutum
Established 1851
*Traditional British label for mens
and womenswear, and accessories*
Flagship store: 100 Regent Street,
London W1

Austin Reed
Established 1900
*Traditional British label for mens
and womenswear*
Flagship store: 103–113 Regent
Street, London W1

Jacques Azagury
b.1956, Morocco
Luxury custom-made evening wear
Own label shop:
50 Knightsbridge, London SW1

Ballantyne
Scottish cashmere knitwear
Flagship store: 4–6 Savile Row,
London W1

Luella Bartley
Womenswear
Major stockist: Harrods, 87–135
Brompton Road, London SW1
Designer contact: Ground Floor,
99 Talbot Street, London W11

Blaak
Sachiko Okada and Aaron Sharif
b.1973, Japan and b.1975, UK
Mens and womenswear
Major stockist: Liberty, 210
Regent Street, London W1
Designer contact: 3rd floor,
144 Shoreditch High Street,
London E1

Manolo Blahnik
b.1943, Canary Islands
Women's shoes
Own label shop:
49–51 Old Church Street,
London SW3

Ozwald Boateng
b.1967, UK
New bespoke tailor
Own label shop: 9 Vigo Street,
London W1

Boudicca
Zowie Broach and Brian Kirkby
Conceptual womenswear
Major stockist: B Store, 6 Conduit
Street, London W1
Studio: Top floor,
6–8 Vestry Street, London N1

Burberry
Established 1856
*Traditional British label for men
and womenswear, and accessories*
Flagship store: 21–23 New Bond
Street, London W1

Ally Capellino
Alison Lloyd
b.1956, UK
Womenswear and accessories
Flagship store: 66 Sloane Street,
London SW3

Robert Cary Williams
b.1965, UK
Womenswear
Designer contact and stockist:
Concrete, 25 Fouberts Place,
London W1

Hussein Chalayan
b.1970, Cyprus
Womenswear
Major stockist: Harvey Nichols,
109–125 Knightsbridge,
London SW1

Caroline Charles
b.1942, Egypt

Womens day and evening wear

Own label shop: 56–57
Beauchamp Place, London SW3

Maria Chen
b.Taiwan

Womenswear

Designer contact and stockist:
Concrete, 25 Fouberts Place,
London W1

Jimmy Choo
b.1961, Malaysia

Women's shoes

Own label shop: 20 Motcomb
Street, London SW1

Clements Ribeiro
Suzanne Clements and
Inacio Ribeiro
b.1969, UK and b.1963, Brazil

Womenswear

Designer contact: 48 South
Molton Street, London W1

Jasper Conran
b.1959, UK

Classic womenswear

Mainline collection: Selfridges,
400 Oxford Street, London W1

Designer contact: 6 Burnsall
Street London SW3

Cordings
Established 1839

Country tailoring and sportswear

Flagship store: 19 Piccadilly,
London W1

Paul Costelloe
b.1945, Ireland

Womenswear

Own label shop: 156 Brompton
Road, London SW3

Patrick Cox
b.1963, Canada

Men's and women's shoes

Own label shop:
129 Sloane Street, London SW1

Neisha Crosland
b.1960, UK

Scarves, handbags, and accessories

Own label shop: 137 Fulham
Road, London SW3

DAKS Simpson
Established 1894

*Traditional British label for
mens and womenswear*

Flagship store: 10 Old Bond
Street, London W1

Eley Kishimoto
Mark Eley and Wakako
Kishimoto
b.1968, UK and b.1965, Japan

Textiles and womenswear

Major stockists: Harvey Nichols,
109–125 Knightsbridge, London
SW1, and Liberty, 210 Regent
Street, London W1

Timothy Everest atelier
b.1960, UK

New bespoke tailor

Own label shop: 32 Elder Street,
London E1

Fake London
Desiree Mejer
b.1968, Spain

Womenswear and accessories

Major stockist: Browns, 23–27
South Molton Street, London W1

Contact: 45 Broadwick Street,
London W1

Nicole Farhi
b.1946, France

*Womenswear, accessories, and
lifestyle products*

Flagship store: 158 New Bond
Street, London W1

Shelley Fox
b. UK

Womenswear

Designer contact: 52b Regents
Studio, 8 Andrews Road,
London E8

Bella Freud
b.1961, UK

Womenswear

Major Stockist: Jaegar, 204 Regent
Street, London W1

John Galliano
b.1960, Gibraltar

*Couture and ready-to-wear
womenswear*

Major stockist: Christian Dior,
22 Sloane Street, London SW1

Gharani Strok
Nargess Gharani and Vanja Strok
b.1970, Iran and b.1969, Croatia

Womenswear

Major stockist: Selfridges,
400 Oxford Street, London W1

Design contact: Unit 3c Long
Island House, 1–4 Warple Way,
London W3

Ghost
Tanya Sarne
b.1947, UK

Womenswear

Own label shop: 36 Ledbury
Road, London W11

Elspeth Gibson
b.1963, UK

Luxury cashmere and evening wear

Own label shop: 7 Pont Street,
London SW1

Gieves & Hawkes
Established late-18th century

*Bespoke tailor and men's
accessories*

Flagship store: 1 Savile Row,
London W1

Gina Shoes
Women's shoes

Own label shop: 189 Sloane
Street, London SW1

Maria Grachvogel
b.1969

Women's eveningwear

Own label shop: 5 South Molton
Street, London SW1

Lulu Guinness
b.1960, UK

Handbags and accessories

Own label shop: 66 Ledbury
Road, London W11

Hackett
Classic men's clothes

Flagship store: 147 Regent Street,
London W1

Katherine Hamnett
b.1948, UK

Womenswear

Own label shop: 20 Sloane Street,
London SW1

Anya Hindmarch
b.1968, UK
Handbags and leather goods
Own label shop: 15–17 Pont
Street, London SW1

Emma Hope
b.1962, UK
Day and evening shoes
Own label shop: 53 Sloane Street,
London SW1

Margaret Howell
b.1946, UK
Classic mens and womenswear
Flagship store: 39 Wigmore
Street, London W1

IE Uniform
Roger Lee and Lesley Sealey
b.1970, Singapore and b.1971, UK
Womenswear
Major stockist: Selfridges, 400
Oxford Street, London W1
Designer contact: 72 Wigmore
Street, London W1

Betty Jackson
b.1949, UK
Womenswear
Own label shop: 311 Brompton
Road, London SW3

Jaegar
Established 1883
*Classic womenswear with
collection by Bella Freud*
Flagship store: 204 Regent Street,
London W1

Richard James
b.1953, UK
New bespoke tailor
Own label shop: 31 Savile Row,
London W1

Stephen Jones
b.1957, UK
Milliner
Own label shop: 36 Great Queen
Street, London WC2

Orla Kiely
b. Ireland
Handbags, clothes, and accessories
Major stockists: Selfridges,
400 Oxford Street, London W1,
and Liberty, 210 Regent Street,
London W1

Sophia Kokosalaki
b.1972, Greece
Womenswear
Major stockist: TopShop Oxford
Circus, 214 Oxford Street,
London W1

Markus Lupfer
b.1968, Germany
Womenswear
Major stockist: Selfridges, 400
Oxford Street, London W1
Designer contact: 1–2 Ravey
Street, London EC2

Julien MacDonald
b.1972, UK
Couture and ready-to-wear
Major stockist: Harrods, 87–135
Brompton Road, London SW1

Stella McCartney
b.1972, UK
Womenswear
Major stockist: Harvey Nichols,
109–125 Knightsbridge,
London SW1

Alexander McQueen
b.1969, UK
Womenswear
Own label shop: 47 Conduit
Street, London W1

Olivia Morris
b.1974, UK
Modern footwear
Own label shop: 19 Portobello
Green, 280 Portobello Road,
London W10

Hamish Morrow
b.1968, South Africa
Womenswear
Designer contact: Unit 12a Links
Yard, 29 Spelman Street,
London E1

Roland Mouret
b. France
Womenswear
Major stockists: Harrods, 87–135
Brompton Road, London SW1,
and Liberty, 210 Regent Street,
London W1
Designer contact: The Courtyard,
250 Kings Road, London SW3

Mulberry
Established 1971
*Classic mens and womenswear,
and leather acessories*
Flagship store: 41–42 New Bond
Street, London W1

N. Peal
Cashmere knitwear
Own label shop: 37 Burlington
Arcade, London W1

Sonja Nuttall
b.1965, UK
Womenswear
Major stockist: Marks & Spencer,
458 Oxford Street, London W1

Jessica Ogden
b.1970, Jamaica
Womenswear
Designer contact: 57a Lant Street,
London SE1

Bruce Oldfield
b.1950, UK
Women's eveningwear
Own label shop: 27 Beauchamp
Place, London SW3

Pearce Fionda
Andrew Fionda and
Reynold Pearce
b.1967, UK and b.1964, UK
Womenswear
Major stockist: Debenhams,
334–348 Oxford Street,
London W1
Designer contact: 27 Horsell
Road, London N5

Marjan Pejoski
b.1968, Macedonia
Womenswear
Major stockists: Kokon To Zai,
57 Greek Street, London W1 and
Koh Samui, 65–67 Monmouth
Street, London W1

Preen

Justin Thornton and
Thea Bregazzi
both b.1970, UK

Womenswear

Own label shop: 5 Portobello
Green, 281 Portobello Road,
London W10

Pringle of Scotland

Established 1815

Classic knitwear

Flagship store: New Bond Street,
London W1

Dai Rees

Dai Rees and Simon Munro,
b.1961, UK and 1962, UK

Womenswear

www.dairees.co.uk

Camilla Ridley

b.1970, UK

Knitwear and accessories

Own label shop: 339 Fulham
Road, London SW10

Julian Roberts

b.1970, UK

Womenswear

Major stockist: 25a Pitfield Street,
London N1

Designer contact:
nothingnothing, Studio 4, 10–14
Hollybush Gardens, London E2

John Rocha

b.1953, Hong Kong

Womenswear

Major stockist: Fenwicks, 63 New
Bond Street, London W1

Russell Sage

b.UK

Womenswear

Designer contact: 10–12 Heddon
Street, London W1

John Smedley

Established 1893

Classic knitwear

Own label shop: 24 Brook Street,
London W1

Paul Smith

b.1946, UK

Menswear

Flagship store: 40–44 Floral
Street, London WC2

Philip Somerville

b.1930, UK

Milliner

Own label shop: 38 Chiltern
Street, London W1

Major stockists: Harrods, 87–135
Brompton Road, London SW1,
and Selfridges, 400 Oxford Street,
London W1

Tomasz Starzewski

b.1962, Poland

Eveningwear

Own label shop: 14 Stanhope
Mews West, London SW7

Oliver Sweeney

b.1954, UK

Bespoke men's shoes

Flagship store: 133 Middlesex
Street, London E1

Tata-Naka

Natasha Surguladze and
Tamara Surguladze
both b.1978, Georgia

Custom-made evening wear

Major stockist: Harrods, 87–135
Brompton Road, London SW1

Designer contact: Concrete,
25 Fouberts Place, London W1

Philip Treacy

b.1967, Ireland

Milliner

Own label shop: 69 Elizabeth
Street, London SW1

Catherine Walker

b.1945, France

*Women's couture and
eveningwear*

Own label shop: 65 Sydney Street,
London SW3

Tristan Webber

b.1971, UK

Womenswear

Major stockists: Harrods, 87–135
Brompton Road, London SW1

Vivienne Westwood

b.1941, UK

Womenswear

Flagship store: 44 Conduit Street,
London W1

Matthew Williamson

b.1971, UK

Womenswear

Designer contact: 37 Percy Street,
London W1

Ronit Zilkha

b.1965, Israel

Womenswear

Flagship store: 21 King's Road,
London SW3

BIBLIOGRAPHY

A National Strategy for the UK Textile and Clothing Industry,
Textile & Clothing Strategy Group, 2000

Amies, Hardy, *Just So Far*, Collins, London, 1954 –, *Still Here*,
Weidenfeld & Nicholson, London, 1984

Arnold, R, *Fashion, Desire and Anxiety*, I.B. Tauris, London, 2001

Ashelford, J, *The Art of Dress*, The National Trust, London, 1996

Barbican Gallery, *JAM: Tokyo – London*, exhibition catalogue,
Booth Clibborn Editions, London, 2001

Barthes, Roland, *The Fashion System*, Jonathan Cape, London, 1990

Barwick, Sandra, *A Century of Style*, Allen & Unwin, London, 1984

Baudot, F, *A Century of Fashion*, Thames & Hudson, London, 1999

Bolton, Andrew, *The Supermodern Wardrobe*, V & A Publications,
London, 2002

Borrelli, Laird, *Fashion Illustration Now*, Thames & Hudson,
London, 2000

Buckley, C, and H Fawcett, *Fashioning the Feminine*, IB Tauris,
London, 2001

Chenoune, Farid, *A History of Men's Fashion*, Flammarion, Paris, 1993

Cheshire, Susi, *British Fashion Designer Report*, London, 1998

Clark, O, and Lady Henrietta Rous (ed.), *The Ossie Clark Diaries*,
Bloomsbury, 1998

Coleridge, Nicholas, *The Fashion Conspiracy*, Heinemann, London, 1988

Collins, Brenda, *Flax to Fabric – The Story of Irish Linen*,
Irish Linen Centre, Northern Ireland, 1994

Connickie, Yvonne, *Fashions of a Decade: The 1960s*, B.T. Batsford,
London, 1990

Constantino, Maria, *Men's Fashion in the 20th Century: from frock
coats to intelligent fibres*, BT Batsford, London, 1997

Cotton, C, *Imperfect Beauty – the making of contemporary fashion
photographs*, V & A Publications, London, 2000

Crafts Council Gallery, *Fabric of Fashion*, exhibition catalogue,
British Arts Council, London, 2000

Crafts Council Gallery, *No Picnic*, exhibition catalogue, London, 1998

Crafts Council Gallery, *Satellites of Fashion*, exhibition catalogue,
London, 1998

Craik, Jennifer, *The Face of Fashion: Cultural Studies in Fashion*,
Routledge, London, 1994

Crane, D, *Fashion and It's Social Agendas*,
University of Chicago Press, 1999

De La Haye, Amy, (ed.), *The Cutting Edge – 50 Years of British Fashion
1947–1997*, V & A, London, 1996

Doe, Tamasin, *Patrick Cox – Wit, Irony and Footwear*,
Thames & Hudson, London, 1998

The Fashion Book, Phaidon, London, 1998

Fontanel, B, *Support and Seduction*, Harry N Abrams, New York, 2001

Frankl, S, *Visionaries: interviews with fashion designers*, London,
V & A, 2001

Gilmour, S, *Punks, Glam and New Romantics*, Heinemann Library, 1999

Gorman, Paul, *The Look: Adventures in Pop and Rock Fashion*,
Sanctuary Publishing, London, 2001

Grunfeld, Nina, *The Royal Shopping Guide*, Pan, London, 1984

Guillaume, Valérie, *Jacques Fath*, Editions Paris-Musées, Paris, 1993

Guy, Alison, (ed.), et al, *Through the Wardrobe*, Berg Publishers,
Oxford, 2001

Hadley, S, *Nylon: The Manmade Revolution*, Bloomsbury, London, 1998

Halliday, Leonard, *The Fashion Makers*, Hodder & Stoughton,
London, 1966

Hartnell, Norman, *Silver and Gold*, Evans Bros, London, 1955

Hayward Gallery, *Addressing the Century – 100 Years of Art & Fashion*,
exhibition catalogue, Hayward Gallery Publishing, London, 1998

Herald, Jacqueline, *Fashion of a Decade: The 1970s*, B.T. Batsford,
London, 1992

Howell, Georgina, *Vogue Women*, Pavilion Books, London, 2000

Hulanicki, Barbara, *From A to Biba*, Hutchinson, London, 1983

Johnson, K and S Lennon, *Appearance and Power*, Berg, Oxford, 1999

Johnston, Lorraine (ed.), *The Fashion Year*, Zomba Books, London, 1985

Jones, Dylan, *Paul Smith True Brit*, Design Museum, London, 1996

Jones, Terry, (ed.), *Smile ID: Fashion and Style: The Best From
20 years of ID*, Benedikt Taschen Verlag, Cologne, 2001

Khornak, L, *Fashion 2001*, Columbus Books, London, 1982

King, Reyahn, Sukhdev Sandhu, James Walvin and Jane Girdman,
Ignatius Sancho – An African Man of Letters, National Portrait Gallery,
London, 1997

Kingswell, T, *Red or Dead: the good, the bad and the ugly*,
Thames & Hudson, London, 1998

Koolhaas, R, et al, *Projects for Prada Part 1*, Fondazione Prada, 2001

Krell, Gene, *Vivienne Westwood*, Thames & Hudson, London, Universe
Publishing, New York, 1997

Laver, James, & Amy De La Haye, *Costume and Fashion: A Concise History*,
rev. ed., Thames & Hudson, London and New York, 1995

Leeds City Art Galleries, *Jean Muir*, exhibition catalogue, Leeds, 1980

Levin, Jo, *GQ Cool*, Pavilion Books, London, 2000

Lobenthal, Joel, *Radical Rags: Fashions of the Sixties*, Abbeville Press,
New York, 1990

Lurie, Alison, *The Language of Clothes*, Hamlyn, Middx, 1982

Martin, Richard and Harold Koda, *Jocks and Nerds – Men's Style in the Twentieth Century*, Rizzoli, New York, 1989

McDermott, Catherine, *20th Century Design*, Carlton, London, 1997

McDermott, Catherine, *Street Style – British Design in the 80s*, Design Council, London, 1987

McDermott, Catherine, *Vivienne Westwood*, Carlton, London, 1999

McDowell, C, *Galliano*, Weidenfeld & Nicolson, London, 1997

McDowell, C, *Fashion Today*, Phaidon, London, 2000

McDowell, C, *The Man of Fashion – Peacock Males and Perfect Gentlemen*, Thames & Hudson, London, 1997

McRobbie, Angela, *British Fashion – Rag Trade or Image Industry?*, Routledge, London, 1998

McRobbie, A, *In the Culture Society: art, fashion and popular music*, Routledge, London, 1999

Mendes,Valerie & Amy De La Haye, *20th Century Fashion*, Thames & Hudson, London, 1999

Muir, Robin, David Bailey: *Chasing Rainbows*, Thames & Hudson, London, 2001

Mulvagh, Jane, *Vivienne Westwood: An Unfashionable Life*, HarperCollins, London, 1998

Mulvagh, Jane, *Vogue History of 20th Century Fashion*, Viking, London, 1988

Museum of London, *Vivienne Westwood – A London Fashion*, exhibition catalogue, London, 1992

Oldfield, Bruce and Georgina Howell, *Bruce Oldfield's Seasons*, Pan Books, London, 1987

Parkins, W, (ed.), *Fashioning the Body Politic*, Berg Publishers, Oxford, 2002

Peacock, John, *Fashion Sourcebooks: The 1960s*, Thames & Hudson, London and New York, 1998

Polan, Brenda (ed.), *The Fashion Year*, Zomba Books, London, 1983, *The Fashion Year*, Zomba Books, London, 1984

Polhemus, Ted, *Streetstyle*, Thames & Hudson, London, 1994

Rhodes, Zandra and Anne Knight, *The Art of Zandra Rhodes*, Jonathan Cape, London, 1984

Roetzel, Bernhard, *Gentlemen – A Timeless Fashion*, Könemann, Cologne, 1999

Rose, Cynthia, *Trade Secrets: Young British talents talk business*, Thames & Hudson, London, 1999

Rothstein, N. (ed.), *Four Hundred Years of Fashion*, V & A Publications, London, 1984

Savage, Jon *England's Dreaming – Sex Pistols and Punk Rock*, Faber and Faber, London, 1991

Schefer, Doris, *What is Beauty? New Definitions from the Fashion Vanguard*, Thames & Hudson, London; Universe Publishing, New York, 1997

Sebba, Anne, *Laura Ashley*, Weidenfeld & Nicholson, London, 1990

Sims, J, *Rock Fashion*, Omnibus Press, London, 1999

Steele, Valerie, *Paris Fashion: A Cultural History*, Oxford University Press, Oxford and New York, 1988

Storey, Helen, *Fighting Fashion*, Faber & Faber, London, 1996

Tucker, Andrew, *The London Fashion Book*, Thames & Hudson, London, 1998

UK Creative Industries – Fashion, Department of Trade and Industry, London, 2001

Walker, Richard, *The Savile Row Story – An Illustrated History*, Prion, London, 1988

Warwick, A and D Cavallaro, *Fashioning the Frame*, Berg, New York, 1998

Watson, L, *Vogue: 20th Century Fashion*, Carlton, London, 1999

Watson, L, *Ossie Clark: Fashion Designer 1942–1996*, Warrington Museum, Warrington, 1999

Wilcox, Claire, (ed.), *Radical Fashion*, V & A Publications, London, 2001

Wilcox, Claire and Valerie Mendes, *Modern Fashion in Detail*, V & A Publications, London, 1991

Wilson, Elizabeth and Lou Taylor, *Through the Looking Glass*, BBC Books, London, 1989

Wolf, R, *Millennium Mode: fashion forecasts from 40 top designers*, Rizzoli, New York, 1999

Worsley, H, *Story of Fashion of the 20th Century*, Könemann UK Ltd, 2000

York, Peter, *Style Wars*, Sidgwick and Jackson, London, 1978

Your Guide To Our Services, Trade Partners UK, 2001

Yoxall, H W, *A Fashion of Life*, Heinemann, London, 1966

INDEX

ACKNOWLEDGMENTS

Author's acknowledgments

I would like to dedicate this book to my daughter, Elizabeth Mary Dale.

Mitchell Beazley would like to acknowledge and thank all those who have helped to provide images for publication in this book.

1 Anya Hindmarch; 2 Museum of London; 4-5 Lochcarron of Scotland; 7 Tate Gallery, London; 8, 9 Hulton Archive; 10 Private collection; 11, 12 Hulton Archive; 13 Redferns/Virginia Turbett; 14 Camera Press/John S Clarke; 15 Rex Features; 17 National Gallery of Canada, Purchased 1907; 19 Private collection; 20 Museum of London; 21 Getty Images/Shuan Egan; 22 Corbis/Bettman; 23 Hulton Archive; 24, 25 Museum of London; 26-27 Camera Press/Lichfield; 28 Corbis/Bettman; 29 Popperfoto; 31 Rex Features/Nils Jorgensen; 33 Margaret Howell Ltd/Koto Bolofo; 35 Chris Moore; 36, 37 Museum of London; 38 Marcus Tomlinson; 39 Chris Moore; 41 Kevin Ford; 42 Richard Waite; 43 Octopus Publishing Group/Steve Tanner; 44, 45, 46, 48 Henry Bourne; 49 The Ronald Grant Archive; 50 Precious McBane; 53 Quarry Bank Mill/Mike Williams/National Trust; 54 top James Smith Photography, bottom Harris Tweed/James Smith Photography; 55 Harris Tweed; 57 Corbis/BDV; 58, 60, 61 Lochcarron of Scotland; 62 Luke Kirwan; 63 James Merrell/Shirleen Crowe PR; 64 Kirkheaton Mills; 65 Morris Bray Photography; 66 Hulton Archive; 68 Paul Costello; 69 Christopher Hill Photographic; 70, 71 John Smedley Ltd/Quantum PR; 72,73 top left, top right Pringle of Scotland; 74 Jo Gordon; 75 Photo:Uli Weber; 76 Museum of London; 78 Chris Moore; 79, 80, 81 Suresh Karadia; 84 Burberry/Mario Testino; 86 top Burberry, bottom Rex Features/Dennis Stone; 87, 88 Burberry; 89 bottom left, bottom right Burberry; 90, 91 top left, top right, 92, 93 Mulberry; 94, 95, 96, 97 top, bottom DAKS Simpson Ltd; 99 Austin Reed/Trew Relations Ltd; 100, 101 Aquascutum Ltd; 102 Jaeger/Nathaniel Goldberg; 103 Jaeger; 105 Debenhams/PR Shots; 107 Topshop; 108 top left, bottom right Marks & Spencer/Jonathan Glynn Smith; top right, bottom left Marks & Spencer/Joaquin Blockscrom; 111 top left, bottom right Marks & Spencer/Max Cardelli; top right, bottom left Marks & Spencer/Michael Thompson; 112 Corbis Sygma; 115 Famous/Jeff Walker; 116, 117 Tim Graham; 119 Corbis Sygma/Stephane Cardinale; 120, 122, 123 Chris Moore; 124 BCPR/Tim Griffiths; 125 Kim Knott; 127 Caroline Charles; 128 top Chloé/Dan Lecca, bottom Corbis Sygma; 129 Chloé/Michel Adjaoui; 130 Chris Moore; 131 Ghost Ltd; 132 Chris Moore; 134 Jimmy Choo/Brower Lewis Ltd; 135 Manolo Blahnik; 136 Emma Hope/phPR; 137 Gina; 138 Patrick Cox; 139 Bill Amberg; 140, 141 Lulu Guinness; 142-143 Anya Hindmarch; 144 Kiely Rowan Ltd/The Communications Store; 146 Philip Treacy/Mark Mattock; 147 Philip Treacy/Robert Fairer; 148 Philip Treacy/Chris Moore; 149 Philip Treacy/Suresh Karadia; 150 Chris Moore; 153 Rex Features; 154 Press Association Picture Library; 155 Vivienne Westwood; 156, 157 Rex Features/Steve Wood; 158 V&A Museum; 159 Rex Features/Charles Knight; 160, 161 Agence France Presse; 162 Corbis Sygma; 163 Octopus Publishing Group/Steve Tanner; 164, 165 Julian Roberts/Nothing Nothing; 166 Octopus Publishing Group/Steve Tanner; 167 Chris Moore; 168 Jessica Ogden/The Garden/JB; 169 Octopus Publishing Group/Steve Tanner; 170, 171 Octopus Publishing Group/Steve Tanner; 172 Chris Moore; 173 Blaak/Bryan Morel PR; 174 Boudicca; 175 Antoni & Alison/Modus; 176-177 Fiona Freund/Stylist: N J Stevenson; 179 Olivia Morris/Mark Mattock; 180, 181, 183, 184, 185, 187 Chris Moore; 188 Maria Chen/Concrete; 189, 190 Maria Chen; 192, 193, 194, 195 Octopus Publishing Group/Steve Tanner